To Brenda

Acknowledgments

Throughout much of the twentieth century, creating a photograph was both an exploratory and an arduous process. From dealing with oversized cameras to using homemade darkrooms, taking the photo from its initial composition to a processed print was truly a feat of perseverance. I'd like to thank all those photographers who were engaged in that. I'd like to thank Todd Larson for his endless assessment of my photos and his support and encouragement during the writing process. In addition, I'd like to thank Kevin Harreld for reading my proposals and helping to make this photography book series possible. Last but not least, special thanks go to Cathleen Small, who has managed to keep me on track with both my writing and my research.

About the Author

Matthew Bamberg is the author of the *101 Quick and Easy Secrets* photography book series, which covers everything from creating winning photographs to using your photographs and emulating the great twentieth-century photographers. Bamberg began his career in the arts as a graduate student at San Francisco State University in 1992. His work in the visual and media arts included video production and software applications. He completed his M.A. in Creative Arts in 1997. After being a public school teacher for 14 years, Bamberg became a photographer and writer. He began to photograph for the articles he was writing while working for the *Desert Sun* and *Palm Springs Life* magazine. He has traveled the world, photographing in the most remote of places from Burma to Bolivia. His photographs have appeared in international magazines, galleries, and retail stores. Bamberg is also the author of *The 50 Greatest Photo Opportunities in San Francisco*.

Books in the *101 Quick and Easy Secrets* photography book series include:

* *101 Quick and Easy Secrets to Create Winning Photographs*
* *101 Quick and Easy Secrets for Using Your Digital Photographs*
* *101 Quick and Easy Ideas Taken from the Master Photographers of the Twentieth Century*

Contents

Introduction

Have you ever seen a photograph in a museum and thought, "I can do that"? With today's digital technology and a dSLR camera, there's quite a bit you can do to emulate those museum pieces. *101 Quick and Easy Ideas Taken from the Master Photographers of the Twentieth Century* helps you to recognize some of the techniques used by the great photographers of the twentieth century.

Each chapter in the book includes a bio of the master photographer (including what life events influenced his or her work) and a description of one or several photographs the photographer shot. In the photograph descriptions, I have described the elements of photography that apply to that work—light, shadow, subject, narrative, and symbolism. I've then re-created a similar photo with one key element that the master photographer used to produce it. Although the master photographers' images are not included in the book for copyright reasons, a website link is provided for most images. From there, you can go on to take your own picture using similar techniques and subjects. In addition, I've attempted to use similar subject matter to the master photographers' photos. In some cases, I've traveled to the exact spot where the master photographer's photo was taken (such as the re-creation of William Eggleston's *Roy's Café* scene in Amboy, California). In others, I've re-created a similar scene in a different place (such as finding a similar scene to Lee Friedlander's barren street scenes).

Also included in the book are the steps to find, compose, and manipulate the new image. There are sidebars that detail the steps to make images black and white as well as to create sepia tones and create softness, among other post-processing techniques.

The Concept

When considering a book about the masters, one mustn't forget the common concepts that they used to photograph their subjects. The book covers many. One such concept is taking a picture from a "worm's-eye" view—a photograph shot from below to make the subject look big. The name of this technique comes from the concept of thinking of yourself as a worm looking up.

Another concept master photographers used—framing shots where two disparate subjects appear to be communicating with each other—is detailed. Whether it is a figure in an ad communicating with a real person or a figure in one ad communicating with a figure in another, the result is the same—common, everyday figures are brought to life in ways that people wouldn't normally think about.

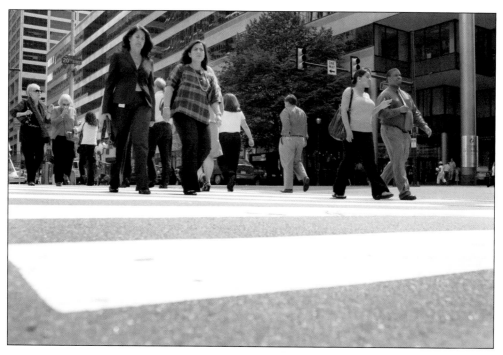

Subjects seen from a worm's-eye view.

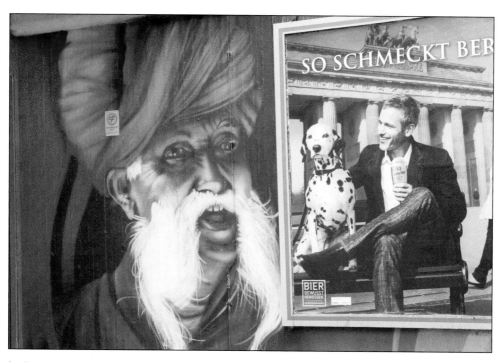

In these two ads, one disparate subject appears to be communicating with another.

The photography techniques introduced in this book are ones that the masters used. By no means am I recommending that you take a shot exactly like the masters did. If I did that, there would be no room for creativity and continued innovation. The techniques illustrated in the book are only a starting point from which you can improve your photography. By the time you have finished reading this book, you'll have a whole new batch of tricks up your sleeve.

Finally, none of the emulated images are from the master photographers themselves. I have taken every photo in this book, and I can only say that it was very rewarding to learn new ways of taking pictures by basing my photography loosely on the master photographers of the twentieth century.

In many of the images, important elements other than the subject may not be noticeably evident if they are not pointed out. For example, in Dorothea Lange's *The Road West*, the starkness along with the light hitting the road makes it look as if you are right in the picture. She obviously took the picture from the center of the road. When you go to emulate the shot, you will be emulating only the subject—and roughly, at that. The other elements of the photograph—light, color, shades of gray—are up to you to refine.

The symbolism of the photos will also change. In Lange's *The Road West*, the road signified the trip west many people took to find work in California. In the photo you take, the symbolism of the road you are photographing will be up to you.

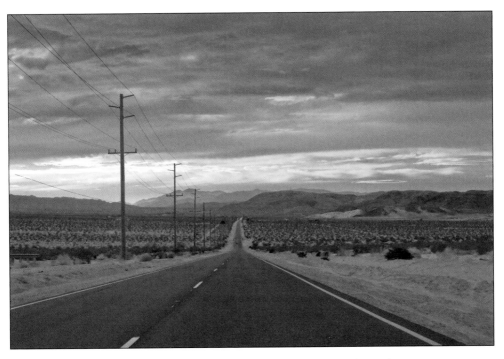

Lonely roads were the subject matter of many twentieth-century photographers; however, each had different light, shadows, perspective, terrain, vegetation, and clouds.

Many of the images will be black and white. There are sidebars about how to tweak black-and-white photos in Raw format, as well as how to create a variety of sepia tones. There is also a discussion about layers with respect to creating a double exposure. Other sidebars will refer to the methods of the artist's work, the photography rules the artist followed and/or broke, and the methods used to set up and photograph still lifes.

Introduction to the Masters

The list of twentieth-century photographers who created techniques and passed them along to professional and amateur photographers alike is long. Many of them became well known, each having created a number of iconic images. After writing this book, I found out that many of the photographers whose pictures I emulated lived well past age 90, adding further credence to my hunch that because of the creativity involved and the constantly seeking of life's refreshing moments, photographers tend to be around a long time. Another thing I discovered was that the great photographers (and artists) of the twentieth century were interconnected—they knew each other and learned from one another.

The book begins with Berenice Abbott, who looked at the world through its architecture from a number of different orientations. It moves on to Ansel Adams and Robert Adams, who both defined novel ways to shoot landscapes—the former in the traditional sense and the latter with a sense of concern about man's effect on the environment.

Paris is put under the microscope though the photographs of Eugène Atget, Brassaï, and Robert Doisneau. The first two defined new ways to use light and shadow during the day and at night, and the third, Doisneau, captured Paris streets through a lens full of unexpected surprises.

Figuring into the photography history equation is Harry Callahan, who looked at people among vast and endless surroundings, and Imogen Cunningham, who saw details up close in the simplest of living things. The former viewed humankind as tiny compared to the world at large, and the latter took elements of plants and animals that we take for granted and put them in close view to reveal patterns that some may not have known ever existed.

Back in the 1960s, Art Linkletter used to say, "Kids are people, too!" That message is brought to life by those photographers who framed children playing in the streets. Henri Cartier-Bresson was a master of composing children observing other children at play, and Helen Levitt caught the unexpected, from an overweight woman and her two kids stuffed into a phone booth to chalk drawings on the pavement of New York City streets.

Catch the eyes on the girl on the right, an expression similar to what Doisneau might have captured.

No discussion of twentieth-century photography would be complete without a nod to composing images of the human form. Many photographers went out of their way to disrobe their subjects (who were often their lovers) to photograph them every which way. Overt eroticism rarely played a role in these photographs, except, quite possibly, with respect to Mapplethorpe, who was determined to not only eroticize but also shock.

Many of the master photographers shot in black and white. In the early part of the century, color film wasn't available. By the middle of the century, the photographers chose to shoot in black and white because that was the medium in which fine art photographers worked. A few mid–twentieth century photographers—William Eggleston and Stephen Shore—broke the anti-color bias of many in the field and saw color as a way to transform the commonplace into compelling subject matter. Color comes alive from both photographers in their work, which took lonely Western outposts, vacuous suburban sprawl, and casual indoor scenes and made them fit to be seen on the walls of the great art museums of the world.

Then there were the photographers who unraveled messages in text and signage, creating art in words and letters. Walker Evans and William Klein were pros at this—Evans through sharp, close-up shots of weathered signs and Klein by using advertisements as his subject matter.

Text and color can change an image's message.

During the twentieth century, the Great Depression came on with a tidal wave of economic blight. Rural and city people alike suffered, as did the American landscape. Dorothea Lange showed migrant workers and their surroundings up close, using a soft-focus lens, which created stunning optical effects of creating lifelike subjects that look as if they're multidimensional.

Photographers Ralph Eugene Meatyard and Frederick Sommer created subjects that ranged from puzzling to bizarre. Meatyard photographed his family members in masks among rustic surroundings, and Sommer photographed dead animals.

Romantic relationships between the photographers and other artists cast a spell on all involved. From Alfred Stieglitz and Georgia O'Keeffe to Tina Modotti and Edward Weston, male photographing female exposed new revelations in romanticism and sexuality.

This is only the beginning of the great photographers' inspiring creativity, multitude of images, and the stories that went along with them during the twentieth century.

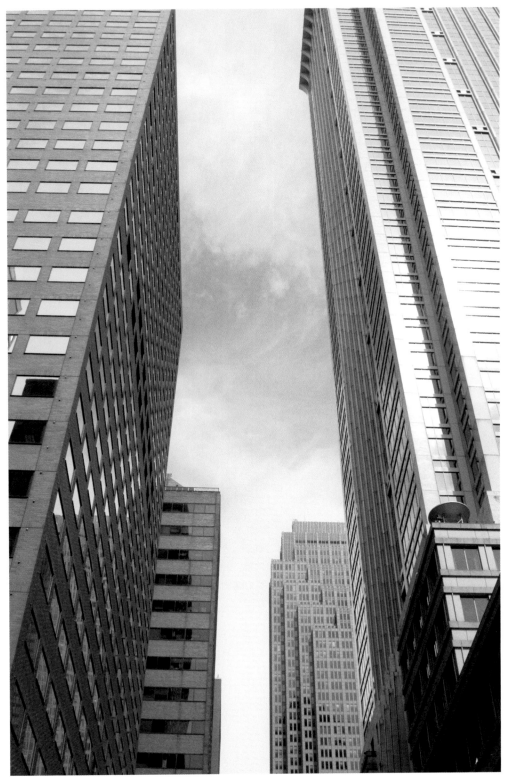

Abbott photographed downtown high rises from the bottom up, similar to this one.

Berenice Abbott
(1898–1991)

Berenice Abbott photographed common themes that taught the world about good photographic composition. She lived in Paris and New York City. In Paris, she was an assistant to experimental artist Man Ray in the 1920s. In his studio she photographed portraits of well-known artists and writers, such as author James Joyce, drummer Buddy Gilmore, and flamboyant artist Jean Cocteau.

During her time in New York City, Abbott worked for the Federal Arts Program. As part of the program, she photographed the streets of New York during the Depression. Her book, *Changing New York*, recorded everything from street corners to architecture and includes images of buildings that have long since been demolished. She also wrote *A Guide to Better Photography* in 1941. She was an admirer of Eugène Atget, whose photos she eventually obtained and promoted after his death in 1927.

Barbershop Photography

If you happen to pass an old-fashioned barbershop window, you could have an opportunity to emulate Berenice Abbott. Barber shops symbolize a men-only world that rarely exists in America anymore. The barbers are disappearing, slowing being replaced by stylists who cut hair at unisex hair salons. Back in Abbott's day, barbers were losing their shaving business because people could do it themselves with the advent of the safety razor.

Abbott has two well-known shots of barbershops. The first—*Tri-Boro Barber School*—was taken at 264 Bowery on October 24, 1935. The second—*Pingpank Barbershop*—was taken at 413 Bleeker Street in Manhattan on May 18, 1938.

You can replicate Abbott's work in her second photo of the barbershop by photographing a vintage barbershop in your area. Abbott took her shot by standing on the curb just to the right of the barbershop in the same way I did in Figure 1.1. (Abbott also uses the same perspective in *Doorway: Tredwell House 29 East 4th Street Manhattan*.)

Fortunately for me, the text of Pingpank Barbershop (http://philosophy-religion.org/bob_family/barber.htm) was oriented in the same way as Louie's in my photo. In the Abbott photo, the words AUGUST PINGPANK arch across the top of the photo, just the way Louie's is oriented, albeit not as elaborately. Also in the Abbott photo, the words BARBER SHOP lie under that text about a third of the way down the photo, just as the words BARBER SHOP do in the Louie's photo. Both photos also have the same orientation. They were taken from a point just to the right of the window, so that the image appears at a slight angle within the frame.

Also notable in both photos are the reflections. In Abbott's photo, you can see a horse-drawn cart; in Figure 1.1, you see the '20s-era Castro Theater.

Building Soup

Abbott worked with the Federal Arts Project, part of President Franklin Roosevelt's New Deal. She shot all around New York City. She's said to have been influenced by Eugène Atget.

She liked his images so much she purchased them right before he died. Many of them were of Paris architecture. She ended up photographing New York City as Atget photographed Paris. Atget is discussed in Chapter 4.

Call it building soup if you will—Abbott shot a mixture of architectural styles filling frames to create contrasting shapes and forms. In Abbott's *Manhattan I* (www.mcny.org/museum-collections/berenice-abbott/a078.htm), a mixture of buildings is set back from the foreground, extending left to right across the frame.

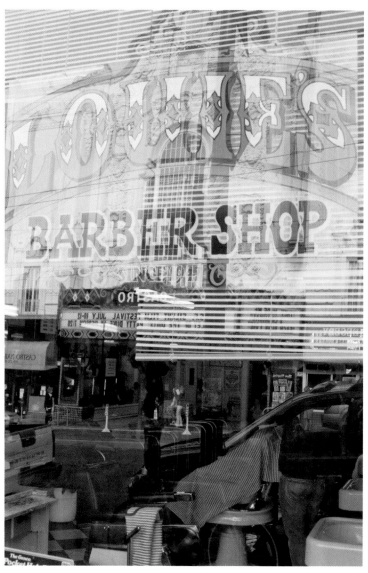

Figure 1.1 Louie's Barber Shop on Castro Street in San Francisco.

JUST WHO WAS MAN RAY?

As an artist working with many different kinds of media, Man Ray came to influence many twentieth-century artists, from Dali to Steiglitz. Man Ray spent much of his time in Paris even though he was an American. He was one of the few Americans to belong to the surrealist movement in Paris.

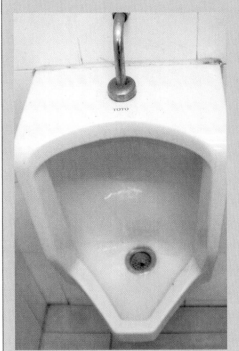

Man Ray was considered a Dadaist—an artist whose work rejected mainstream art and who was keenly aware of the early twentieth-century social movements, working for freedom from social constraints. Dadaism enveloped anything that was taboo in the art world, from photographs of ceramic toilets to assemblages made from everyday items.

One of Man Ray's best-known images is that of a woman's eyes and nose shot at an angle with perfect water drops dotting her face (at www.bbc.co.uk/photography/genius/gallery/ray.shtml). In creating Dadaist images, Man Ray brought fourth a new era in art and photography. Almost anything offbeat, weird, wild, and/or wonderful was fair game for a photographic subject.

Figure 1.2 is an example of Dadaism. Not only is it a bizarre subject, it's also taken from a unique vantage point—the same vantage point a man would see it from as he is urinating.

Figure 1.2 An example of Dadaism.

You can get this effect from almost any big-city skyline, provided you're far enough away from the downtown area so that the buildings stand out. Abbott studied New York architecture before she photographed it with an examination of how many stories the buildings were, when they were built, how they were lit, and where the sun was with respect to the buildings at various times during the day.

Figure 1.3 shows San Francisco's skyline from a similar perspective to that of Abbott's *Manhattan I*. The two major buildings in the image were built in the late 1960s. Just as Abbott captured a sense of time and place in her photo, so does this photo.

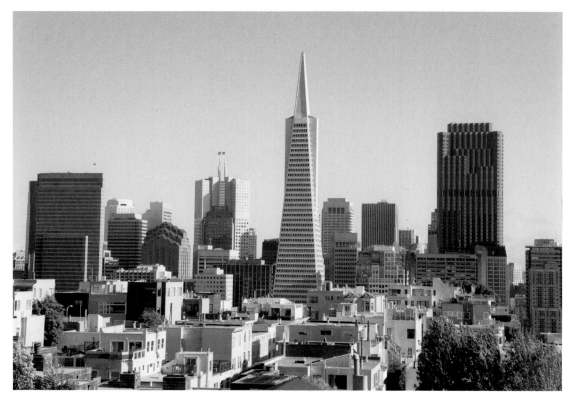

Figure 1.3 The two most prominent buildings in this picture were built in the late '60s.

The Power of Negative Space

By pointing her camera upward at several buildings, not only did Abbott use the sky, the negative space in her images (see the following "Carving Out the Sky" sidebar), to delineate patterns in the frame, she also made the buildings appear to have uniform heights, even though some in the frame were much taller than others. In her image *Canyon: Broadway and Exchange Place* (www.mcny.org/museum-collections/berenice-abbott/a150.htm), Abbott has produced an effect of flattening the tops of the buildings, making it difficult to distinguish which building is taller than the other.

I've done the same thing in Figure 1.4. Upon glancing at the image, you might miss the fact that the buildings on the right side of the image are much taller than those on the left. Also of note are the converging lines of the image. They make the buildings look as if they are going to fall over.

Figure 1.4 When you point the camera straight up at several buildings, they can appear to be all the same height.

BLACK AND WHITE CONVERSION IN PHOTOSHOP

You can change the contrast and gray tones in Photoshop easily. You can do this either in Photoshop Raw or in the main program. If you've shot in Raw, when you open the image it first comes up in a Raw window, where you can tweak the image in many ways.

There are eight icons at the top of the Raw dialog box, below the list of settings and the histogram of your image. The first thing you'll want to do is tweak the Basic Settings (the first icon). Just move the sliders (Exposure, Recovery, Fill Light, Blacks, Brightness, and Contrast) around to get the effect you want. The fourth one over is HSL/Grayscale. After you click on that icon, you'll get to convert to black and white by clicking on Convert to Grayscale. From there, you can tweak the color sliders (which are actually grayscale sliders) to hone in even more on the contrast.

In the main program, all you have to do is navigate to Image > Adjustments > Black & White. Color sliders will appear in a dialog box. (They're actually grayscale sliders.) Click and drag those to get the effect you want.

CARVING OUT THE SKY

Abbott's work brought out the importance of the sky above and alongside the buildings in a shot. When you shoot buildings with your camera pointing upward, the sky can act as a powerful element in your architecture shots. In these types of shots, the sky can be described as negative space in the frame, while the buildings are positive space.

There is an alternative way to view the photograph when you have effectively used negative space. You can have that space feature shapes and forms that affect the look of your image. The light emitted from the sky also makes the negative space more prominent in the image. In Figure 1.5, you not only notice the building that towers (which happens to curve as it moves upward in the frame) into the sky, but also evident are striking, thick converging lines of alternating shades of light and dark from left to right across the frame.

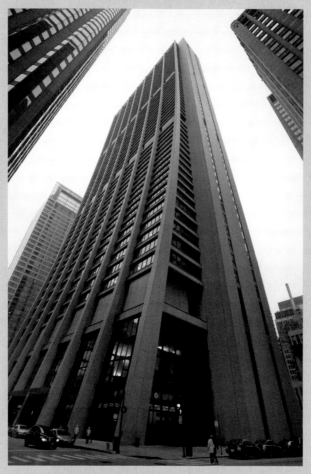

Figure 1.5 The sky is delineated by the dark shapes of the buildings around it.

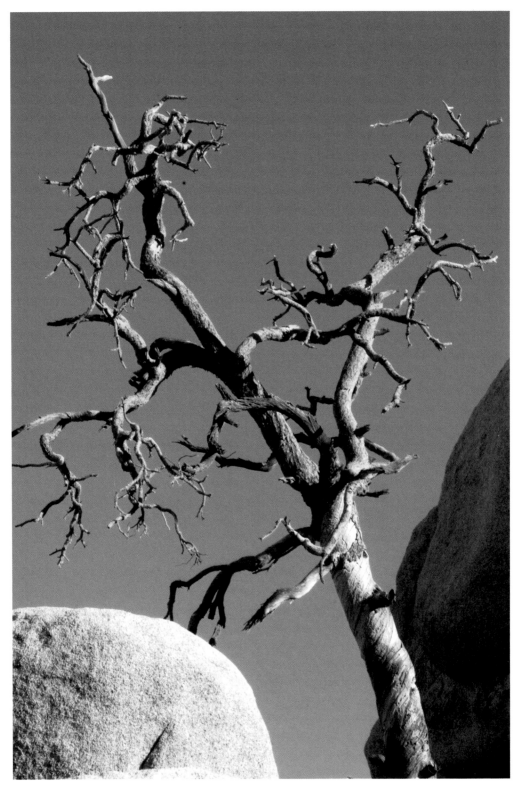

Adams photographed trees of unusual shapes similar to this one.

CHAPTER 2
Ansel Adams
(1902–1984)

Ansel Adams' compassion for the environment is evident in his photography, He captured the beauty of untouched California land like no other photographer, visualizing, assessing, and creating prints that had near-perfect tonal balance. His photos were meant to illustrate an untouched land so that when people consider developing it, they'll think twice about the natural beauty that they might be discarding in their pursuits. This compassion is what makes his photographs so compelling. His landscape photographs have captured the imaginations of people all over the world.

Adams was born and bred in California. At first he had musical interests, but after taking some photos on a trip up into the California mountains, he became enamored with the craft. Adams had his first photography show in 1932 at a San Francisco museum.

Adams came to know many of the finest photographers of the twentieth century, including Dorothea Lange and Edward Weston. He was a member of the f/64 group, which was a group of photographers that created an admiration of fine detailed landscapes (f/64 refers to an extremely small aperture), lifting the medium to the category of fine art. Adams also invented the zone system—calculations of exposure in different parts of the frame to ensure that a complete set of gray tones is included in the shot.

Photographing and Photoshopping Trees

This image is similar to *Aspens, Dawn, Dolores River Canyon, Autumn, Colorado, 1937* (www.artic.edu/aic/collections/artwork/65360) in the book *Trees*—a collection 55 photographs of trees taken in the American West. In Figure 2.1, a similar grouping of trees fills the frame. It was taken near Strasbourg, France.

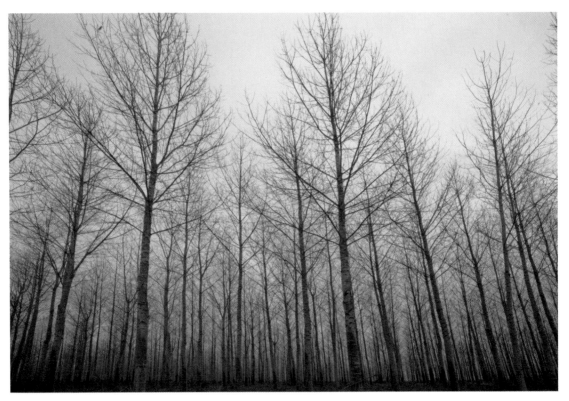

Figure 2.1 Original black-and-white image.

Adams used a wide gamut of tones in his black-and-white photographs. He used the zone system, which he invented and which gave great detail to his photographs.

Adams also had tools in his black-and-white darkroom to manipulate his images. He used push-processing, or altering the process time to correct exposure, to create more contrast between his landscape subjects (trees, in this case) and the sky. He also burned and dodged during the printing process.

In Photoshop, you can do similar manipulations to those Adams did with film. I manipulated the color image in Photoshop Raw to get black and white, which is shown in Figure 2.1. After that, I applied Layer > New Adjustment Layer > Invert to get a dark sky. Then I applied Layer > New Adjustment Layer > Curves to get more contrast between the landscape and dark sky. Finally, I used the Dodge and Burn tools to touch up the photo. The result is shown in Figure 2.2.

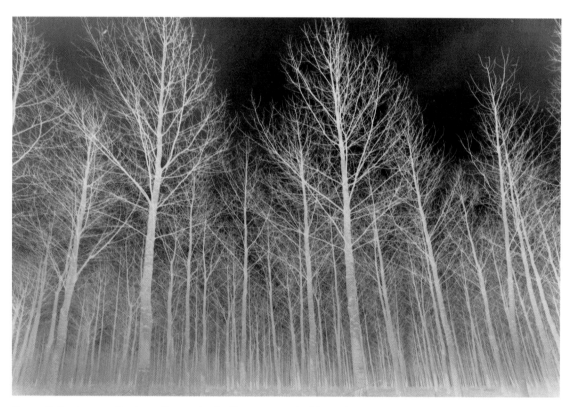

Figure 2.2 Image after inverting and adjusting contrast in Photoshop.

ZONING IN TO TONAL PURITY

Ansel Adams and Fred Archer developed a zone system to control every level from light to dark in a photograph through both exposure and the paper that the image was printed on. The zone system is designed to make sure that you get correct exposures when taking a picture. The system begins with a tonal chart with nine zones that range from dark black to pure white. The system is based on middle gray (Zone 5) so that the exposure for every other zone will be calculated to be more or less than that value.

To put the zone system to use, the photographer assesses a scene by breaking it into parts and then affixing a zone to each part. The light meter provides an exposure that will give the area that's been metered a perfect Zone 5 gray—what most of us would call the middle value between black and white. So, when the meter is pointed at a snowman or a brand-new white Cadillac, it tells the camera/photographer to set an exposure that will make that white into middle gray.

To get the correct brightness in the image, you must increase the exposure by two stops. On the opposite side of the scene—the snowman's black hat or the Cadillac's fine Corinthian black leather interior—the black will be metered to provide middle gray, ending in a washed out image. You need to underexpose by 2 stops. After you auto-focus on that black or white spot (and set your exposure), you can hold down the shutter halfway and move the camera to another spot and shoot, but your exposure will be off. To remedy the situation, you can adjust your exposure compensation, setting it up or down two stops, depending on whether what you focused on was black or white, and shoot again.

Of course none of this matters if you use evaluative or matrix metering. (The zone system in the digital world only works when your camera is set to center-weighted metering or spot metering.) Setting your camera to evaluative or matrix mode will adjust the highlights and shadow in your frame for the best contrast between light and dark because it measures the light from different points throughout the frame.

Redefining Sky

To get his images sharp, Adams often shot at f/64. In fact, he founded a group with the same name with some other California photographers. Adams' photograph *Yosemite Falls from Old Village, 1953* shows that by using extremely narrow apertures, landscapes become sharp throughout the photograph. In this photograph, fine details are revealed in the leaves of the trees in the foreground and the rock of the mountain in the middle ground. Adams' shoots were a challenge. He was also shooting medium-to-large format, using a Hasselblad 2-1/4" camera or a 4×5 or

8×10 view camera. All of those are heavy, and the view cameras are extremely hard to handhold and focus because the image is displayed on the back glass upside-down (and you need a hood for visibility). Adams used a tripod to take his landscape photographs, even at midday. He had to because when you take pictures at such narrow apertures, your shutter has to remain open longer to get proper exposure. He also scouted out a location for some time, checking to see when the light was best as well as when the weather was favorable for obtaining a sharp photo (at times during the day when there was little or no wind).

Adams included the trees in the valley with a bit of the valley floor in the foreground so that in his image there were three areas of demarcation to this landscape: trees in valley, mountain/falls, and sky—a clear demarcation of foreground, middle ground, and background. Also, his photo included both the upper and lower falls.

While Adams didn't follow the photography rule known as the Rule of Thirds (placing prominent subjects/objects a third of the way over from the either edge or the top/bottom of the frame), he did make an effort to place subjects/objects off center in the frame. In his image of Yosemite Falls, he placed the waterfall just to the right of the center of the frame. He also had the mountains reaching the top of the frame so that the sky was cut off when looking at the image from left to right.

Figure 2.3, a replica of Adams' shot in the same area, shows the falls from Yosemite Lodge. From that vantage point, the growth of the valley vegetation is so thick that it's difficult to see the lower falls. Even so, the view of the falls from that vantage point is quite impressive. The image was taken with an f/stop of f/9, a good setting to get a sharp image without a tripod.

To replicate the darker skies that Adams had a fondness for in the image of Yosemite Falls shown here, I tweaked the blue slider in the HSL/Grayscale area of the Raw dialog box in Photoshop. (See the "Black and White Conversion in Photoshop" sidebar in Chapter 1.)

Reflecting Freeway Light in Black and White

In the 1960s, Adams moved away from photographing nature and became involved in how the environment was being affected by human development. He became an advocate for the environment, photographing the things that were ailing it.

Adams created an image of a web of freeways (*Freeway Interchange, Los Angeles, 1967* at americajr.com/pictures/Freeway-Interchange.jpg) that move up and down the frame as part of his movement to show how human development affects landscapes. The image is remarkable for two reasons—it was taken from above (an aerial view) so you're looking directly down on the freeways, and there's no development around them. The image looks minimalist to say the least—all you see are roadways, about half a dozen strips that curve every which way.

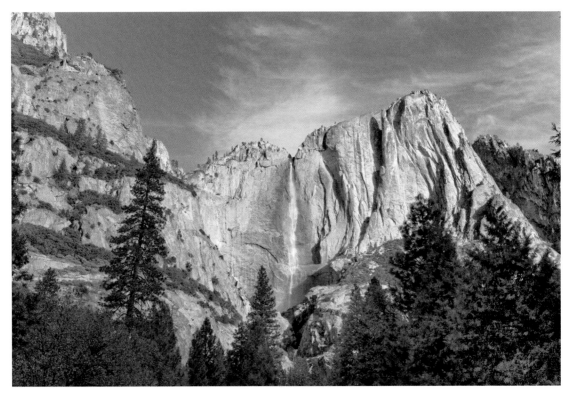

Figure 2.3 Darker skies in this photo add depth to the scene.

In Figure 2.4, I've taken a similar image, albeit one a bit busier than Adams'. It was taken from the top of Bernal Heights in San Francisco. The patterns of light on the freeway in this image are similar to those in Adams' image.

The light reflection in both images is significant. It reflects differently depending on the slope of the pavement of the freeway, giving the freeway arms different shades of gray. It's probably due to the age of the pavement; the newer road in the middle of the frame is apparently reflecting less sunlight because the pavement is darker.

After the 1960s, Adams printed his black-and-white images with more contrast. Today you can do this easily in Photoshop. See the "Black and White Conversion in Photoshop" sidebar in Chapter 1 to learn how to do this. I was able to enhance the contrast in the freeway image shown so that the pavement seems have more varied light reflections off of it.

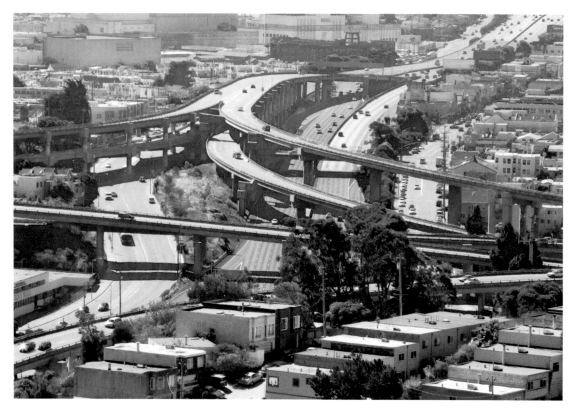

Figure 2.4 Light reflection varies over different parts of the freeway interchange.

Perspective Revised

Perspective played a role in Adams' work. In his work *Road, Nevada Desert, 1960*, he manipulated traditional perspective using the landforms of the Western desert. He made three dimensions out of two by using a road that led to a vanishing point, a road that seemingly went on forever. The traditional perspective, though, stopped there.

In Adams' work, the road is set directly in the middle of the frame. He took the picture from the top of hill so that when it went down, part of the slope was hidden, resulting in a horizontal line cutting through the middle of the frame. Also, a mountain range obscured the horizon line, adding uneven, curvy lines that divided land and sky.

In a similar image of the California desert shown in Figure 2.5, there are similarities and differences to Adams' work. In both, the road appears very wide in the foreground and narrows quickly toward the middle ground. From the middle ground to the horizon, the road appears to narrow much more slowly. Both desert landscapes are similar—desert lands of wide-open space.

Also, both begin at the top of tiny hills. In Adams' piece the road varies in gray tones from white to black, appearing well worn. In Figure 2.5, the road has fewer gray tones and is almost uniform in color. Notice, too, the telephone poles in the figure. There are none in Adams' work. Finally, the clouds are different—puffy cumulus in Adams' work and layered stratus in the replica. More sun in Adams' work makes the lighting more contrasty.

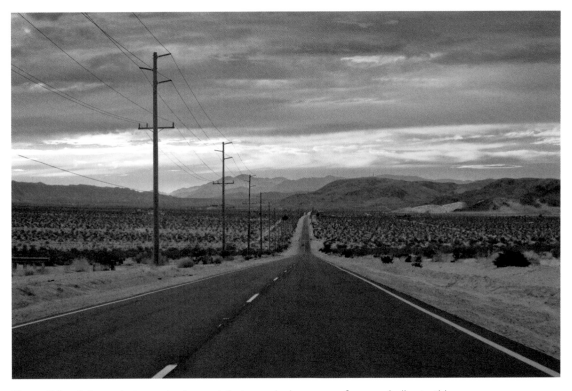

Figure 2.5 Adams photographed a road that seemingly goes on forever, similar to this one.

Robert Adams (1937–)

In an interview with PBS, Robert Adams (not the son of Ansel) mused that in a great picture, everything fits. He feels art's job is to reconcile us to life. His photos of the western United States show an environment that has gone awry, combined with the beauty of the natural world. He shot the suburbs of Denver and Los Angeles, Eastern Colorado, Southern California, and Northwest Oregon. He currently resides in Oregon.

Adams' photos show vast environments with human markings, mostly damaging ones that change the landscape. In their own way, his photographs are immaculate in their use of light and landscape. He documented the suburban tract houses outside Denver in photographs that show endless human development in wide-open spaces. Adams has authored many books, including *Turning Back* (2005), *What We Bought* (1995), *Beauty in Photography: Essays in Defense of Traditional Values* (1981), *From the Missouri West* (1980), and *The New West* (1974).

Black Smoke

While Ansel Adams illustrated the beauty of nature in his photographs, Robert Adams showed how this beauty is subject to the harming influence of manmade development. One such picture, *Burning Oil Sludge North of Denver, Colorado, 1973* (www.getty.edu/art/gettyguide/artObjectDetails?artobj=249223), is of thick black smoke rising from burning oil sludge in a picturesque snowy Colorado setting. The picture was taken from a distance away from the smoky setting. You can see an oil derrick to the right of the burning area and a bare tree to the left. The Rockies sit in the background, extending about a sixth of the way from the bottom of the frame. Parts of the sky are the same shade of black and white as the snow-covered ground.

Smoke as a harmful ingredient of nature is one way to express how humans can degrade the land. Figure 3.1 shows an image of heavy black smoke contrasted by the white sand of a desert wash, a similar unexpected beauty to that of Adams' 1973 work. To get this picture, I had to stop my car when I saw black smoke billowing into the air. I hit the site just in time—before the fireman got there. After they sprayed the site with water, the smoke turned white (light shades of gray).

> **NOTE**
> Black smoke results from the burning of petroleum products.

Both Adams' work and the picture in Figure 3.1 show black smoke blown by the wind. The black smoke in Adams' work comes from burning oil sludge; in the car burning in the wash, it is caused by the gas tank and rubber (a petroleum product) burning.

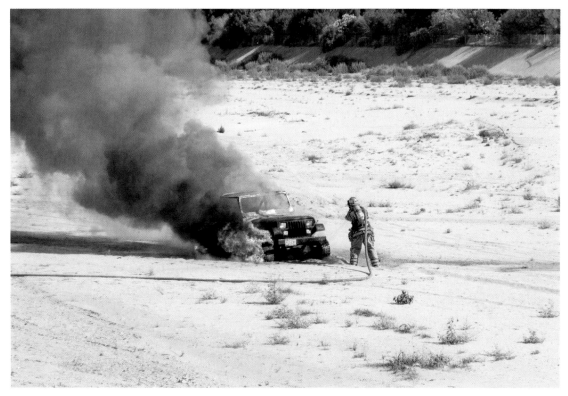

Figure 3.1 This shot shows the contrast of black smoke juxtaposed with the white sand in Palm Desert, California.

Smoggy Light

Robert Adams once said, "I took pictures in Southern California over a period of three years, and the strange thing is that although Southern California stands under this pall of smog, nonetheless the light that filters down through that smog is extraordinary." Adams' work included *Looking Past Citrus Groves into the San Bernardino Valley; Northeast of Riverside, California* (www.pbs.org/art21/slideshow/popup.php?slide=1344). The image, taken in 1983, shows a sky that gradually lightens as the frame reaches the horizon. A hill in the foreground changes from light to dark as you look from left to right in the frame. The foreground contains a valley that extends into a mountain in the middle left of the frame. In the right side of the frame, the valley extends to a far-off mountain range, which sits on the horizon in haze, probably due to the marine layer, which sits off the coast during the day. (See the upcoming "California's Haze Is Part of a Marine Layer" sidebar.)

In Figure 3.2, you can clearly see a layer of smog caused by a temperature inversion (air getting warmer as you go up from the ground) so that the smog is trapped below a certain altitude (above which the air gets cooler again as you go up). The light is eerie yet compelling. In the foreground is a forest that clearly has seen better times. Branches are bare, and trees look unhealthy (which they are, from the smog). The image is in the same general area where Adams took his image. Both address smog's ability to manipulate light.

Figure 3.2 Smog in the mountain areas northeast of Riverside, California.

Scrawling in Pristine Lands

Nowhere can man's effect on the environment be seen more than in graffiti scrawled directly on the natural environment—not on walls built by man, but on rocks built by nature. The juxtaposition of the two shows the contrast of human markings on the natural world. In *From Lookout Mountain, at Buffalo Bill's Grave. Jefferson County, Colorado, 1970* (www.pbs.org/art21/ slideshow/popup.php?slide=1336), Adams' emphasis is not only about man's effect on the environment, but also on the light. Adams was drawn to the dramatic light of high altitudes.

CALIFORNIA'S HAZE IS PART OF A MARINE LAYER

Similar pictures of California show one prominent feature that contributes to the smog—the fog. Up and down California's coast, upwelling caused by the earth's rotation on its axis sweeps the top layer of warm water out to sea in the Pacific, leaving cool water on the coast. During the spring and summer, as the northern hemisphere warms, a shallow layer of cool air sits under it from the upwelling of the ocean. At night, as the land cools, the cool air drifts inland, condensing as it cools. (Cool air can't hold as much moisture as warm air can.) This causes the fog. The smog comes when the pollutants in the atmosphere get trapped in the cool foggy air, which can't move above the lighter warmer air.

Figure 3.3 The haze in this image is caused by the marine layer, which lies just off the coast during the day.

When emulating a photo by the masters, the first thing you have to look for is how the light looks in the image. When emulating the subject/object of a shot, you have to consider the light in all zones of the frame. For example, while Ansel Adams had a darkened sky in many of his images, Robert Adams' sky was hazy, low-contrast light that obscured backgrounds without blurring them. You can adjust the light easily in Photoshop, instead of in the printing process like the masters did. (See the "Black and White Conversion in Photoshop" sidebar in Chapter 1.)

When I found rocks with scrawling on them that looked similar to those Adams photographed (see Figure 3.4), I was ecstatic, especially because the rocks overlooked a scenic vista. When I shot this, I knew I had to have a sharp background, so I adjusted my f/stop upward so that the aperture of my camera was narrow. In post-processing, I juxtaposed Adams' shot of Lookout Mountain against the shot I took near Riverside, California. Because Photoshop gave me a lot of latitude as far as changing the light, I was able to lighten the sky to match the sky in Adams' shot. I also paid attention to the shadows in the Adams' shot. They were dark. I was able to darken the shadows to match in my shot.

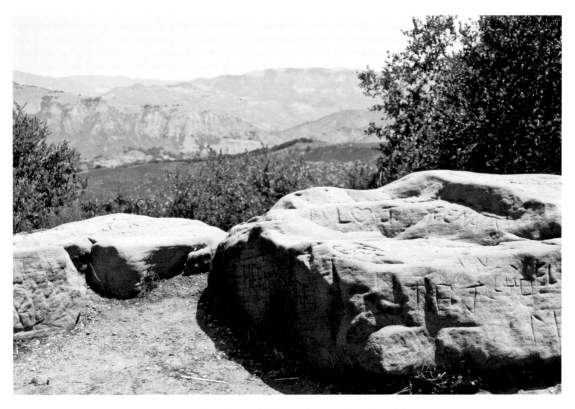

Figure 3.4 Marks made by man in otherwise pristine settings can be disturbing.

Eugène Atget
(1857–1927)

Here's a French photographer who never shot the Eiffel Tower, even as it was being built. Eugène Atget caught Paris as if it were from an earlier era. He didn't look for buildings that were being constructed (as the Eiffel Tower was), but instead, buildings that were to be demolished. He photographed the city in every which way, from life in the cafés and parks to scenes from business and commerce. Atget sold his photographs to painters, who then went on to re-create the scenes in paintings.

His photographs of Paris streets and parks were shadowy, often dark scenes that led to spots of blown highlights somewhere in the frame. In many of his photographs, the streets and stairs slope up into the frame, as if the scene were on a stage. Also present in many of his photos are geometrical objects well defined in the frame. Atget also discovered the idea of layering by photographing store windows reflecting items near them. (An example of this can be seen in the Louie's Barber Shop photo in Chapter 1.)

Le Cirque Shadows

Eugène Atget photographed Paris in all its early twentieth-century glory. Vast contrasts existed between the old and the modern—from old wooden pull carts to more modern carousels. With his keen eye, Atget photographed daily life of the city with cameras that had almost no adjustments. No one even knows what the focal length of his lens was.

Atget almost always used narrow apertures, which is evident in *Le Cirque* (www.umt.edu/ montanamuseum/photo/atget/atget.htm), an image that was shot straight on with the entire length of the carousel included in the frame. Everything in the frame is slightly soft, but not soft enough that you can't see the lettering, "Crème Eclipse" in the background. Atget used natural lighting in that image. He oriented his camera so that the sunlight was behind him, casting light over portions of the ride facing the sun. Part of the background has blasting highlights, and on the ride there are dark spots underneath the animals and horse and cart, as well as the decorated ceiling. Most noticeable is that the brightest light is cast on the animals just to the right of the center of the frame.

You don't have to be in Paris to get an image of a merry-go-round; go to any big city around the world, and you can usually find one. The image in Figure 4.1 shows a carousel on Pier 39 in San Francisco. In that image, I focused on part of the ride at much the same angle as Atget did in his image. The lighting, however, was not the same. Neither was the aged look of the picture.

Digital images can have a plasticky look, which fortunately can be adjusted in Photoshop. To get the lighting right, I used a spotlight in the dialog box after I navigated to Filter > Render > Lighting Effects. Then, to get rid of the sharpness (something I almost never do because sharp focus is a representation of the quality of an image these days), I had to soften the image slightly. I navigated to Blur > Lens Blur and adjusted the slider as needed to get the same softness as in Atget's image. Finally, I used the Dodge and Burn tools to further tweak the light so that it appears similar to that in Atget's image.

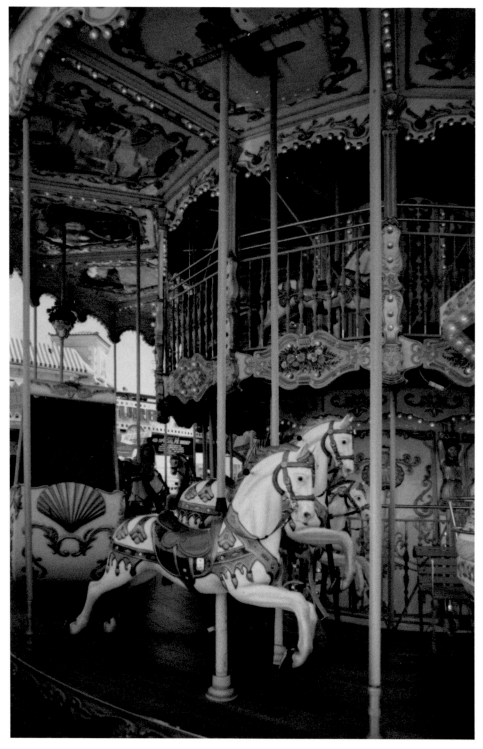

Figure 4.1 Le Cirque lighting.

Catch the Right Angle

Atget photographed sculptures in Versailles from every angle, creating a different focal point in each shot. In close-ups of vase sculptures, his focal point would be sculpted characters on the face of the vase. Often, he would place the sculpture one-third of the way from the side of the frame in a shot from a distance, following the Rule of Thirds.

In his image *Parc Versailles 1905*, Atget photographed a sculpture of a vase so that the corner of the platform on which the base sits was in the foreground. You see the platform so that it is turned on its axis about 30 degrees. The staircases on either side of the platform come together—one on the left from the background to the foreground, and the other remaining mostly in the foreground.

I took the image in Figure 4.2—a sculpture at Hearst Castle—so that the base upon which the sculpture sits was set in the same orientation as the base of the vase in the Atget photo. Instead of having staircases come together in the frame, there are railings.

In short, capturing your image from a compelling angle can make or break a photograph. If you're photographing a statue in a palace, take it so the corner of the base upon which the statue sits reaches into the foreground of the frame.

CREATING SEPIA TONES IN PHOTOSHOP RAW

The Atget photo of the vase, platform, and staircases was processed with a sepia tone. To re-create it, convert your photo to black and white, as discussed in Chapter 1. Then open your photo in the main program of Photoshop. Navigate to Mode > RGB Color to make the program recognize color. Then navigate to Image > Adjustments > Color Balance. Tweak the sliders until you get a match for the Atget photo. You'll find that the color values for Midtones will be 19, 7, and −29. The Highlights values will be about 15, −8, and 2. The Shadows will be about −20, −9, and −10.

Another way to do this is to go to Image > Adjustments > Photo Filter and select Sepia from the menu, with the option of choosing how much color to add to the image.

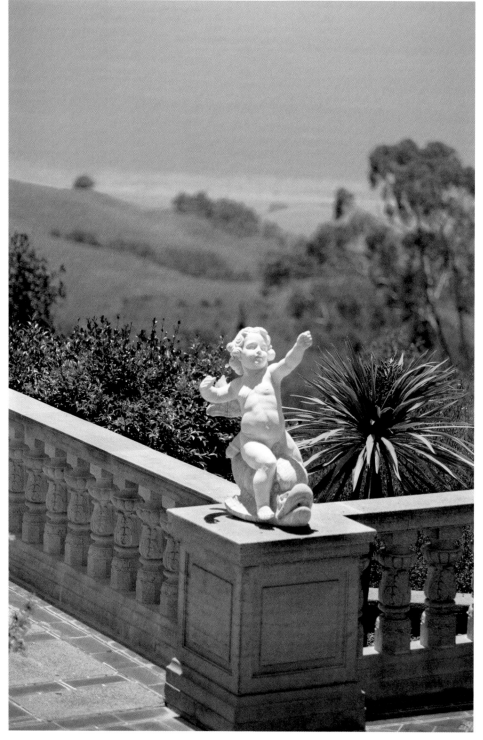

Figure 4.2 One angle of many in which a sculpture can be shot.

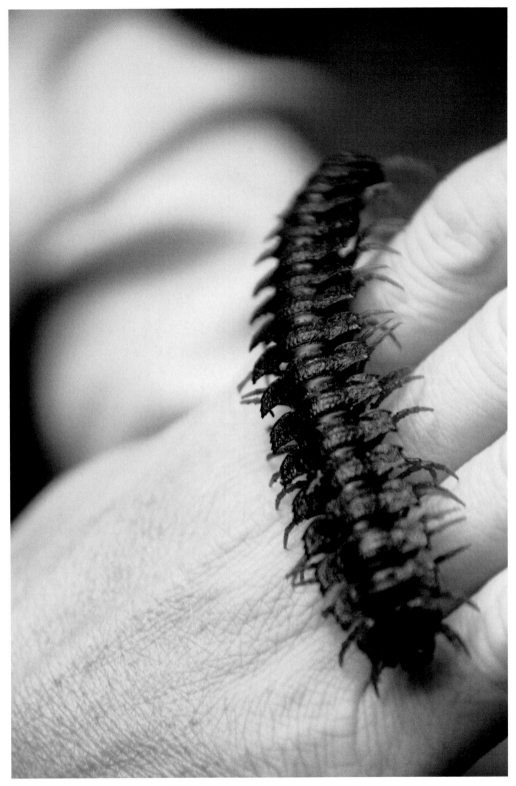

A close-up of a hand with something extra.

CHAPTER 5
Bill Brandt
(1904–1983)

In the 1930s, when Bill Brandt photographed the people of London, he found a split between the classes in a tough economic climate. Many of these images are portraits of people in daily activities, such as a portrait of a woman at a crowded beach and one of a family at the dinner table. He also photographed nudes and landscapes, often adding surrealistic elements to many of his photos. In one such photo, he has a profile of a woman turned on her side so she looks up in the foreground, with windows in the background.

Brandt was born in Germany. After becoming a studio photographer in his early 20s, he got a chance to meet Man Ray (see the "Just Who Was Man Ray?" sidebar in Chapter 1), who ended up influencing his photography, making it more surreal.

Brandt's portraits of writers and artists appeared in *Harper's Bazaar* and other magazines. Many of his photos use only dark and light tones, which gives them a Hitchcock-like appearance.

The Wet Cobblestone Street

Bill Brandt photographed a wet cobblestone street in Halifax, Yorkshire in 1937. The photo *A Snicket in Halifax* (virtualphilosopher.com/2006/08/halifax_snicket.html), like many of his other images, was taken in the rain. The *New York Times* wrote that his and other photographers' artistry had elements of "the rejection of the picturesque and the sentimental." That is indeed the case with this photo.

In *Snicket*, there is a cobblestone ramp that leads to a light-gray sky. The ramp goes from bright reflection in the middle of the ramp gradually to darker tones along the sides. On the right side of the ramp is a dark side of a building. On the left side, behind the ramp, is a building about four stories high, with nondescript windows on each story and a gabled roof.

I have emulated the same lighting of a street in the image in Figure 5.1, which I shot in Paris. As in Brandt's picture, the cobblestone pavement takes up most of the frame. The street also leads to a much lighter background.

To emulate the lighting, I changed the photo to black and white in Photoshop. (I had taken the image as a JPEG, so I couldn't edit in Raw.) To do this, I had to lower the brightness and contrast (Image > Adjustments > Brightness/Contrast) considerably, as Brandt's picture shows a hazy cast without any blasting whites in the reflected light on the cobbled ramp. Next, I navigated to Image > Adjustments > Black & White and lowered most of the color sliders. (I clicked and dragged most of the sliders to the left.) I was careful to keep the background light while making both sides of the street dark. Finally, I touched up the lighting to match that of Brandt's photo.

> **NOTE**
>
> If you're going to use a photo from the Internet to replicate the brightness, contrast, and tone of the photo, make sure the photo you are looking at is from an art gallery or a museum that actually has the photo in their collection. Their photos are likely to be more accurate than those on general art sites.

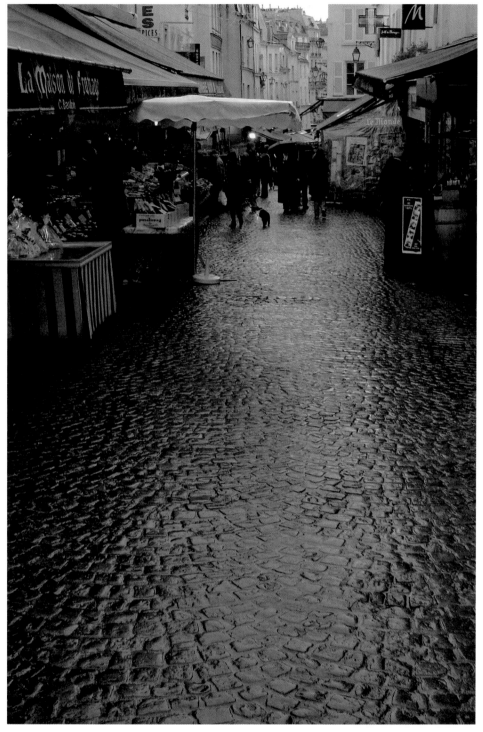

Figure 5.1 If you happen to be in an area with cobblestone streets, find one going uphill and photograph it in the rain (or just after).

Human Body Parts Close-Ups

Bill Brandt not only photographed urban landscapes; he also photographed nude body parts to exaggerate the look them. Often his background would be the inside of a room or a rocky beach. Here are some descriptions of how he photographed body parts:

✳ Naked woman from the waist up with a hand extended forward on a table; door open slightly in the room in the background

✳ Bottom of crossed feet, with the right one turned outward and in shadow except for toes and the left one facing away from the right and totally lit up

✳ Close-up shots of an elbow on top of a woman's crossed legs, highlighting the curve that forms where the two legs cross

✳ The inside of a hand on a bed of smooth rocks, the opening dark with shadow.

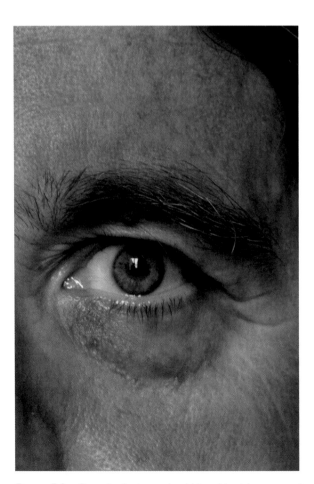

Brandt's eye portraits were the result of his keen attention to contrast. He believed in two things about the eye and its surrounding area on the face. First, that it is a place of high contrasts, where shadows meet highlights, and second, that the components that make up the eye show an area of intense internal processes of the human body. As you can see in the emulation of one of his eye shots in Figure 5.2, the eye and the area around it are a compelling mix of geometry, texture, light, and feeling.

Figure 5.2 Brandt photographed his subjects' eyes up close.

It might look as if taking a close-up of the eye is an easy task. It isn't. Most of Brandt's eye portraits were sharp throughout the frame. You'll need a tripod or other sturdy surface upon which to set your camera to prevent blur from camera shake. You'll also need to set the timer on your camera so it doesn't shake when you press the shutter release button. Finally, your subject needs to remain absolutely still, concentrating on keeping his eye open.

In post-processing, you'll need to add the chiaroscuro that was present in Brandt's work. He was known to have manipulated his photos extensively when he processed them in the darkroom. To do this in the digital darkroom, just use the Burn tool around the eye and face until you get a nice combination of shadows and highlights.

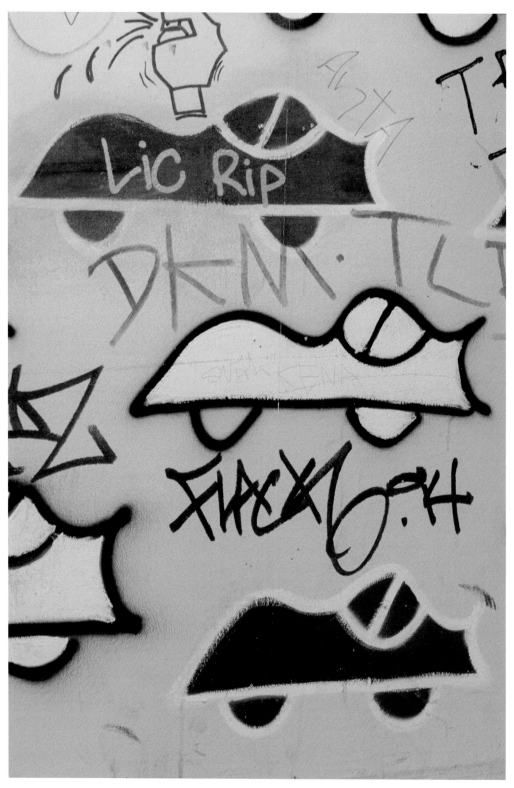

Be on the lookout for good graffiti.

CHAPTER 6
Brassaï (1899–1984)

Paris photographer Brassaï (Gyula Halász) was actually born in Transylvania, though he lived in Paris most of his life. His most famous works come from his book *Paris de nuit* (*Paris by Night*). Brassaï photographed everyone from the poor and disenfranchised to the wealthy elite. His images include a flamboyant woman inside a café, a statue in the fog at the park, and a lamp-lined staircase. Each is a work of art in shadow and light. His misty street scenes and shadowy ladies of the night figures captivated the Paris art world. Later in his life, he photographed painters Pablo Picasso and Salvador Dali. Brassaï was also a filmmaker and a writer. His film *Tant qu'il aura des bêtes* won an award at the Cannes Film Festival in 1956.

Surrealist Graffiti

Brassaï created a series of photographs that he took over a 30-year period in which he recorded graffiti on the walls of Paris. These images were exhibited at the New York Museum of Modern Art in 1957. Brassaï wrote of graffiti as "standing alone and naked, like a conscript in front of a recruiting board, and it should be allowed to be its own judge."

Capturing graffiti is an easy way to bring out expressive art from the streets—an act of contempt for many, which in itself is a launching pad for the conveyance of messages that express myriad feelings. Brassaï opted to capture graffiti that represented surrealist art forms, shapes, and forms that caught the attention of Picasso and Miró, who were avid collectors of the photos. Many of these images contained simple lines and forms—some merely odd-shaped heads with eyes, mouth, and nose.

Brassaï sought out the graffiti first and then would photograph it when the light was right—something that you really don't have to do with today's digital cameras, where you can tweak everything from exposures to shadows and highlights.

To emulate Brassaï's work, you can scout out graffiti in cities where its presence isn't shunned as it is in many American cities. Cities in Europe, Asia, and South America have many places where you can shoot all kinds of graffiti. Berlin is one fine spot to find the art in many forms, including scrawling with a surrealistic bent, as shown in Figures 6.1. Note the simplistic faces and the odd shapes and lines that make up the features of the characters in the image.

Framing is important when shooting graffiti—you don't want too much in one frame. Much of the time you won't find an isolated graffiti figure. What you *will* find are all kinds of scrawling by different artists together on one wall. To have an effective photograph, you'll have to frame only one part of the wall on which the graffiti was drawn. In Figure 6.1, I isolated what I had been looking for—simple faces that used some of the same techniques of the surrealistic artists of the 1920s.

As far as camera settings go, when shooting graffiti, it's all dependent on the light that's being cast upon it. When the sun is shining on the work, I use a medium-sized aperture (f/5.6-9) to pick up the color. When I find graffiti in the shade, my first concern is getting a soft image, so I use as wide an aperture as my lens will allow—usually on the order of f/2.8-4.

Tweaking the images in Photoshop gives me a lot of leeway in changing the color contrasts, so that even if I took an image of some bright-colored graffiti in the shade on a cloudy day, I could still make the colors compelling when I work with the image in Photoshop Raw.

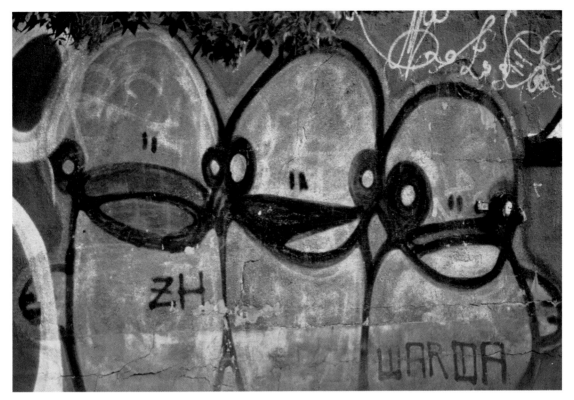

Figure 6.1 Brassaï shot graffiti of simple faces made with odd shapes and forms similar to these ones.

Finally, in Figure 6.1, I converted the images to black and white in Photoshop Raw. In that program (in the HSL/Grayscale mode), you have incredible control over the gray tones in the image when you tweak them by moving the sliders. (See the "Black and White Conversion in Photoshop" sidebar in Chapter 1.)

N O T E
After you take a few shots of some graffiti of simple images, compare them to the paintings of Miró and Picasso, and you'll see many similarities in the shapes and forms.

Paris (or Any Big City) at Night

Night comes once a day, yet many of us never really get out into it. It's true—photographers do photograph frequently at and before dawn and at and after dusk. Their mission is to get that navy blue sky and light trails from vehicular traffic that blesses those times of day, but night, when it's pitch black and when you get a not-so-compelling black background, discourages many from going out. But if you don't go out at night, you're missing Brassaï-type photo ops.

Brassaï was a master of nighttime photography. He wasn't afraid of anything that would come his way. In his *Paris by Night* series, he photographed prostitutes (www.masters-of-photography.com/B/brassai/brassai_prostitute_full.html), misty street scenes, and vistas from up above.

In Figure 6.2, I began with a sharp shot. The streets had been wet, so I had a really good photograph to work with in post-processing. My aim was to get it to look misty, like Brassaï's photograph of the same landmark. Brassaï caught that landmark from a balcony, which he shows in dark tones in the foreground. I got my shot from the top of a Ferris wheel. (I show the bar of the car in the foreground.)

To get the photo looking like Brassaï's, I first tweaked the exposure in Photoshop Raw. I used the slider to overexpose the photograph slightly, as Brassaï's is slightly overexposed. Then I added a little fill light. Last of the color tweaks was lowering the contrast to almost the lowest value it would go (−46). This flattened the color to match that of Brassaï's.

Next, I converted to grayscale by checking the Convert to Grayscale box in the HSL/Grayscale window of Photoshop Raw. I then tweaked the color sliders (grayscale after converting to black and white) so that maximum light was reflected from the pavement surfaces.

To make it sepia, navigate to Mode > RGB Color in the main program of Photoshop. Then navigate to Adjustments > Color Balance and tweak colors as needed to match the Brassaï image.

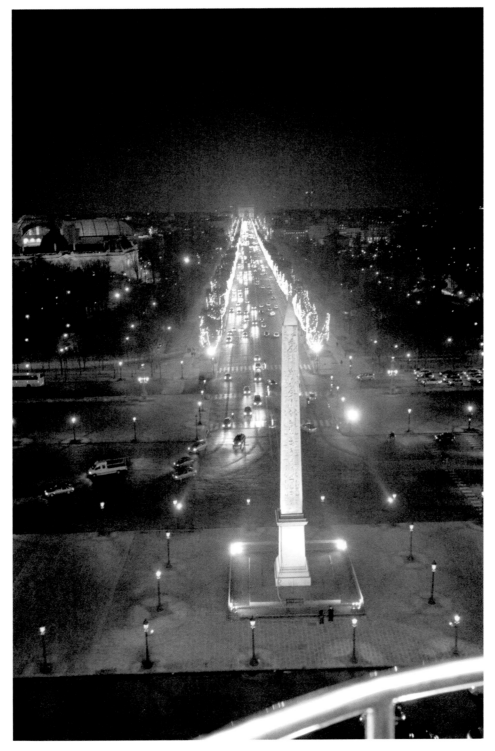

Figure 6.2 Paris at night from above can be shot with high ISO speeds.

PHOTOGRAPHING THE UNWILLING

Of course, no photographer who's writing about ways to emulate twentieth-century photographers would miss an opportunity to go out on the street at night to capture the underworld. Its luring camp makes for stunning shots. Brassaï photographed a number of Paris call girls. When he did, he'd place the subject prominently in the frame with a night shadow stretching from her feet along the ground below. His technique was simple—he shot them using a flash. Today, with high ISO speeds, you can get away with not using a flash. In Figure 6.3, I used an ISO of 1600 to capture two call girls in Berlin.

Generally, call girls are unwilling subjects. The truth of the matter is if you photograph them as Brassaï did (up close with a flash), you're liable to get yelled at or worse. I confess that I did get yelled at, and it could have been worse, so a shot of a call girl is best taken from a distance—and even then it's not completely safe.

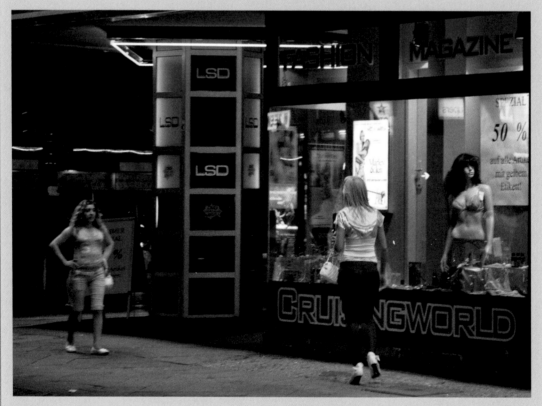

Figure 6.3 Be careful when photographing night figures.

Harry Callahan
(1912–1999)

Harry Callahan was known to get up every day and walk around the cities where he lived (Detroit, Chicago, and Providence, Rhode Island), photographing what interested him. Callahan's wife, Eleanor, posed for many of his photographs. Wherever he shot, he took the time to include Eleanor in some of his photos. These photos are quite remarkable. In one, her head comes out of the water, long hair wet, with ends swirling among small waves, reflection muted down into the frame. In another, she stands in front of a building (which is soft in the background) in the left third of the frame with three windows from the building around her, two on top and one to the left. It's as if she were the missing window.

Callahan, who was born in Detroit, worked for Chrysler for a time before he became a photographer. His interest in photography was cemented when he took a class taught by Ansel Adams. After seeing the results that Adams got using a large format camera, Callahan acquired one and began shooting with it. By the 1960s, Callahan's work was well known. He had a major exhibition with Robert Frank in 1962 at the Museum of Modern Art in New York.

Callahan's landscapes taken in the 1970s are sweeping vistas where Eleanor and his daughter, Barbara, sometimes were seen as tiny elements in the frame. Later in his life, Callahan traveled to Morocco, Portugal, and Ireland. His color photographs of his travels were said to be as good as his black-and-white images in his earlier work.

Vast Landscapes with Tiny People

Callahan favored vast landscapes where people were seen as miniature but important elements of the frame. In *Cape Cod, 1972*, Callahan shows a vast beach, ocean, and sky with one tiny, solitary human being. In this image he pays close attention to the Rule of Thirds. The sky takes up the top third of the frame, and the beach and water take up the lower two-thirds of the frame.

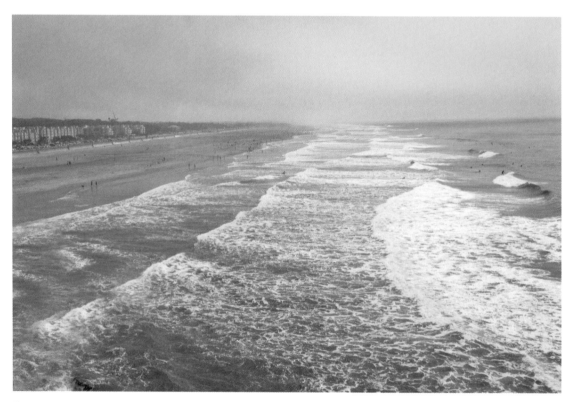

Figure 7.1 Callahan photographed vast landscapes similar to this one.

In this landscape and other similar ones, Callahan describes a world as an abstract place dealing with textures of the elements—sand, waves, sea, clouds, and sky. He was a soft-spoken person, and that is revealed in his work. He doesn't aim to tell stories or use photographs in any kind of photojournalistic sense.

In Figure 7.1, the vastness of Ocean Beach is shown from the Cliff House in San Francisco. The miniature people on the beach emulate those found in Callahan's photographs.

You can create a similar beach landscape to Callahan by placing yourself a good distance away from the landscape you are photographing, preferably above it. Use the Rule of Thirds when framing the landscape, making sure the sky occupies the top third of the frame. When shooting, use a narrow aperture (f/11 is good) so that everything in the frame is sharp. If you can, use a tripod to get the sharpest picture possible. If you use a tripod, you can shoot at f/32, which will have you shooting at a slightly longer shutter speed. In all cases, use an ISO speed of 200 or below so your picture is noiseless.

Minimalist Windows

Callahan took to photographing architectural details of building exteriors in 1949. Two things are evident in one of Callahan's images in the series *Chicago, 1949*. The buildings are photographed straight on, with no converging lines, and contrast was provided by including very light and very dark tones.

In one image of the *Chicago* series, Callahan took the façade of the building and cropped it so that only the windows were shown—40 of them evenly distributed throughout the frame, with a row of smaller windows running down the middle of the frame. Viewers' eyes stick to the image because among windows where the shade is pulled down, creating light-toned windows, there are other windows scattered throughout with different tones. In these windows, either the shade is pulled halfway up, creating a multi-toned window, or the window looks textured because of closed drapes inside it. In short, there is predictable repetition in the shapes and forms of the photograph; however, the tones do not repeat in any pattern.

To emulate Callahan's image, the first thing I had to do is find an image that contained all windows. I selected one that had no converging lines. To avoid converging lines in a frame, you have to shoot from far away. You constantly have to be on the lookout when you're in the downtowns of cities for good building photo ops. When you're in a position to shoot from a distance and can see that part of a building with repeating elements will fit in the frame, take advantage of the opportunity to photograph it.

The image in Figure 7.2 shows what I came up with. It's the same general idea as Callahan's image except there are fewer differences in the tones and textures of the windows.

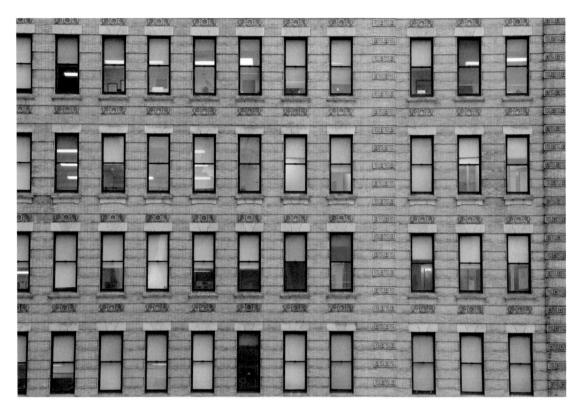

Figure 7.2 Photograph showing repeating light and dark tones in the frame.

CHAPTER 8
Henri Cartier-Bresson (1908–2004)

As a photojournalist, Henri Cartier-Bresson founded the Magnum Agency, which has a library of images that cover the time period from the Spanish Civil War to today. He developed street/candid photography as an art and was one of the first to use 35mm film.

Early in his career, he traveled the world, photographing fine details of humanity. In 1952, his book *Images à la sauvette* (*The Decisive Moment*) was published. Often called a snap-shooter, Cartier-Bresson was not taken seriously by some because of the time it took to get his shot. But, indeed, he had a gifted eye for detail and composition. In many of his images, he sought to get an interaction between the subject and the lens. The best way to sum up the style of Cartier-Bresson is with a quote from Truman Capote, who wrote about Cartier-Bresson's use of multiple cameras: "I remember once watching Bresson at work on a street in New Orleans—dancing along the pavement like an agitated dragonfly…click-click-click (the camera seems part of his own body) clicking away with a joyous intensity, a religious absorption."

Moving Group of People

Photographing a group of people in public is one of the basic things you can do in candid photography. It might seem to be an easy thing to do—until you go out and try it. In Cartier-Bresson's 1958 photograph, *Cross Section of American Youth, New York*, he finds just the right kind of people—young men—in the right location—in front of a Camel cigarette billboard—to make for a compelling shot. His framing follows the Rule of Thirds to a T. The bottom two-thirds of the image consists of the men from the thighs upward to the tops of their heads. The top third contains a building on the left and a Camel billboard on the right. Bresson said of his technique: "To take a photograph means to recognize—simultaneously and within a fraction of a second—both the fact itself and the rigorous organization of visually perceived forms that give it meaning."

Figure 8.1 shows a scene in Berlin that is framed in the same way as Cartier-Bresson's, except the scene is people coming off of a subway train, which offers compelling material for a photograph. Something is happening in this photograph that Cartier-Bresson would have looked for. The boy in the photograph has made contact with the lens. In Cartier-Bresson's photos of children, he always picked images where the subjects made contact with the lens. It allows viewers to look into the subjects' eyes so that they develop a relationship with them. It's as if the viewer has made contact with the subjects when he or she is looking at the image. The boy in the subway image almost looks as if he's thinking, "I see you taking a picture of me."

To get this image, I used a wide aperture (f/2.8) telephoto lens. The wide aperture was able to stop the movement of the people so you could see each person in detail. I set the camera to ISO 800. I believed the light was good enough that I didn't have to go higher and risk the chance of getting noise.

The workflow in Photoshop was fascinating because upon initial inspection of the photo, I saw blown highlights in the colors. All I had to do to get rid of them was lower the Exposure slider in Photoshop Raw. After that, I converted the image to black and white and tweaked the HSL/Grayscale slider colors (shades of gray) so each would lighten the photo a bit, because it had been dark from lowering the exposure in the Basic settings. I was pleased because for an indoor shot without a tripod, the photo was very sharp.

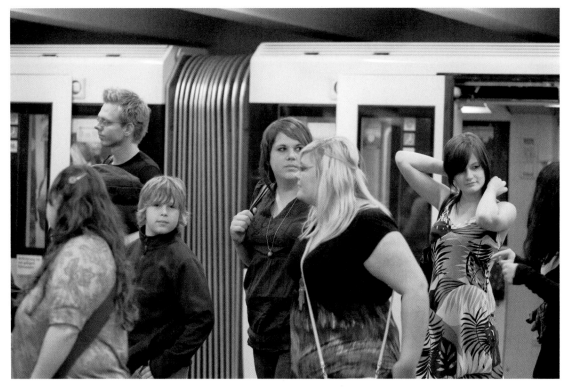

Figure 8.1 A subway station is a good place to get a compelling shot of people.

Kids Playing a Game with Spectators

A photograph of naked kids playing on the shore of an African lake moved Henri Cartier-Bresson to take up photography. Kids can make very compelling subjects.

In Cartier-Bresson's *The Poor Play It in the Streets*, there is a group of kids playing on the streets of New York. The image shows two kids playing near an intersection while others watch. One spectator is on a small bicycle; another is standing in the foreground at the bottom left of the frame. There is much depth to the photograph because the background is a fenced yard along a sidewalk, which moves well into the frame. The rhythm of the kids' movement is notable also. With regard to a photograph's rhythm, Cartier-Bresson said, "What reinforces the content of a photograph is the sense of rhythm—the relationship between shapes and values."

The shot in Figure 8.2 taken in Shanghai shows some kids playing soccer on the pavement in a park. The shot is similar to Cartier-Bresson's in that the subjects are engaged in playing a game. Their movement adds fluidity to the frame. They're very flexible, and it shows in each subject in the different frozen action poses they assume in the shot.

Last are the spectators. Cartier-Bresson had them scattered throughout the frame. In the emulated shot, they stand on the sidelines in the foreground of the frame, silhouetted as if they're watching a movie in a theater. Spectators in a shot add to a viewer's interest because they increase the focus on what's going on.

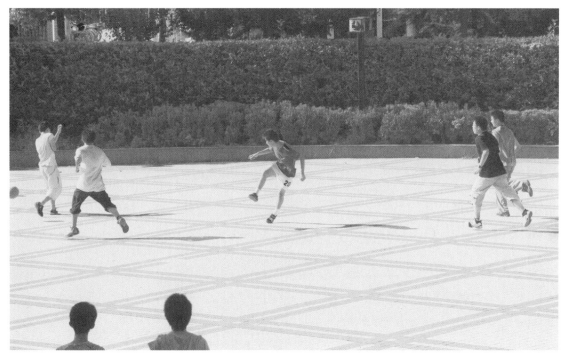

Figure 8.2 The rhythm of the kids' movements is compelling.

USING LAYERS TO MINIMIZE CONTRAST

In Cartier-Bresson's *The Poor Play It in the Streets*, there is a slight haze cast over the frame. This effect happens a lot with film. To create this, most of the time you can lower your contrast in Photoshop. (Cartier-Bresson did that in the darkroom.) When you're working with digital images, though, they often have such a high contrast that lowering it does little to create a hazy film effect.

There is a way you can get this, though. Just open your image, then navigate to Layer > New Fill Layer > Solid Color. In the dialog box that comes up, name the layer and choose gray from the Color drop-down menu. In the Pick a Solid Color dialog box that comes up, click OK. Your image will be replaced with solid gray, but not to worry—it'll be fixed in a moment. Navigate to Window > Layers. Select your color fill layer and adjust the Opacity slider to your liking, and voilà, you have a slight haze over your image.

Imogen Cunningham
(1883–1976)

Cunningham was both a scientist and a photographer, not to mention one of the first women in photography. She studied the chemistry of the film developing process. One of her first images was a nude self-portrait taken on the campus of the University of Washington.

In her early career, Cunningham worked in the studio of Edward S. Curtis. Later, she had her own studio in Seattle, where she photographed portraits of people. She became an expert developer, using platinum paper to make prints. A few years after she changed her photographic style from soft- to hard-focus photographs, she became a member of the f/64 group (Ansel Adams was also a member), a group dedicated to the fine details in nature. During this time she made a series of plant photographs, up-close documents that were almost scientific in nature. In 1988, her granddaughter made an Academy Award–nominated documentary about Cunningham's life.

Details of Pattern and Form

Cunningham was well versed in many areas of photography, from street photography, to nudes, to modern industrial landscapes, to plants. In the early 1920s, Cunningham photographed the plants and flowers in her backyard garden. She studied the magnolia blossom, photographing it extensively. She was known to have used simple equipment. For many years she used a 4×5 revolving back Graflex with an 8-inch Tessar lens.

She began photographing at 18 and did so into her 90s, making her a photographer longer than most of the greats of the twentieth century.

Cunningham's image of a magnolia is stunning in its detail. In her 1925 photograph, *Magnolia Blossom*, it's quite likely that she arranged the flower before she photographed, as she didn't always photograph her plant and flower subjects in their natural settings. The curly anthers of the magnolia were shown in fine detail. The entire flower occupied the frame, with petals showing up soft in the foreground and sharp in the background. Most astonishing is that a petal of the flower rises up behind the anther and stigma, making incredible contrast between the two.

You can focus on details of pattern and form easily with a good point-and-shoot camera. Since good macro lenses for dSLR cameras are expensive, you might go with a point-and-shoot camera with a good lens to capture an image like this. These cameras are known to have excellent macro lenses on par with some that fit into dSLR cameras. You can also use a telephoto lens by stepping away from the subject and then focusing on it.

In the photograph in Figure 9.1, the goal was to have a sharp anther and stamen. I photographed it at f/2.8 with a telephoto lens to get this part of the flower sharp. Any narrower opening of the aperture, and the anther and stamen would have become soft, because the shutter would've had to remain open longer. This flower was not staged. It was photographed as it bloomed on a magnolia tree on the grounds of Hearst Castle.

You can shoot the flower from the tree, as I did, or remove a flower and stage it inside. If you shoot outside, it's best to use a tripod on a day when the wind isn't blowing. If you use a wide aperture, it's possible to get the stamen and anthers sharp without a tripod.

Zebra Skin

Cunningham had an interest in patterns and form, which began with her close-up images of cypress tree trunks along the Central California coast. After a zoo visit in the early 1920s, she undertook a study of the animal. She discovered the abstract black-and-white pattern of the zebra.

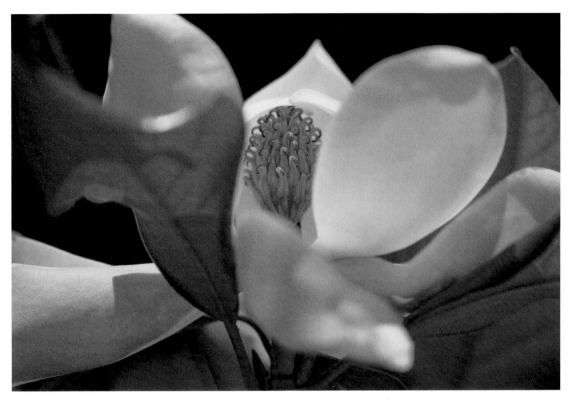

Figure 9.1 Close-up side view of a magnolia blossom.

In one of her photos of a zebra, she shows a zebra's body from its backside to just before its front leg. Strikingly evident in that photograph is the pattern of stripes that show up as thick diagonal lines, which curve down into the bottom of the frame. The lines are mesmerizing and appear to be an optical illusion.

Figure 9.2 shows a similar pattern in a photo that was cropped in the same way Cunningham framed (or cropped) her photo. You can emulate her zebra photo at a zoo. You have to catch the zebra so that you can frame a view of it from its side to get the same stripe configuration in the emulated photo as in Cunningham's photo. To get a sharp shot you'll probably need a tripod, because it's most likely that you'll have to zoom in to get a close-up. You don't necessarily have to frame the photo so that it only includes part of the zebra's body; you can frame it so you show the whole animal and then crop it later.

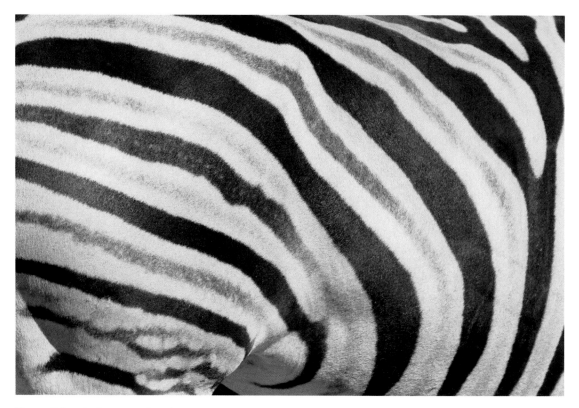

Figure 9.2 A close-up of a zebra can cause your eyes to cross.

CHAPTER 10
Robert Doisneau
(1912–1994)

Probably the most playful of the twentieth-century photographers, Robert Doisneau made it a point to amuse. Whether it be a child gazing at the clock in a classroom or two children walking on their hands with their bodies in the same configuration, Doisneau walked the streets of Paris looking for the antics people, mostly children, could get into. Whether he got his material from the inside of a café or someone's home, his photographs showed the happy moments in French life. His photograph, *Le baiser de l'hôtel de ville* (*Kiss by the Hotel de Ville*) has been viewed all over the world, making it one of the most recognizable images of Paris.

In early adulthood, Doisneau struggled to make ends meet. There was a time he made postcards for a living. Doisneau photographed the liberation of Paris at the end of World War II. These photos have become iconic. Later in his life, he went on to be published in *Life* and *Vogue*. Today, he remains a hero of French popular culture with calendars, cards, and books that contain his photographs on sale all over the city.

Human Interaction with Surroundings

Robert Doisneau was a master at catching human interaction with everything from characters embedded in architecture to clocks hanging on the wall. His famous 1952 work, *L'enfer boite de nuit, Place Pigalle, Paris* (*Hell Nightclub*), has a uniformed man walking by the open mouth of a huge monster embedded into the façade of a building. He caught the man juxtaposed against the inside of the mouth, which is a slide-down door with horizontal stripes. Above him are teeth, nose, and huge, bulging eyes.

In essence, this (and most) Doisneau photographs used Paris backdrops creatively. He made images playful in fascinating narratives, juxtaposing Parisians against a backdrop of quintessential Paris.

Today, Paris is still as special as it was in the 1940s, when Doisneau photographed it. Few places in the world have an abundance of huge poster advertisements that you can touch as Paris does. The Paris subway system has walls plastered with huge ads, which make for some fun photography —especially when you have subjects interact with them.

Figure 10.2 is an image with a Doisneau spirit of making a story out of the surrounding environment. The image uses an open mouth in the same way Doisneau did in his *L'enfer boite de nuit*. The narrative is there (the woman's head is being eaten by a model), and it's French (it's advertising French mineral water).

Wait for Foreground Subjects

Doisneau said, "The marvels of daily life are exciting; no movie director can arrange the unexpected that you find in the street." In Paris and other cities, this is no understatement. If you are aware of your surroundings, you can find a plethora of good shots.

In *Les jardins du Champ de Mars*, shot in 1944, Doisneau caught a group of running and jumping children with the Eiffel Tower in the background, off center in the frame, and trees to the right of it. The children in the foreground are sharp, and the Eiffel Tower is a tad soft.

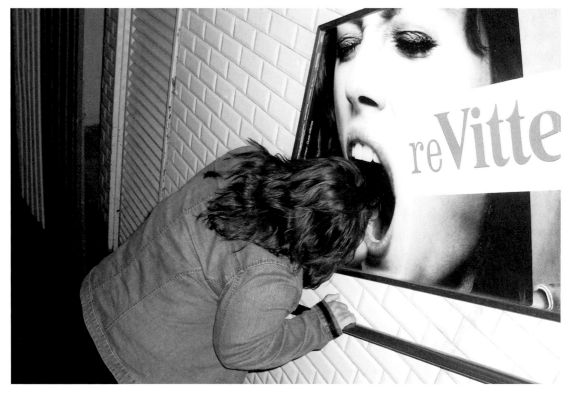

Figure 10.1 Doisneau played with his surroundings—and you can, too.

Figure 10.2 shows a girl on a bicycle with training wheels. The Eiffel Tower is also in the background in that shot, at almost the same place in the frame as in the Doisneau photo. When I was taking the photograph in Figure 10.2, I first noticed how beautiful the setting of the building and Eiffel Tower were together. Then I saw the little girl, pulled out my camera, and shot the scene.

There are two ways to get a good background around a compelling subject when you are in a big city such as Paris. The first is to look for good backgrounds when you are walking around. Normally, a good background is a shot that would look great by itself in the frame, as the Eiffel Tower would. When you've found one, wait around until something interesting comes into the foreground. The second way to get a good background is to first spot your subject. Then make your way around it until you see that your background is acceptable.

To freeze action of something moving, you need to use a wide aperture. You can use aperture priority mode, setting your aperture to f/5 (wider if it's cloudy). If you set your aperture very wide (f/2.8 or wider) only part of your subject(s) will come out sharp (the part around the auto-focus point.

Figure 10.2 Adding a foreground subject makes a photo more compelling.

NOTE

Sometimes you'll have to shoot quickly, and your auto-focus just won't do its job fast enough. If this is the case, you can use manual focus. Simply manually focus about 6 feet in front of you before you take your shot. Set your aperture to f/8. This only works if your subjects are not moving quickly.

Frame the Audience

Armed with a camera set with an aperture that was neither wide nor narrow, Doisneau caught a crowd watching a man curl a barbell in his image *Banquiste, Place De La Bastille*, taken in 1946. With biceps flexed, the man takes the barbell not in his hands, but on his forearms. He's slightly stooped over with knees bent, an action that makes what he is doing look tough. The barbell consists of two round weight balls at each end. Behind the weightlifter is a man who looks to be presenting the show. Behind him, a large crowd gazes, looking at the man's back. In the distance is a carousel.

Doisneau had something going for him with regard to the fashion of Paris in the '40s. Almost everyone wore black. The man lifting the barbell in the foreground is wearing a tank top on pale skin, which provides excellent contrast against the black background of the people's clothes. Also, the contrast between the black bodies and light faces makes the spectators' heads prominent, so you can see a mass of humanity in a little bit of space.

In the image nearly the entire frame is sharp, signaling that Doisneau didn't use an ultra-wide aperture to take the photo. If he did, the crowd would have been soft and the weightlifter sharp. In the image, the fact that the crowd is sharp makes it more important than if it were soft. You get a real look at French people of that era.

Street theater always captivates, whether it's in real life or in a photograph. Catching a street performance in the way that Doisneau did requires that you do two things: Set your aperture to between f/4 to f/5.6 so that there's a better possibility that the entire frame stays sharp, and make sure that you frame a crowd behind the performer. To get a better chance for your shot to be sharp, you'll have to shoot at least a dozen pictures of the scene. You might think that the framing is obvious and that you'll always get a crowd in the background. Many times you won't, because you'll be facing the performer along with other people, and no one will be behind him. When you shoot, you'll get a background of whatever's on the street, not a compelling possibility.

Figure 10.3 shows a street performance in Berlin. (The Brandenburg Gate is in the distant background.) In the shot I framed a crowd behind the performers. Because the crowd was arranged in a semicircle around the performer, I could not get them in the background while standing to watch the front of the performers' bodies. I had to move in back of the performers and crowd, where no one else stood, and shoot the performers so that the crowd was behind them.

Figure 10.3 Street performers framed with an audience watching.

CHAPTER 11
William Eggleston
(1939–)

Eggleston spent most of his childhood in Mississippi. As a teenager, he attended boarding school, a place where he really never connected because his interest in art was not considered masculine among his peers at the school. Most of his college days were spent at Ole Miss (University of Mississippi), where he discovered his interest in photography. He spent five years there but never received a degree.

Eggleston's achievements began when he experimented with color photography in the mid-'60s. In 1969, he showed his color snapshots, which he brought in a suitcase, to John Szarkowski of the New York Museum of Modern Art (MOMA). The museum ended up buying one of his prints.

While teaching at Harvard in the mid-'70s, Eggleston discovered a process of printing photos—dye-transfer printing—that gave photos the ultimate in color saturation. His photos using this process ended up in a show at MOMA, to much fanfare. The show cemented his position as one of the finest color photographers in the country at the time.

One of Eggleston's most famous images, *Memphis*, c. 1969–70, is a tricycle taken at ground level set in the middle of the frame and occupying most of it, with suburban houses and sky in the background.

Find Muted Color Tones in a Landscape

Eggleston tended to look for things whose colors were muted from being sun-drenched for a long period of time. From old barricades to rooftop signs and vintage cars, Eggleston made good use of faded color. His landscapes, which usually contained human-made subjects—a house, road, or sign—were not only taken in the southern United States. He photographed one Western town hit by perpetual desert sun—Amboy, California. A faded landscape, an old gas station, and a diner sit in the middle of nowhere under a chalky blue sky. The place's distinguishing characteristic is the big Roy's sign. Eggleston's photograph of the place is a stunning study of muted colors with continuous tonal ranges from the highlights to shadows.

Eggleston used color in what appeared to be inadvertent use. Up until the 1970s, color photography was ubiquitous (in magazines, on television, and in snapshots), but it was not the medium of fine art photographers, who had, up until then, shot in black and white. Shooting indiscriminately to highlight color had not yet been experimented with. Eggleston brought color to the forefront of everything one sees every day. He used Kodachrome film and made prints with a dye-transfer process (a now defunct process of transferring dyes from three images onto a one piece of paper, which produced the richest tonal ranges of all photographic processes).

Digital photographs tend to have vivid colors—often too vivid. Dealing with the color is best done with an image processing program after taking the picture. The way you tweak colors in, say, Photoshop or Elements depends upon what kind of color you start with. To get similar color to what Eggleston has in his photos, there are a number of options you can use in Photoshop. (Granted, nothing is as good as the dye-transfer process, but you can get near it if you tweak long enough.) You'll have to use a number of tools. The options are contained both in the Raw window of Photoshop and in the main program.

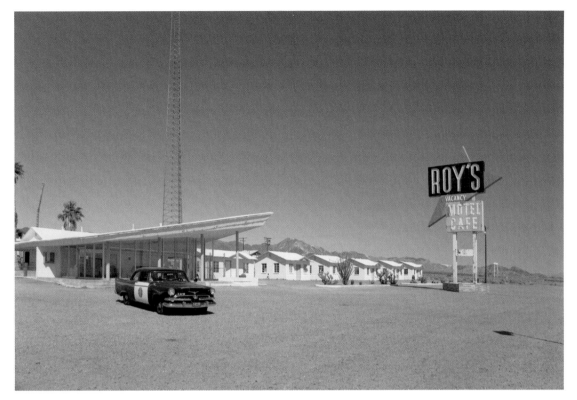

Figure 11.1 Eggleston photographed Roy's in Amboy, California.

In the Raw window, consider adjusting the temperature, tint, exposure (to lighten/darken color), recovery (to darken the center of the frame outward), vibrance, and saturation in the Basic Settings window. In the HSL/Grayscale window, you can also work with color. When you click the Saturation tab, you'll get a window where you can tweak many colors. I find that the blues need less saturation than the other colors, and the reds need more to emulate an Eggleston photo. Last are the colors in the Luminance tab. Tweak those by eyeing them in an effort to mute the color in your shot.

In Figure 11.1, you see many of the same elements as in the Eggleston photo because both were taken at the same place—Amboy, California. Both shots have the police car. (I got lucky because it was there on the day I photographed. Many times it isn't.) Eggleston's shot is framed differently, with the shot focusing more on the gas pumps that are in the foreground on the left edge of the frame next to bare pavement, which covers the rest of the frame, leading to the police car and Roy's sign in the background. In the emulated shot, I've tweaked the color by desaturating it in Photoshop Raw so that it looks like that in Eggleston's photo.

Photograph an Old Car with an Added Extra

Taking a picture with power means that you have to have something more than just a subject. Take an old Mustang, for instance. Snapping a shot of one, say, parked in a parking lot doesn't offer your viewer much of anything but an old car. Eggleston photographed cars among fascinating surroundings. Other external elements brought his images together, from the bright colors to a stray item somewhere in the frame. This is exemplified in his Cadillac series. He has a picture of an old car (though it wasn't old when he took the picture) surrounded by minimalist, yet colorful surroundings. The car is parked in front of vertical siding of a building that extends above horizontal siding along the side of the car. The sidings are unique shades of muted oranges, yellows, and browns. The car is parked perfectly so that it fits snugly into the area where the sidings meet.

What is really relevant in terms of Eggleston's technique in this shot is that he includes part of a Ranger vehicle. (You can see the name at the right edge of the frame.) He could have easily cropped that vehicle out of the picture, but he didn't. Eggleston rarely cropped his images. Finally, one of the most important aspects of the image is a crumbled-up paper bag in the foreground of the frame. It just makes you look at the image a bit longer to try to figure out why it's there.

Figure 11.2 shows an old car with some added elements of interest. The first and most prominent is that the car is for sale. Because the car and the background are different shades of beige, the red-orange letters of the For Sale sign really stand out. Also of note are the rectangular shapes in the background of the windows, door, and an area where the surface is recessed. Then there's the green door, which adds just the right amount of color to the minimalist background. The horizontal siding of the building in the image and the similar model of car make the image stunningly similar to Eggleston's.

Oh, and about that crumbled-up paper bag in the Eggleston photo. You can easily add one to your shot by using Photoshop.

Photograph a Bright Color Indoors

Deep red tones are a trademark of one of Eggleston's most famous photographs, *Red Ceiling* (minerva.union.edu/photoatunion/PhotoBlog/Eggleston/eggleston_red_ceiling.jpg). The photo consists of the top of two walls that intersect covering the bottom of the frame, leading up to the ceiling with a light bulb in the middle in the rest of the frame. Three different wires coming together in different places on the hardware of a light fixture that juts out prominently break up the ceiling. Very notable in the bottom-right portion of the photograph is a cut-off poster of sexual positions of multicolored figures. Eggleston commented about the photo, saying that

Figure 11.2 Interesting added elements can make or break a picture.

"when you look at the dye [in the print that used the dye-transfer process], it is like red blood that's wet on the wall."

Finding striking colors inside buildings isn't easy. There are just not that many buildings that are painted bright colors inside. If you're lucky enough to find one, you can follow some simple suggestions to make the image compelling. First, include the floor or ceiling to give the image depth. Next, use objects that contrast with the background. Eggleston used objects that provided much contrast with the background, such as the light-colored wires, light bulb, and fixture base in the photograph of the red ceiling.

In Figure 11.3, a table and chair are tucked where two blue walls meet. The colors—the browns and blues—are rich in tone and not antiseptic. (Rarely did Eggleston photograph anything that was antiseptic.) There's more to this picture than the table, chair, and blue walls; there are stray items similar to added items in Eggleston photographs (such as the wires and the sexual position poster in *Red Ceiling*)—white numbers on the chair, papers on the table, and a black plastic bag in the background on the large ledge beneath the window. All keep viewers' eyes on the photo with views that probably will be more than just glances.

Figure 11.3 Any bright color is worth photographing indoors.

Find Beauty in Junky Surroundings

In many of Eggleston's photos, trash is strewn about randomly. His images, many of which were taken in the southern U.S., deal with the commonplace, from gas pumps at a gas station to barricades on the side of the road. In *Karco, 1983–86*, (timelookingaround.files.wordpress.com/2008/10/eggleston_karco.jpg) Eggleston takes us on a trip to an auto store with signs covering the page, from a No Parking sign in the foreground to a pile of signs one on top of another—Dayton Tires, Mufflers, Auto Tops, Seat Covers, and Uniroyal—the text of each in a different color. Also in the image are signs seen sideways as well as a white building with red signs (Car Wash, Enter) painted on it.

In an image taken in the western U.S. in Figure 11.4, there is colorful sign among a pile of tires painted yellow in front of a fence with barbed wire on top. There are more signs behind the fence among other elements, including a very colorful truck. Many elements similar to these can be found in a variety of Eggleston's work.

Figure 11.4 Eggleston often included old signs similar to these in his photographs.

You can get some ideas for photographing junk by knowing what Eggleston put in his frame. Among some of the many images he took are:

❋ Close-ups of blue, red, and yellow toy animals on a dark reflective surface

❋ A pile of dolls on the hood of a Cadillac

❋ A row of old mailboxes on a rural road

❋ Abandoned, rusted vehicles

❋ A pile of garbage in front of a colorful wall

❋ A ditch filled with muddy water and empty cans (most of which are in a box)

❋ A thick light green pole with Christmas lights dangling diagonally around it

❋ A façade of a building covered in small signs

One thing is for sure: No matter what was in Eggleston's frame, the color always stood out—reds, blues, yellows, greens, and even browns—in smooth tones that made your eyes stick to the image.

Evans photographed signage of his era in black and white.

Walker Evans
(1903–1975)

Walker Evans grew up in a well-to-do Chicago suburb until his parents split up, at which time he moved to New York. He wasn't supposed to become a photographer, but instead was expected to garner a professional position in which the financial rewards were handsome. Evans wouldn't have all that. At first he wanted to become a writer. After he decided to become a photographer, he came to the conclusion that what was popular in photography—artistic and commercial prints—wasn't what he wanted to photograph.

As a photographer, Evans traveled to Cuba to provide photographs for the book *The Crime of Cuba*. He then went on to become a photographer for the United States government's Farm Security Administration, a program to help poor farmers. His photographs documented the rural poverty in the South. After his work for the FSA, Evans went out on his own. He went on to become a photographer and writer for both *Time* and *Fortune* magazines.

While Evans photographed the downtrodden in America, creating a body of work that included abandoned buildings, faded signs, and Depression-era families, he detoured from that subject matter at times, turning to modern Chicago architecture. The change probably could have been due to his corporate work at *Fortune* magazine, where he started working in 1945.

Find Showbills on City Walls

Walker Evans was the son of a copywriter for an advertising agency; hence, he had an interest in advertisements, especially showbills. Two of his most popular images are of showbills for minstrel shows. One showbill, *Showbill, Demopolis, Alabama,* shows large sans serif text reading Silas Green Show. There are dancers twirling, many with their arms up in the air, in what looks like flapper outfits with dozens of dangling pieces of material extending from them. In the background is a black man with a microphone. Just in case if you were wondering, Silas Green was one of the characters in the minstrel show for which the poster was advertising. This show toured the south for decades in the early and mid-twentieth century. In another showbill poster, *Minstrel Poster, Alabama, 1936*, there are African-Americans engaged in a number of activities under the text, "J.C. Lincoln's Sunny South Minstrels." On the right of the showbill are two copies of another poster going down the wall that act as borders for the right side of the photograph.

> **NOTE**
> To see all of Evan's showbill posters, enter "minstrel" in the Search box at cybermuse.gallery.ca/cybermuse.

Showbills usually have interesting images on them, very photographable ones. If you can find dancers on a sign, billboard, or showbill (as Evans did), all the better.

When you convert them into black and white, the image assumes a dated look. The control you have of the gray tones on these types of images when working in Photoshop Raw (see Chapter 1) is amazing. Figure 12.1 shows a showbill advertising a dancing show in Berlin, Germany. Not only is the poster in the frame, but there is also a reflection of cars on the street in the glass window behind which the showbill was placed.

Figure 12.1 Dancers on a poster in Germany as seen through a storefront window.

Frame the Façade of an Old Storefront

In *Roadside Stand, Vicinity of Birmingham, Alabama, 1936* (cybermuse.gallery.ca/cybermuse/ search/artwork_e.jsp?mkey=18290), a fish store is shot straight on. In the image the word FISH is painted on the front, and added text reads, "Honest Weights, Square Dealings." Next to the word FISH is an illustration of a big fish. On top of the shop is another sign that reads:

F.M. POINTER
The Old Reliable
HOUSE MOVER

There are also signs on either side of the door that read as follows all in caps:

SPECIAL
TO DAY
RIVERFISH
CATFISH 20
TROUT
PERCH 15
DRUM 15
BUFFALO 15
EEL 20

Two young men are holding watermelons in front.

In the 1936 image *Auto Parts Shop, Atlanta, Georgia*, Evans photographed an auto parts store straight on, the same way the fish store was shot. A car occupies the foreground. What's notable about the image is the tires hanging on the façade of the store. They're scattered about in the frame, looking almost like donuts. The sign reads CHEROKEE PARTS STORE extending the width of the façade on top of GARAGE WORK.

Evans' aforementioned book, *The Crime of Cuba* was popular with artists and writers because of its leftist content. Part of his repertoire was the façades of Havana storefronts. In one he frames two men standing in front of a store in front of one of two giant, dark doorways. In between the doorways is an illustration of a stove. There is also a giant key hanging at the top of the doorway where the men are standing.

In Figure 12.2, you see a man making keys in front of a façade with giant keys painted on it. The shot, taken in Mexico, has keys hung on the back wall in neat rows. The text on the building (SERVICIO a DOMICILIO) is written in Spanish and stylized with stars on top of the letter "i" instead of dots.

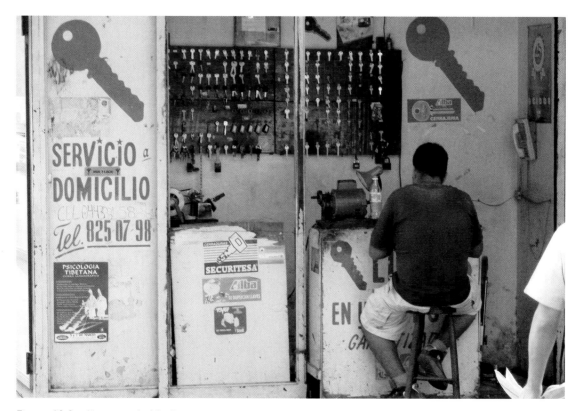

Figure 12.2 Key store in Mexico.

Isolate Interesting Windows on a Building

Walker Evans had a keen interest in architecture. He shot Victorians in Boston and high rises in Chicago, as well as dilapidated buildings in the South. In *Windows of an Apartment Building on Michigan Ave (1947)* Evans photographed a modern building with only windows appearing in the frame. The image was taken at an angle so that the windows grow steadily smaller as you move through the frame. You can see the lines that the framing of the windows make in the frame as they repeat themselves converging from left to right. Finally, there's a roll in the windows on every other floor, leaving them protruding throughout the frame. On the rightmost part of the building, the windows are all the same.

When you find protruding elements in architecture and photograph them, it creates depth in your image. In Figure 12.3, the architecture is very stylized, with the frames of the windows protruding from the façade of the building, albeit in a very different way than they do in Evans' photograph of a modern Chicago apartment building.

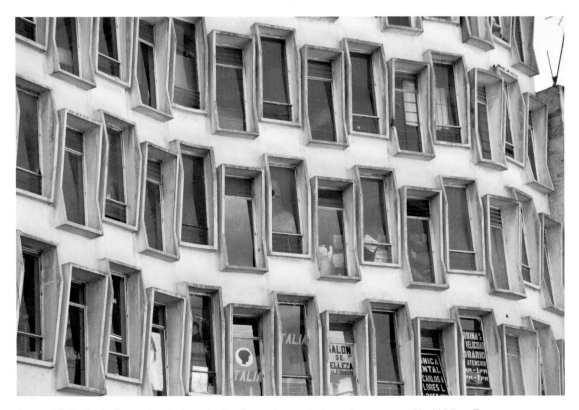

Figure 12.3 Including only windows in the frame is a technique that was used by Walker Evans.

There are considerations you should take into account when photographing just the windows of a building—mainly, where the sun is located with respect to the building. In Figure 12.3, the sharpness is the result of an equatorial sun (the photo was taken in Quito, Ecuador) behind clouds, giving optimum light on the building. If direct sunlight were cast on the building, there would be a risk of getting blown highlights on the façade above and below the windows. You'd need a polarizing filter to prevent that.

Lee Friedlander (1934–)

Have you ever been on a street photography shoot to photograph scenes that most photographers avoid? If you have, you could be emulating Lee Friedlander.

Friedlander's photographs of street scenes with shadows are known to have shown the complexity of urban landscape. He was said to be influenced by the book *The Americans*, which was photographed by Robert Frank and includes text by Jack Kerouac. The book contained images (many of which were solemn) obtained on a cross-country trip across America in the mid-1950s.

One of Frank's better-known photographs is of a motel room bed with a television at the end of it with a baby on the screen. Also notable were the images he took of Madonna in the late '70s that appeared in Playboy in 1985. He was paid only $25 for the photo shoot. One of the photos recently sold for $37,500 at an auction house in New York.

Later in his life, Friedlander photographed stems of plants because they reminded him of his legs, which had to be operated on for arthritis.

In 2001, the New York Museum of Modern Art (MOMA) and the National Gallery of Art in Washington, DC acquired many of his photographs.

Frame Scenes That Other Photographers Avoid

In *Albuquerque, New Mexico, 1972* (www.nytimes.com/imagepages/2005/05/26/arts/ 29geft_CA3ready.html), Friedlander includes a number of vertical objects in the frame—a fire hydrant and pole in the foreground; a dog, traffic light, and front of a car in the middle ground; and telephone poles, a house, and a high-rise apartment building in the background. He said of these types of photos that he deliberately includes "those poles and trees and stuff" that other photographers avoid. Also of note are the shadows that these various objects cast on the ground and other objects.

While photographing the backs of signs, poles, and telephone wires on the street might not sound aesthetically appealing, they can be framed so that that the mundane reality of their presence is unique and compelling. Each sign, pole, and other manmade object creates shadows that are constantly in flux on bright, sunny days. Manipulating these shadows in the frame can create visual surprises. In *New Mexico, 2001* (www.andrewsmithgallery.com/exhibitions/ leefriedlander/newmexico/leefriedlander.html), Friedlander photographed traffic signs and their poles with the ends of the shadows of the objects in the foreground and the actual objects in the middle ground or background. This is the perspective from which Figure 13.1 was photographed.

Photographing in this manner means that you are shooting into the sun, which can create problems of overexposure of the sky in the background. To prevent overexposure and the blown highlights that come with it, you need to use a lens shade and a polarizing lens and set your exposure compensation down a few stops. In Figure 13.1, the exposure compensation was set down 1 1/3 stops. To be sure, you'll get the faces of the sign dark using this technique, but you can easily lighten them in post-processing using an image processing program. The lightening can take place after you've converted your image into black and white with the grayscale sliders in the HSL Grayscale tab of Photoshop Raw.

Figure 13.1 Shadows can make mundane objects compelling.

Use a Fence to Add Lines to Your Photo

In a photograph, there's little that will appeal more to the curious nature of humans than a look over a fence into a person's yard, especially if the yard contains an interesting landscape or items. One of the most common inclinations of a photographer is to peek over fences, into holes in walls, through windows, and into doorways and various and sundry other places.

Friedlander used fences as borders in many of his photos. In *Santa Fe, New Mexico, 1995*, you get a look over a fence into someone's backyard, a spot filled with tree branches that spread throughout the frame. The simple wooden fence is similar to that shown in Figure 13.2. Friedlander often photographed scenes with wood fences with space between each plank of wood. They provided a set of vertical lines, which in a way adds a sense of strength to a frame otherwise filled with helter-skelter objects. Again, Friedlander gave us a photo subject matter that most other photographers would have avoided.

Figure 13.2 A peek over a fence offers an intriguing view of a front yard.

While the contents of the yard in Figure 13.2 are something more likely to be photographed than the scraggly tree branches in Friedlander's photo, the intent is similar: to give you a look into an anonymous person's property. The open gate of the fence also spells out an invitation (if you dare) to enter into the quaint space beyond the fence.

John Gutmann
(1905–1998)

Born in Germany, John Gutmann came to the United States in 1933 to escape the Nazis. In Germany he had trained as a painter. He found America fascinating, photographing things he had never seen in Europe—tattoo parlors, drive-in businesses, and huge movie theaters. He also photographed automobiles inside and out, and he photographed jazz musicians, such as Count Basie.

What made Gutmann different from other photographers of the time is that he worked outside the FSA (Farm Security Administration). Many well-known photographers of the '30s photographed for this government agency, and their photos were often solemn artifacts of the Great Depression. Gutmann's were not. His eye for all things American, including pop culture, made his photographs much less grim. Looking up at what was going on was just as important as looking around. For Gutmann, many times a worm's-eye view (looking up at subjects) was the only important view. "I was seeing America with an outsider's eyes—the automobiles, the speed, the freedom, the graffiti," he was reported to have said in a 1989 interview.

Gutmann was a professor at San Francisco State University (the author's alma mater!) from 1938 to 1973. In 1989, Gutmann's work had traveled to both coasts in a retrospective by the San Francisco Museum of Modern Art.

Gutmann took pictures of the signs people used to make to advertise their businesses. These signs contained quite a bit of text. When people did this, it was called *instant messaging*. Today, you instant message on a cell phone; back then, it meant to display signs so they could be seen from a distance.

Shoot an Object with Writing Covering the Entire Surface

In *Yes, Columbus Did Discover America, San Francisco, 1938* (http://skarlinski.com/?p=324; scroll to bottom of page), words and phrases cover a car from bumper to bumper in front of a store where the awning contains similar written text. Expressions such as "Lies are falling thick and fast," "The truth marches on," "The big dog that's barking loud now won't bite," and "Honor thy father and thy mother" are written in white on a black car. This white area sits in the middle of the bottom of the frame. Also in white with black writing on it is the awning of the liquor store, which sits in the top third of the frame, one third of the way in from the left border of the shot. The placement of the two white areas shifts the balance of the photo to the left, so that the focus of the photo lies just to the left of the center. Almost hidden in the photo is a man reading the paper underneath the awning.

In a similar photo to Gutmann's shot is a truck with writing all over it (see Figure 14.1). The truck sits out in the open desert near the Salton Sea in Niland, California. It's part of a giant manmade mountain coined Salvation Mountain. An elderly man has spent years building the mountain and painting it and surrounding objects, making it a great spot to photograph.

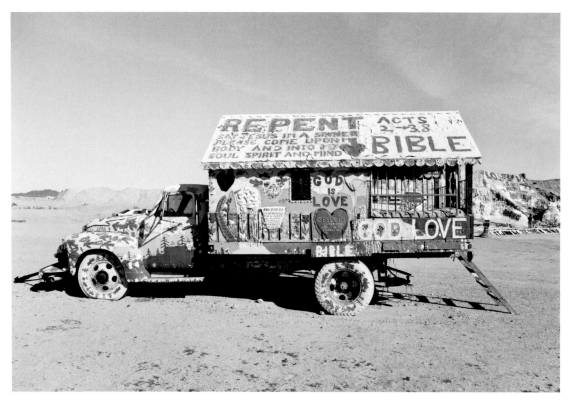

Figure 14.1 Of all the photographers of the twentieth century, Gutmann may be the most unique—his captures of life are so well framed that you cease to believe they are real scenes from real life.

Place a Person's Back in the Foreground in a Two-Shot of a Couple Facing Each Other

In *Mardi Gras Jitterbug, New Orleans, 1937*, Gutmann places a full-length portrait of a man's back in the foreground. To his left, in the background, is a woman facing him. They are dancing the jitterbug. The woman is wearing a mask and a short skirt. The photo has a European feel because the mask that the girl is wearing looks Venetian.

This type of shot works in a variety of circumstances, from illustrating two people talking to depicting a couple dancing (as in the Gutmann shot). In television, they call similarly placed subjects an *over-the-shoulder* shot. Although that shot is used more in close-ups, it applies to long-shot photos, too.

Gutmann also placed his subjects in the following ways, some intentionally and some candidly:

✳ *Japanese Girl and Geisha Friend, San Francisco, 1939* (www.johngutmann.org/photographs/spectacle/18.html) and *Chief Monk and Novice of a Buddhist Temple*: Face in foreground on the right side of the frame; another face to the left (from the camera) and behind the first one. Both heads turned sideways facing left.

✳ *The Fleet Is In, San Francisco, 1934* (www.johngutmann.org/photographs/beyond/03.html): Side portrait of woman with two sailors' backs in front of her.

✳ *Face Behind Veil, 1939* (www.johngutmann.org/photographs/beyond/15.html): Front of face covers entire frame.

✳ *Texas Women, 1937*: Full-body frontal portrait of two women, each holding something. (The one on the left is holding a purse and coat; the one on the right is holding a gift box.)

Gutmann was known to create photographs of unique subject matter that reminded him of his European roots. In Figure 14.2, a man is playing an accordion with a woman. The photo was taken at the Just for Laughs Festival in Montreal, Canada. Both Gutmann's shot (*Mardi Gras Jitterbug, New Orleans, 1937*) and this shot have a European feel because of the face decorations of the women in the photos. In Gutmann's image, the woman wears a mask at a Mardi Gras festival, a custom with roots in Europe. They wear similar masks at the Carnival in Venice.

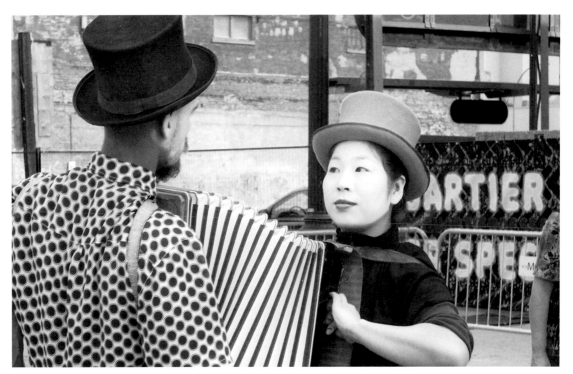

Figure 14.2 Place a person's back in the immediate foreground when two people are facing each other.

Both New Orleans' Mardi Gras and the Carnival of Venice have to do with religious before-Lent celebrations in late winter. These European roots date back to the Middle Ages. In Figure 14.2, the women has her face painted similar to that of a mime. Mimes performed in Greek and Roman times. Their presence continued in Italy through the Middle Ages. By the 1800s, miming emerged in France as a form of slapstick comedy. Mime continued making inroads west. One of the most popular mime troupes in the United States is based in San Francisco. They host free performances all over the city. Finally, the Just for Laughs Festival in Montreal has many mimes. That festival takes place in July in Montreal. Both the mime troupe and the Just for Laughs Festival offer remarkable photo ops that are reminiscent of the twentieth century.

Shoot a Person Performing a Gymnastic Feat

Get out your fast lens and shoot like Gutmann did. Gutmann photographed divers and gymnasts, mostly women, while they were in the air, such as his famous photo of diver Marjorie Gestring at the 1936 Olympics. In 1939, he also took a remarkable photograph of a Czechoslovakian male gymnast on the uneven bars—quite interesting since they are a women's event. At any rate, the three woman watching the woman performing a shoulder stand with her back arched significantly are all wearing the same uniform. Each has her arms up to block the sun while watching. Shadows are cast over their eyes. Finally, he took a photograph of a woman doing a one-handed back walkover. He caught her in the middle of the trick so that she appears to be standing on one hand with her legs kicking apart.

Figure 14.3 shows a man doing a one-handed handstand while he balances his body sideways. This brings up an important issue in the difference between the early to mid-twentieth century and the late twentieth century and early twenty-first century. The first thing is the clothes. People back in Gutmann's time were more formal and would not have worn clothes that are so loose that they flip up while doing gymnastic tricks. They would most likely have had their shirts tucked in. The photo, though, displays male sexuality as seen in the late twentieth century—men could be seen as figures fit for modeling just as easily as women could. Also, with respect to the trick: By the late twentieth century, gymnastics became much more complex. The stunts were more challenging—some of them so complex that it takes some time to figure out how a person could do such a thing. Today, gymnastics has become integrated with dancing, creating the art form that began in the late twentieth century, break dancing. When photographing break dancing, be sure to shoot at a narrow aperture in Aperture Priority mode so that the subject performing is frozen.

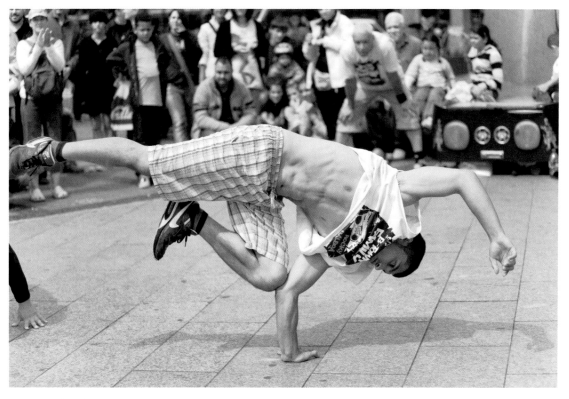

Figure 14.3 Gymnastics changed drastically throughout the twentieth century.

Lewis Hine
(1874–1940)

A school administrator gave Lewis Hine his first camera while he was a teacher in New York. One of his first experiences with the camera was photographing immigrants who came to Ellis Island, in an effort to present them in a more positive light to overcome the anti-immigrant fervor that had swept the country.

In 1908, the National Child Labor Committee (NCLC) hired Hine to investigate and photograph child labor practices in the United States. He photographed children wherever they worked. His work made people aware of abuses that took place in the workplace and helped to strengthen child labor laws.

After he left the NCLC, Hine traveled to Europe with the Red Cross to document the aftereffects of World War I. After coming home from Europe, Hine had the opportunity to make the most compelling photographs of his career. He was hired to photograph the building of the Empire State Building. These are some of the best photographs of construction workers building a project ever taken. They were published in the book *Men at Work* in 1932.

Document Child Labor

In his battle against child labor in the early twentieth century, Lewis Hine shot a set of very compelling photographs. After experiencing miserable working conditions in a factory he worked in, Hine photographed children in similar working conditions for the National Child Labor Committee, traveling from New England to Texas. Hine was one of the first photographers to document oppressed people in an effort to bring them into the limelight to create change. Hine did what many photographers back then and today would like to do—he got into factories, mills, and farms to photograph people working. Sometimes to get into these places, he posed as an insurance inspector. What he documented was children, some as young as four years old, working for 12 hours a day. One of his more remarkable photographs (*Newsies at Skeeter Branch, St. Louis, Missouri* at www.metmuseum.org/home.asp; type "newsies" into Search box) is of three newsies (boys who sell newspapers), one of whom is smoking a cigar, his mouth and cheeks totally engulfed in thick white smoke, and the other two puffing on cigarettes.

In Figure 15.1, a very young child is selling fresh-flower necklaces at a Buddhist temple in Burma. Every day she pleads with visitors to the temple to buy her wares. She has no compunction about coming up to people and following them around until they either say yes or give her a firm and loud no. While children in the developing world work long hours for little pay, those in the United States don't (see the "Awareness through Documentation" sidebar) because of the child labor laws that were drafted, some as a result of Hine's photographs.

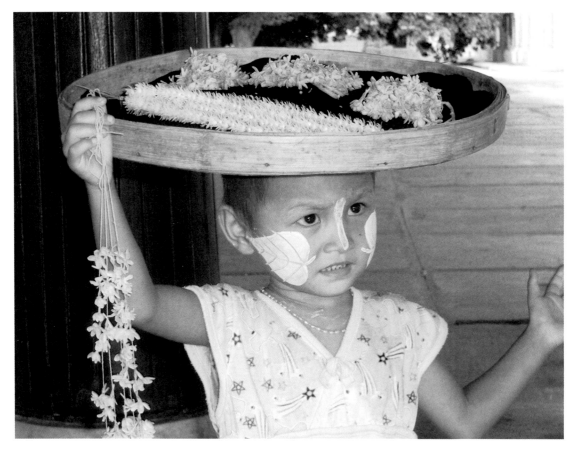

Figure 15.1 Little girl selling fresh-flower necklaces in Burma.

AWARENESS THROUGH DOCUMENTATION

At the turn of the last century, millions of children worked in factories, inside mines, on the street selling newspapers, and in businesses run from the children's homes. It wasn't until 1938, when the Fair Labor Standards Act was passed, that people had to abide by new child labor laws. Today, the Feds have some of the most lenient labor laws. Individual states have separate laws that supersede the federal laws. The Feds require that the minimum age to work is 14—younger if the child is working on the farm. One of the most important stipulations of these laws is that children can't work during school hours.

From kids selling Chiclets on the street in Mexico to shoeshine boys in Bolivia (see Figure 15.2), children work all over the world. Photographing them is a way of documenting that the practice of making children work hasn't gone away. Letting people know about child labor abuses around the world is easier than ever because you can post photos of children working and write about them on blogs and websites. While at first glance the photographs of these children may look sweet or rambunctious, they really aren't. You don't have to go any further than looking at the expressions on their faces to see innocence lost. (See the girl's face in Figure 15.2.)

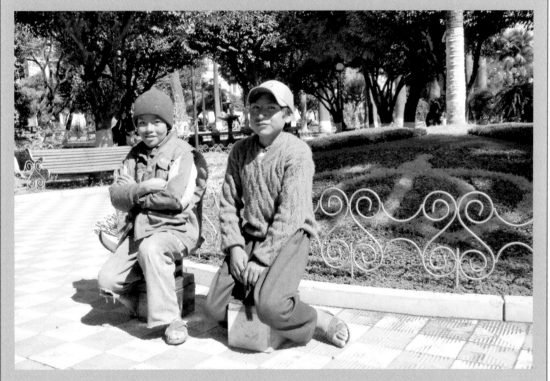

Figure 15.2 Working children in Sucre, Bolivia.

CHAPTER 16
André Kertész
(1894–1985)

Andre Kertész spent his youth in Hungary. He became a photographer after he taught himself how to use a camera early in his life (at 20). A few years later, Kertész moved to Paris, where he became well known in artistic circles. His friends were members of the Dada movement, which refused to accept art how it had been seen by the mainstream public. While in Paris, Kertész photographed well-known painters Mondrian and Chagall.

He moved to the United States in the '30s, where he photographed for such magazines as *Vogue*, *Harper's Bazaar*, and *Look*. He also photographed for *House and Garden* magazine for many years. His photographs gave the magazine a new look.

Kertész photographed common, everyday scenes that were filled with geometrical objects. He also photographed female nude forms that were the result of a reflection created by placing the models in front of curved funhouse mirrors.

Near the end of his life, dissatisfied by the requirements of New York magazine editors, Kertész stayed in his apartment and photographed what was down below, as well as still lifes from objects he put on his windowsill.

Photograph Someone Reading

Andre Kertész spent the better part of his life taking photographs, many of which were of people reading. A book of photographs, *On Reading*, was published in 1971.

Here are descriptions of the images he shot of people reading:

✳ *Carnival, Paris, 1926*: Woman reading behind stage.

✳ *Nara, 1968*: People reading on a subway.

✳ *Esztergom, Hungary*: Three boys reading; they are huddled close together and placed just off center in the frame.

✳ *New York, 1950*: Boy at newsstand; the newsstand occupies more than half of the left side of frame. Boy is wearing an overcoat.

✳ *Pont des Arts, Paris*: Man reading between trees as seen from above; bridge with people walking at top of frame, man at bottom of frame.

✳ *Second Ave, NY, 1969*: Man reading in antique store. Man is just off center in the bottom of the frame, surrounded by lamps and a huge poster of an African-American man.

✳ *Buenos Aires, 1962*: Man reading while walking by a wall covered with graffiti.

✳ *Académie Française, Paris, 1929*: Man reading on ladder among shelves of books.

✳ *Fourth Avenue, New York*: Close-up of a man using a magnifying glass to read at an outdoor book stall.

✳ *Untitled, 1964*: Long shot of a woman reading on a roof. The woman is very small at the bottom middle of the frame, with building walls in the background. Some sky at the top right of the frame.

✽ *Untitled, 1970*: Close-up of wrought-iron chairs (diamond pattern) in the foreground and middle ground; woman reading in the top middle of the frame in the background, behind the group of chairs.

✽ Woman reading through a curtain in a balcony window.

As you can see from the descriptions of his images, Kertész's images of people reading varied widely.

Just as Kertész's photographs show people totally absorbed in the reading process, so, too, does the image of the reader in Figure 16.1. The reader's gaze into the book reminds viewers how engaging such a solitary activity can be. He's older and probably doesn't see too well, hence his close look at the book. The picture is so sharp at 100-percent resolution onscreen that you can actually read the text of the book. The sharpness is due to shooting at a wide aperture, with the auto-focus point set directly on the book. The picture was shot at the outdoor part of a café on the Caribbean island of St. Thomas, Virgin Islands.

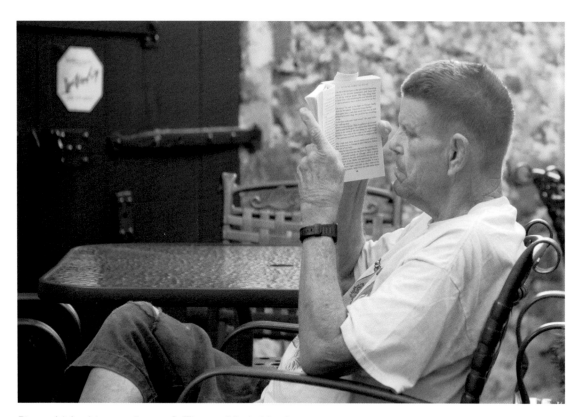

Figure 16.1 Man reading on St. Thomas, Virgin Islands.

Photograph Your Own Shadow

Kertész did a lot of work with shadows in his images. When you're out photographing, you can forget shadows are there—they're something you have to look carefully for. Photographing shadows is best early in the morning or late in the afternoon, when they're long enough to crawl up walls. However, shadows don't necessarily have to crawl up walls to look upright. In Kertész's image, *Study of People and Shadows, Paris, 1928* (www.getty.edu/art/gettyguide/artObjectDetails ?artobj=62327), he photographed four people from above so that their shadows extended along the ground and looked upright because of the downward perspective of the shot.

Although a photograph of your own shadow might not sound all that interesting on its own, adding it to other elements in the frame can make for quite an interesting photo. In *Lion and Shadow, 1949* (www.nga.gov/exhibitions/2005/kertesz/kertesz_ss1.shtm), Kertész photographed his own shadow, framing it so that it showed up on the bottom of a door that has a window in it. Looking out the window is the head of a large plastic lion. Kertész used his shadow as a self-portrait. It's as if he dared the lion to roar at him.

In Figure 16.2, my shadow looks as if it's approaching the dog—a daring proposition indeed. The photo was taken in Bolivia, a country where dogs roam the streets as if they own them. Approach them the wrong way, and you might find yourself missing a piece of flesh. I didn't convert this image to black and white because the contrast between the yellow light of the sun and the nearly navy-blue color of the shadowed areas is stunning, not to mention the rust-colored dog and its shadow. The robin's-egg blue of the lines that make up the swinging doors also enhances the frame.

Stage or Find a Still Life

Andre Kertész was a master at taking still-life photographs. From his image of a fork and plate to the drooping flower in a glass vase, his still lifes manipulated light and shadow as well as painters did in their paintings centuries earlier. His still lifes mixed disparate elements to create a unique vision of the world. In one, *Still Life, Paris, 1926*, he photographed a folded newspaper on top of a stack of magazines, a half-filled wine bottle, a wine glass, and a plate of overripe bananas. In that photo, the intensity of light increases gradually from a dark area in the lower-left corner of the photograph to a light-colored wall in the top-right part of the photo.

In Figure 16.3, I created a compelling still life from a vignette shot at a shop in the Caribbean. After I converted the photo to black and white, I tweaked with the Burn and Dodge tools to vary the intensity of light reflected off of the fruit.

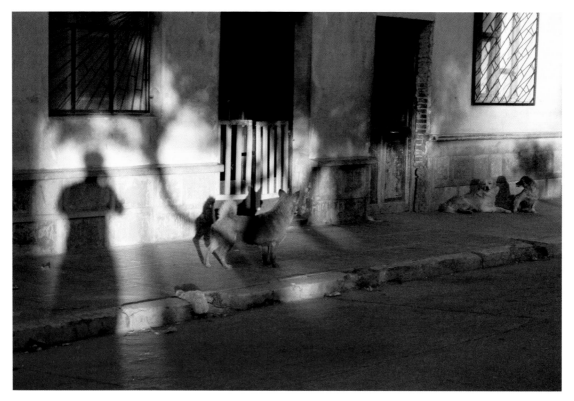

Figure 16.2 A shadow can often act as if it were a real person in an image.

In addition to the varying intensity of light, texture played an important role in creating the still life in Figure 16.3. From the smoothness of the citrus skin to the rough edges of the pinecone, looking at the image becomes almost synonymous with touching it.

Kertész created little vignettes with household objects set on his windowsill and then photographed them to make his still lifes. You can do the same thing. Lighting can be provided by the sun coming though a window or the ambient light in a room. You can provide fill lighting by using a reflector. If you're going to use low-angle lighting to create shadows, you have to consider the shadows as subjects in your image. As I mentioned earlier, there is much you can do with lighting after the fact in Photoshop. You can also find still lifes already made, as I did in Figure 16.3. The sky is the limit with still lifes. All you have to do is supply the creativity.

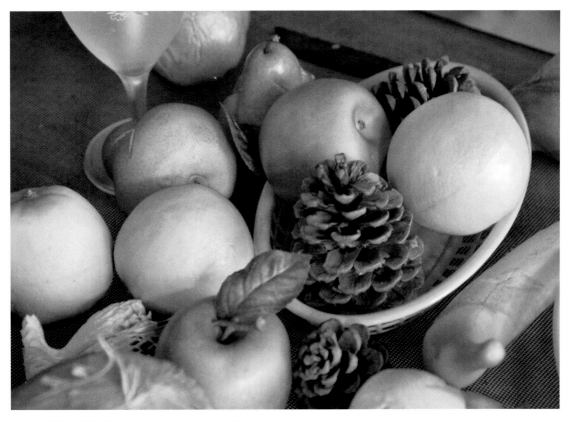

Figure 16.3 Still lifes date back to ancient times.

TAKING THE STILL LIFE
FROM PAINTING TO PHOTOGRAPHY

Still lifes were popular in ancient Greece and Rome and later were used for religious purposes. It wasn't until Leonardo Da Vinci, who used watercolors to paint still lifes, that the art form was used for nonreligious purposes. When trading specimens of nature became common in the sixteenth century, artists began to paint what was being traded. From tulips to fruit, subjects of still life painting varied widely. The long-ago still-life paintings of sunflowers by Vincent van Gogh, fruit by Paul Cezanne, and a guitar by Pablo Picasso remain popular with the masses today.

Dorothea Lange created still lifes with garden tools in her Depression photographs of the farm, and many photographers from the twentieth century knew how to paint and were well versed in the painting techniques used to create still life paintings. But of all the twentieth-century master photographers, it was probably André Kertész (and Man Ray) who worked the most with still lifes.

Figure 16.4 shows a still life created from stacks of old license plates at an antique store in Paris. Antique stores are a gold mine for finding still-life photo ops. Worn antiques can make a photograph look like a Realist painting.

Figure 16.4 Arrangements in antique stores make great still lifes.

A soda ad sign emulating Klein's 7UP sign.

William Klein (1928–)

As a Jewish kid in an Irish neighborhood, William Klein often felt out of place. Klein and his friends found refuge from their neighborhood in the New York Museum of Modern Art (MOMA), looking at art and watching films.

Klein served in the army for a brief period of time before going to Paris to study at the Sorbonne. In Paris, Klein learned to paint and exhibited his paintings around Europe. He then returned to New York, where he photographed all parts of the city, some of which he had never visited. The photographs were published in the book *New York Is Good and Good for You*. Klein developed a signature style that included blur, distortion, graininess, and abstraction in his photos.

Klein went on to photograph for *Vogue*, where, after some hesitance, they accepted his style. The magazine became very successful in part due to Klein's photos. In 1965, Klein decided to go into filmmaking, ceasing his photographic work.

Frame Soda Ads or Signs

Just as sodas can cool and refresh, so can pictures of their advertisements. That's what graphic designers had in mind when they designed them. Some may think that photographing a sign or other graphic from the street is just copying it. That's not really the case. When you photograph a sign or an ad, you have to consider first preservation of it and then how to compose it, as well as what settings to use on your camera when you shoot it.

In William Klein's *7UP, 2001* (www.eyestorm.com/secondary_works/detail/William_Klein/9791.html), he framed a 7UP sign that's attached to a tree. The metal is folded and filled with subtle imperfections. In the frame, the sign sits at the bottom, and part of the tree trunk sits at the top. The background is white, filled with leafless twigs. On the sign is "YOU LIKE IT...IT LIKES YOU." These words make the photograph compelling—they roll across the bottom of the sign as if they were singing. There are groups of bubbles floating around the sign. What's most powerful about the words is the personification of a soda drink—trying to imagine why a bottle of soda would like you.

Figure 17.1 shows a sign for a café called Orange Crush. The vivid text of the word "Crush" makes an already powerful word even more so. The lighting, too, seems different; it takes a second for the viewer to notice that the photo was taken with a flash. The harshness of the light makes the text stand out in seemingly another dimension. If you look at the image long enough, the "Crush" seems to pop out of the gray elliptical background. Finally, the wires and their shadows stretch diagonally across the bottom of the frame. They could be interpreted as signs of strength, as they hold the sign to the building to which the sign is attached.

Photograph Active Children

Klein often took blurred, grainy images of children. The blur was a result of his keeping the shutter open on his camera while the children were moving. No photographer with any clout had done that before. To some, it was shocking and unprofessional; to others, new and innovative. In a 1989 interview, Klein said, "I came to photography from the outside, so the rules of photography didn't interest me."

Figure 17.1 Graphics from old advertisements make compelling shots.

In *Girl Dancing in Brooklyn, 1955* (www.eyestorm.com/secondary_works/detail/William_Klein/9782.html), Klein photographed a girl on the street in a loose dress pleated at the waist. Her arms form a diamond with her head in the middle in the top third of the frame. Her body fills the frame from the below the waist at the bottom of the frame to a bit of white space just above her wrists, which are bent downward so her hands touch her head. The image is grainy and contains dark black areas. (See the next section, "Make Images Grainy.")

In Figure 17.2, a little girl is caught on a swing. Her image is blurred because the camera focused on the background as the girl swung through the frame. Her image is more out of focus than the girl's in Klein's photo because she is moving faster on the swing than a girl would move while dancing.

Figure 17.2 Blurring an object can show movement.

Make Images Grainy

Klein worked for *Vogue* as a fashion photographer, often taking his subjects out into the streets because of his inexperience with studio lighting. While this work is significant, it wasn't what got him the most attention. Klein worked with fast film (film at high ISO speeds, in digital-speak), often overexposing and blurring his shots—techniques that other photographers of the era avoided and that made him controversial among his peers. Klein has been called an anti-photographer because some thought that his shots were taken carelessly.

Part of his photographic process was experimenting with different film and printing on different papers, often coming up with mistakes that ended up being compelling photos.

In the photo *New York, 1954* (www.metmuseum.org/toah/images/h2/h2_1989.1038.2.jpg), Klein photographed a woman turning around in an instantaneous moment. She smokes a cigarette with a long cigarette holder. The photo is grainy and soft with dark blacks and blown highlights. This was signature Klein, a photographer who put new meaning into capturing a moment in time by creating an ethereal haze as part of his image.

In Figure 17.3, the actress Mamie Van Doren was photographed coming into an art opening. The image was blurred due to the movement of her head. To make the image look ethereal, I added noise and increased the highlights and shadows. For instructions about how to do this, see the "Photoshop an Ethereal Feeling" sidebar.

Figure 17.3 Grainy Mamie Van Doren photo taken in Palm Springs, CA.

Form a Relationship, However Brief, with Your Subjects

William Klein frequently interacted with his subjects before taking their picture. He got them to act out a role in front of the camera, yet the subjects chose the role they wanted to play. He'd often use a wide-angle lens and place it very near the subjects he was photographing, causing them to either dance (refer to the "Photograph Active Children" section earlier in this chapter) or duck, as in the image *Two Girls, 1961*.

Many of his photographs included a prop, often a gun, such as *Gun 1, New York, 1955* (artnet.com; type "gun 1955" into the Search box)—a photograph of a boy pointing a gun at the lens with another, smaller boy looking on from the side. The boy with the gun has an expression of disdain on his face. The boy's fist wrapped around the gun is much bigger in the frame because of its close proximity to the lens. In another shot, *Gun 2, Little Italy, 1955* (www.masters-of-photography.com/K/klein/klein_gun2_full.html), a gun held by an adult (whose head is out of the frame) is pointed at one of two children, a boy and girl, who are standing close to one another in the right part of the frame. The gun is pointed at the boy as he holds the adult's hand. There's also another child next to the adult, in the left side of the frame.

PHOTOSHOP AN ETHEREAL FEELING

You can take a normal photo of a person, turn it into black and white, add blown highlights and dark areas, and create noise in the photo to emulate Klein's style, as shown in Figure 17.4. This process has been applied to fast film.

Here are the Photoshop/ Elements steps to do this:

1. Image > Adjustments > Black & White.
2. Image > Adjustments > Levels. Slide the middle slider to the right until part of hair becomes solid black.
3. Filter > Blur > Lens Blur. Tweak the sliders in the Iris section (Radius, Blade Curvature, and Rotation) and then tweak the noise.

Figure 17.4 You can create an ethereal feeling using Photoshop.

All three children have wide, welcoming smiles. This photo is great narrative. It's playful and engaging and remarkably framed.

In Figure 17.5, there are two boys in a corner of a building huddled next to each other, one smoking a hookah. Before I took the shot, I asked them if I could take their picture, and then I asked them to smoke the pipe. The boys obliged me. During the shot I had to talk to them because they weren't doing anything. Then one boy made a fist with his thumb through it to the frame, while the other boy did as directed—he smoked the pipe. At the moment I caught the shot, the boy making the fist stuck his tongue out, which was picked up by the camera.

Although I didn't get the smoke I wanted from the pipe (I'm not sure whether it was lit), I did get other interesting results, which I would have never gotten if I hadn't had the gumption to ask the boys if I could take their photograph.

Figure 17.5 Boys smoking a hookah in Berlin.

Lange captured complex facial expressions in the way this image has.

Dorothea Lange (1895–1965)

No photographer has presented a look at America during a specific era like Dorothea Lange did during the Great Depression. Her work made people aware of the suffering that was occurring in the rural areas of America.

Lange opened a portrait studio in San Francisco in 1918. She moved her work to the street when she discovered the number of people who were becoming homeless and out of work in San Francisco. In 1935, she joined the FSA to photograph the suffering that was occurring as a result of the Depression. In 1939, she published a book of her photographs titled *American Exodus: A Record of Human Erosion.* She also documented the Japanese internment during World War II. In the 1950s, she did assignments for *Life* magazine.

Throughout much of her career, Lange photographed with a large Graflex camera and tripod. The camera produced 4×5 negatives. She also used an 8×10 camera. In some of the shots of Lange, she's holding her 8×10 camera, and it has a stovepipe viewfinder that's a good foot tall, making it about waist level for some of her shots.

Photograph Signs of Poverty

Lange photographed the suffering of people brought on by the Great Depression. She documented the suffering that poverty can bring. To catch these types of images on the street, you have to be quick and have a fast lens (with a wide aperture of at least f/4) that focuses quickly. When you're in the field, you step back and zoom in for close-ups.

The expressions of Lange's subjects showed suffering, offering a glimpse into a life with just enough to survive—the slight frown, the squinting, puzzled eyes, the slightly tilted head, or the hand on the face, all indicative of worry and survival.

In *Woman of the High Plains "If You Die, You're Dead–That's All." Texas Panhandle, 1938*, Lange photographed a woman with one hand on her head and the other on her neck. The woman is thin and wears a smock-like dress. In the background is the sky, which covers most of the frame behind her. There's a small strip of land at the bottom of the frame. It's evident that Lange stooped down to take the photo, pointing the camera slightly upward to give the woman such a large stature.

Finding people struggling is not an easy task. You can photograph the homeless in U.S. cities and/or photograph people in a third-world country to get images similar to Lange's. I believe that one of the main aims of images of people who are homeless or who live in poor countries is to get the viewer to see, feel, and try to understand what it's like to be them.

In Figure 18.1, a woman sits in the main plaza of St. John's. The background is stark, so the woman's features stand out. (You always want to photograph the person away from a busy background if possible.) Because the woman was sitting down, I was able to frame the photo with the ground as the background. Of special appeal in this photo are the woman's hands. Her fingers are spread out, and some touch one another. Her outfit is makeshift—a T-shirt over which she wears a tank top. The tank top has the names of the islands printed on it. Also noteworthy is the serious, tight-lipped facial expression, similar to the expression the woman of the high plains wears in Lange's photograph.

Figure 18.1 A woman in Antigua, West Indies.

Shoot Inside of a Streetcar

Lange shot the San Francisco cable cars in the mid 1950s. Lange wrote of the cable car: "The cable car is almost like an animal owned and ridden personally like the passenger. They hop on and off as on and off a little pony saddled and ready to go...." She photographed cable cars from outside and inside.

THE SOFT-FOCUS LENS

The distraught mother in the portrait *Migrant Mother, 1938*—one of the most compelling photos that represents the Great Depression in the United States—has two daughters whose heads are turned away from the lens, one on each shoulder, and a baby on her lap. The image, taken in Nipomo, California (on the central coast northwest of Santa Barbara), was one of a series of migrant farm workers. Blow that image to 100-percent resolution on a computer screen, and it's soft. Not ordinary soft, but a controlled softness only gotten by using a special lens.

Many of Lange's portraits have a soft focus because she used a special type of lens—a soft-focus camera lens. She probably used a Rodenstock Imagon (soft-focus) lens with the Graflex camera she was known to have used to take the picture. With this type of lens, she had to shoot at many different apertures because the extent of the softness was unpredictable. You can see the softness that such a lens can bring to the frame in her image, *Migrant Mother* (http://www.loc.gov/rr/print/list/128_migm.html).

You can buy a soft-focus lens at photography shops and at Amazon.com. The Canon EF 135mm is a lens that can take pictures in soft focus (it also takes sharp images) by twisting a ring. When the ring is twisted, the camera shoots with a spherical aberration over the sharp image, which makes the image soft. Reviews of this lens have pointed out that there's nothing you can do in Photoshop like the effect you can create from the lens.

In *Streetcar Faces*, there is a woman occupying a third of the left side of the frame. She sits next to a divider, part of which has four horizontal bars behind some glass, that leads to an entryway where a boy stands. Sunlight comes in through the window next to her and extends through the frame over her and to the boy. Behind the glass divider and bars, there is the back of a man with a hat on.

Let me first say that photographing in cable cars is not easy; people tend to look away when you hold up your camera, especially if it's a dSLR of any size. To get shots of some of the people looking at the camera, you first have to look as if you are taking a picture of the car's interior. Figure 18.2 shows a shot that was taken from the back of a cable car with the camera aimed toward the front. In the first few shots I took of the scene, no faces showed up in the frame; everyone was looking away. I took a few more shots after waiting a minute or two for the conductor to turn around. He did, and so did the young man in the foreground, which made the shot a bit more interesting.

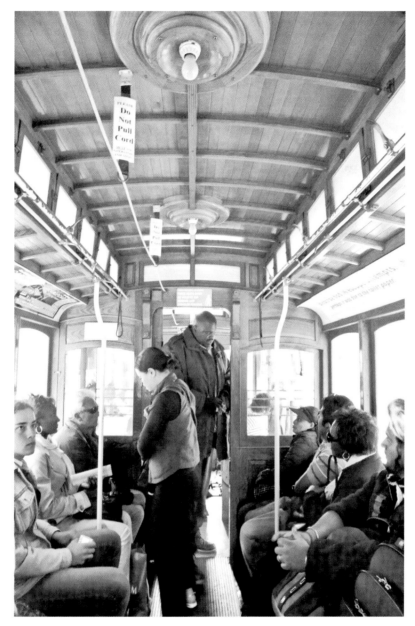

Figure 18.2 Compelling images can be caught inside streetcars.

I didn't use a flash in the photo for two reasons: It's bothersome to many people, and I don't like the harsh light you get from it. There's plenty of natural light coming into the cable car to get a decent shot when you use a high ISO speed. In this shot I used ISO 800 and got a fairly sharp image—not bad considering the car was moving when I had the shutter open.

One last note: Before processing the photo in Photoshop Raw, it looked very dark—so dark that I could have deleted it, thinking the image was too far gone to save in post-processing. I didn't, though—instead, I got home and found that after increasing the Exposure slider in Photoshop Raw, the image lightened adequately without much noise.

Photograph a Café or a Restaurant Counter

The counter of a café usually has details that make for an interesting shot, from napkin holders to sugar dispensers. Many cafés are in old buildings, which have lots of character. When you're shooting inside, keep your aperture wide and set your focus point on an object or a person you find interesting. For a sharp shot, set your ISO speed to about 800.

Lange often framed her subjects from the back or side so you couldn't see their faces. In *Café Near Pinole, California, 1956* (www.houkgallery.com/lange/moma093.htm), there is a side view of a man who sits on a stool in the left part of the frame. The counter begins in the foreground. Two stools sit empty in front of the man. The man wears a cowboy hat and has his elbow on the counter and his face is blocked with his hand as he takes a drag on a cigarette. His sleeves are rolled up, and his back is muscular. In the right two-thirds of the frame is a wall, in front of which there is a fan on top of a cigarette machine. On the right side of the cigarette machine is a pay rotary dial telephone, and on the left is a coat hanger. Directly in back of the man is a large jukebox, which you see from the side.

A similar picture taken in Mexico (where there are lots of old cafés) shows the back of a man sitting in a row of stools with backs (see Figure 18.3). The stools are tightly packed, so you can imagine how close together people eat when the place is packed. Just as in Lange's photo, there are fine details worth noting. The man is stirring his coffee with a spoon; there are napkin holders and sugar dispensers on the counter. There's a milkshake machine at the top of the frame, and there's a woman working behind the counter with an apron on. Of interest, also, is that the man wears a plaid shirt, which is positioned in the left third of the frame. It breaks up the monotony of the rest of the solid colors in the photo.

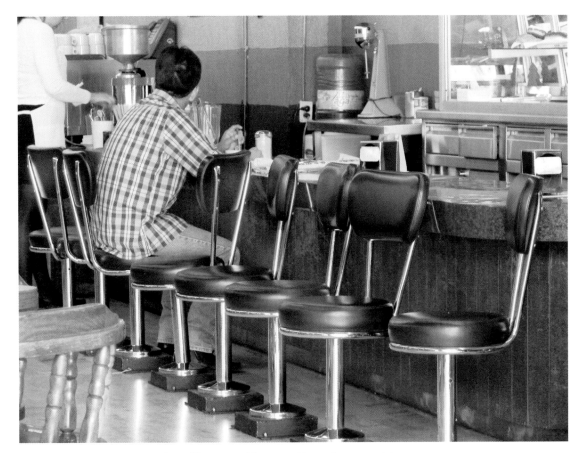

Figure 18.3 The counter of a café was used in one of Lange's compositions.

An example of what you can do similar to Laughlin using shapes and shadows.

Clarence John Laughlin (1905–1985)

Initially, Clarence Laughlin wanted to be a poet. While he was a bank teller, he wrote poems that he tried to sell. He went on to teach himself photography and build his own dark room. Although Laughlin dropped out of high school, he was a voracious reader, which affected his writing, making it elaborate and haughty in his lengthy captions for his photos. As a Southern photographer, Laughlin was known for his photographs of plantations. He also photographed the New Orleans levee system as it was being built.

Laughlin grouped his photographs by categories, which can be loosely described as follows: still lifes, marine and tree forms, industrialism, metal, glass, New Orleans fantasy, lost New Orleans, satires, lost people, visual poetry, Louisiana plantations, color, rocks, human anatomy, sculpture, objects, sense of space, Victorian architecture, and Europe. Laughlin once said, "It should be possible for even the photographer—just as for the creative poet or painter—to use the object as a stepping stone to a realm of meaning completely beyond itself."

Frame a Spiral

The Magnificent Spiral (No, 3), 1946 (www.iphotocentral.com/showcase/p_detail.php/153/1/0/0/14337) was taken at Afton Villa near St. Francisville, Louisiana. It was included in Laughlin's book, *Ghosts Along the Mississippi*. The photo was taken at an old plantation. The view is looking up (as is the view of the spiral escalators) so that the frame looks like the inside of a nautilus shell. The photo appears to begin in the bottom third of the frame with the railing and vertical wood supports, and a small part of the stairs marches upward until they almost disappear with perspective in the upper third of the frame. The spiral then continues inward until it circles around a lit light fixture in the middle, one-third down from the top of the frame (following the Rule of Thirds). Laughlin also took other shots of this staircase, including one from up above, showing the staircase going down, with stairs and railings surfaces visible. Laughlin took many images of this staircase and numbered each one.

In an image I emulated to look like Laughlin's, the thick line going through the frame in Figure 19.1 might throw you off because it seems to disrupt the flow of the spiral staircase in the frame. If you look at the image long enough, though, you'll find an optical illusion where the skylight is at the top. The circle that makes up the skylight appears to be broken, with the half on the right side displaced downward.

Make a Double Exposure

Many of Laughlin's works are architectural. He had been an architectural photographer after World War II. He used double exposures to create surrealistic images. Laughlin's *Ghosts Along the Mississippi* was a book of photographs and text of old Louisiana houses. He tried to capture the plantations before they were destroyed.

In *Besieging Wilderness, Number Two, 1938* (www.masters-of-photography.com/L/laughlin/laughlin_wilderness_full.html) Laughlin created a double exposure of a plantation overlaid with a huge tree with Spanish moss. The tangled branches of the tree look as if they are growing out of the house. Laughlin shot these images on film. A double exposure occurs when you set your camera to take two pictures on the same piece of film.

Figure 19.1 You can photograph spiral staircases or architectural elements from below, as in this shot.

For a double exposure to work visually, the two pictures should have something in common. For example, in Laughlin's image, both the tree and the mansion are located in Louisiana. The tree juxtaposed over the plantation house looks as if it is part of the front yard of the house. Figure 19.2 is a double exposure made up of two pictures taken in San Juan, Puerto Rico. In the picture, palm trees are overlaid on top of a Romanesque-style home. The palm trees look as if they are in the front yard of the house if you imagine you are looking at the picture in three dimensions.

Figure 19.2 Double exposures are easy to produce in Photoshop.

In digital photography, most double exposures are made in post-processing in Photoshop or Elements. See the following sidebar for an explanation of how to do it.

CREATING A DOUBLE EXPOSURE IN PHOTOSHOP

To create a double exposure in Photoshop/Elements, you first have to open the two images (which need to be the same size) you want to overlay on each other. Then:

1. Click on the Move tool in the Tools palette.
2. Click and drag on one image to move it over to the other.
3. Choose Window > Layers.
4. In the Layers palette, slide the Opacity slider so that the photos mix together to your liking.
5. Choose Layer > Flatten Image.

That's it! It looks more complicated than it really is.

CHAPTER 20
Helen Levitt
(1913–2009)

Helen Levitt never married. Over her lifetime, photography saw many changes. In the '40s, children played in the streets of New York City, making them easy subjects to photograph. Levitt was swept up by that opportunity, photographing children playing in the streets whenever she could. All of these images are in black and white because color photography had not yet arrived. By the '60s, color photography technology became widespread. Levitt didn't take pictures of children in the streets in color because by that time she couldn't find children playing in the street like in the '40s; as she put it, "they were inside watching television."

Levitt had her first solo exhibition at The Museum of Modern Art in 1943. She went on to work with Walker Evans, photographing inside the New York subway system. She not only photographed inside the stations, but also inside the subway cars. Levitt photographed with a Leica camera, to which she attached a right-angle viewfinder (an instrument to attach to a lens so that the shooter is facing in one direction and the lens in another), so that subjects were unaware of her efforts to photograph them. Although Levitt had no formal schooling in photography, she trained herself by going to the museum and looking at the compositions in paintings. Her street photography is among the best of the twentieth century. She published a couple of books, including *A Way of Seeing* and *In The Street: Chalk Drawings And Messages, New York City, 1938–1948*.

Photograph Children Playing

There's no doubt about it, Helen Levitt loved to take candid photographs of children. But did she actually love children? The answer to that question would be no. "People think I love children, but I don't," Levitt told Adan Gopnik in a 2001 article in the *New Yorker*. "Not more than the next person. It was just that children were out in the streets." Indeed they were when she photographed them in the 1930s and 1940s. She photographed them often on the streets of New York City. Levitt also once said, "I don't have kids, and I don't know people who have them."

In one photo, *New York, 1988* (she didn't name her photos), a large woman is crammed into a phone booth with two children.

One thing Levitt usually did with her photographs of children was to frame them from a distance. You'll also almost always see more than one child in the frame. She had a knack for finding formations of children that pleased the eye. In one such picture, she captured four African-American girls walking down on the sidewalk in the foreground next to an empty street that moves into a vanishing point on the right top side of the frame. Three of the smaller girls walk with their backs to the camera, and a larger, heavier girl walks just at the edge of the right side of the frame, separated from the other three. There is nothing else in the frame except a wall and street.

There's another point to note. Levitt has few photographs of children in color. By the time color photography came about in the 1960s, fewer children were playing outside; many were inside watching television in air-conditioned dwellings.

In Figure 20.1, a girl and boy are playing in the sand. The photo was taken at a sand castle attraction that takes place on a simulated beach every summer. In a similar manner to the way Levitt balanced a black boy with a white girl in one photo and three little girls with a bigger girl in the frame of another photo, a big boy and a little girl are balanced in the frame in this photo.

Figure 20.1 Children playing in the sand.

Getting this shot wasn't easy. I had to circle the sand play area several times, pointing my camera at the sand castles that were around the play area and then quickly shooting the play area several times as I worked my way around it.

Make a Near Match in Colors Duplicated in the Frame

In the color photograph *New York, 1971*, of a shirtless man, Levitt has the shorts of the man a near match for one of the colors of an umbrella over a nearby food stand. The man, who is bald on the top of his head, stands with his back to the frame with the support of a cane. He's looking to the left of the frame.

In other photographs, too, Levitt managed to find color as an important focal point in her photographs. For example, a child stoops down with the top of her head in front of the lens, body spider-like, in front of the tail end of a blasting lime-green car, with a baby-blue VW parked across the street and visible in the background. Or twin boys, about 12 or 13, facing each other in light-brown, button-down, long-sleeve shirts, holding light-brown pigeons. In the background is a black vent from a rooftop that divides them and also matches their hair.

In a similar image of a near-match color in Figure 20.2, a man dressed in light purple stands against a purple car. The pants and the jacket that is wrapped around the man's waist are a near match in color to the car. He appears to be posing for the shot, but he's not. He is one of a big crowd who are watching the millions of people run and walk in the Bay to Breakers foot race in San Francisco.

Figure 20.2 Matching color can play an important role when composing a photograph.

Find Animals in Configurations of Three

Levitt never lacked for getting interesting photos on the street. Although most of her photos were of children playing on the streets of New York City, sometimes she shot grownups and, yes, even animals.

In a color photograph, *New York, 1971*, (www.artnet.com/artwork/425928960/138991/helen-levitt-new-york.html) three roosters are walking in front of two rows of old kitchen chairs. Their combs (the red part on top of their heads) match four of the chairs on the left side of the frame. The bottom half of the frame contains nothing but dark gray, dirty pavement. The roosters are framed so that they are halfway up from the bottom of the frame (in front of the legs of the chairs). The chairs take up the top half of the frame.

In yet another photograph, *New Hampshire, 1983* (www.laurencemillergallery.com/Images/ levitt_sbs35.jpg), she catches three animals running in a line—a pony in front and a sheep and a goat following it. In that photo, the framing is flawless. In the background is a heavily wooded area. The rest of the frame contains a path on which the animals are running, lined by a patch of grass with an ornamental plant in the middle.

In Figure 20.3 there are three dogs visible in front of a Buenos Aires, Argentina, café. The dogs are brown, which coordinates with the brown tables in front of which they sit. If you look closely, there are also three people sitting that can be seen through the window of the café. You also can't miss that the dogs are engaging in some cleaning up of themselves.

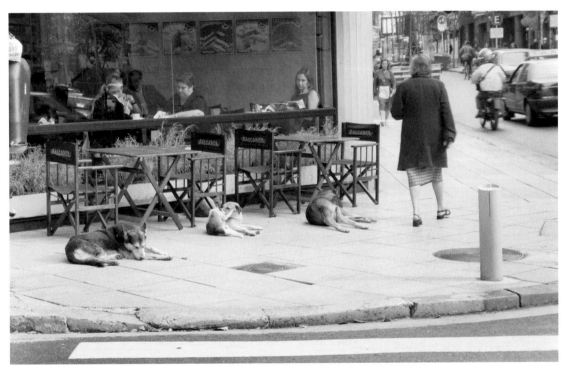

Figure 20.3 Levitt photographed three roosters in a similar configuration to these three dogs.

Find Chalk Drawings on the Sidewalk or Building Walls

Levitt was one of the first photographers to shoot graffiti. At the time (in the 1940s), people used to write and draw on walls and the street with chalk. Levitt photographed these scrawlings, which ranged from detailed illustrations of women, to kids on bikes, to four-letter words in script, to pictures interacting with items on billboards. The drawings lasted only until precipitation began to fall.

Of the scrawlings Levitt spotted, many were interesting perspectives of life in the city. Some included:

✳ Have you got a jolly face?

✳ I love you Newton, By Mere scoot

✳ A decetive lives here

✳ I am a killer

✳ May and junior wet out to the stor

✳ An spent 10k; a trew story

✳ Ruby loves Max but Max hates Ruby.

A book of these drawings—*In the Street: Chalk Drawings and Messages, New York City, 1938–1948*—was published in 1987.

Figure 20.4 is a chalk drawing of SpongeBob photographed at a block party in Philadelphia, Pennsylvania. To this day, the tradition of drawing on the street with chalk continues. During a walk through the streets of many Eastern and Midwestern cities on any non-rainy/snow day, you can find chalk drawings somewhere.

Figure 20.4 Drawing pictures on the sidewalk is popular in Eastern Seaboard cities.

Find a Window with a Subject Looking Out

Levitt photographed the poor and working-class neighborhoods of New York City. One photo op she sought was people looking out from their apartment building windows. This is a kind of photo op that looks easier to do than it really is. You can easily end up playing a game of cat-and-mouse if the person looking out the window sees you.

In Levitt's version of the looking-out-the-window photo op, she has an African-American woman looking out a window lined with pleated curtains. Other than the curtains and the woman, the inside of the apartment shows up black. The palm of the woman's hand shows up much lighter than the rest of her and provides a near match to the color of her tight, long-sleeved blouse. There is an empty glass in front of her on the ledge of the building. The woman is placed just off center in the frame.

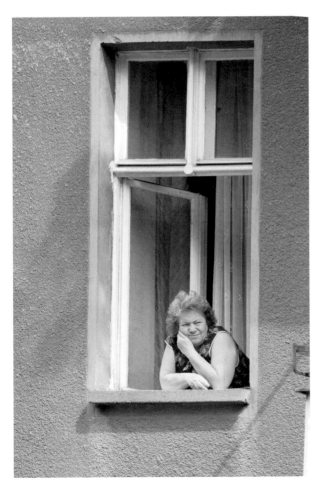

While Levitt's photo of a woman looking out a window was orientated as a landscape, the photo in Figure 20.5 is orientated as a portrait. Like Levitt's portrait, the woman leans over the sill with her hand on her face, but her palm faces inward. Both images show working-class people.

Figure 20.5 A woman looks out of a window in an old apartment building.

WHAT'S UNDER THE HOOD?

If Levitt saw empty chairs on the street or a car hood open, she knew that people would appear, and sometimes she would wait around until they did. Levitt took a photograph of a '70s two-door red car with blue doors. The image shows a man leaning under the hood and the legs of another man coming out next to him.

Think of how many times you've passed someone working on a car and never thought to take a photograph of it. I can think of many, so after I saw this image of Levitt's, it wasn't hard to find a person working on a car, especially on the outskirts of downtown Los Angeles. Figure 20.6 shows my version of this unique task, which a passerby probably wouldn't notice, even though the size and space such a task occupies would seem to warrant someone's attention. Finally, in most cases, this is a working man's task. A wealthy person most likely would have someone else work on the vehicle.

Figure 20.6 Man works under a van.

Robert Mapplethorpe (1946–1989)

Probably the most lurid photographer of the twentieth century was Robert Mapplethorpe. His work generated controversy and skepticism among the public because it contained staged acts of human eroticism. These images, which were only a part of his portfolio, had been accepted by galleries and museums, only to bring about a heated public discussion of what kind of art should be publicly funded by the U.S. government. While some of his images displayed overt sexual acts, others were beautifully crafted nudes of both men and women. His portraits range from head shots of Andy Warhol to profiles of himself in drag. He even photographed Arnold Schwarzenegger in a bathing suit. He began painting and drawing when in art school. Robert Mapplethorpe's portrait of Andy Warhol is among the top 10 photographs that sold for the most money.

Mapplethorpe grew up in Queens, New York. He started out in art by making sculptures in the 1960s. He went on to do mixed-media work, finally moving on to only photography. He first used a Polaroid camera and then moved on to a Hasselblad medium-format camera. Mapplethorpe acquired AIDS when very few treatments were available. His explicit pictures of the disease stunned people with regard to its complications, including red-blue raised blotches on the skin all over the body associated with the condition of Kaposi's sarcoma. A year before he died of the disease, he established the Mapplethorpe Foundation to raise awareness of photography as an art form and to fund AIDS research.

Shoot the Heads of Statues as Profiles

By the 1980s, Mapplethorpe photographs became less sexual and more classical. He took portraits of people and also shot statues, making them look human-like by photographing them as if they were alive. He used cool studio lighting (lighting that produces little heat) and added contrasting backgrounds to complement his subjects, including statues.

Usually, the first thing one considers when photographing a statue is getting the entire piece in the frame. That's not necessarily the most compelling way to frame the photograph. When you consider an entire statue as if it were a live person, many more ways to frame it become apparent. In 1988, Mapplethorpe shot a statue of Apollo, including only the eyes, nose, mouth, and chin in a side portrait. The statue is in the left two-thirds of the frame looking right. The right part of the frame—the background—is pitch black.

Figure 21.1 shows a statue framed as a profile with a black background. You can photograph whole-body statues in parts, from framing the face as a profile by zooming in on the side of the face, to framing only the torso by eliminating the head and legs from your frame.

In Mapplethorpe's *Spartacus, 1988*, a statue is framed from the hips up to the head with a little added head room at the top. In *Sluggard, 1988*, a statue with flexed biceps is framed from the groin up to just past the head.

Make a Black Background for a Flower Image

Mapplethorpe often would frame a flower so that the stems would come out from the side or corner of the frame. In *Orchids, 1989*, he brings a group of orchids attached to a stem into the frame from right corner of the frame. He also uses a black background for these white flowers. He takes the same approach with one calla lily in *Calla Lily, 1987*.

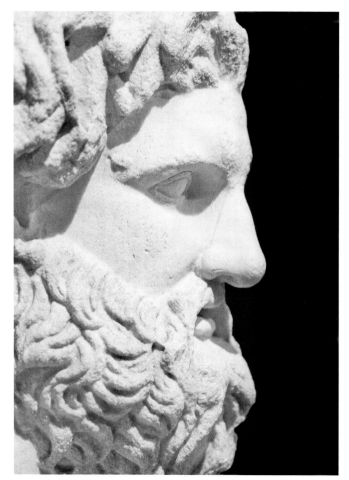

Figure 21.1 Give a statue a fresh look by photographing its profile.

> **NOTE**
> You can go to www.mapplethorpe.org/portfolios/flowers to see a slideshow of
> Mapplethorpe's flowers.

Mapplethorpe was fond of orchids and calla lilies. He almost always included the entire flower in the frame, not cropping a bit of it out. Many of his images of these flowers had near-solid backgrounds that were slightly textured. To provide a texture for your backgrounds, see the upcoming "Making a Gradient Background" sidebar.

The flower in Figure 21.2 has a black background, which is textured ever so slightly to give the background more depth.

Here are the steps to make this background in Photoshop/Elements:

1. Make your foreground black and your background dark gray.
2. Choose Filter > Render > Clouds.
3. Choose Filter > Blur > Surface Blur, adjusting radius and threshold to your liking.
4. Repeat as necessary for uniformity by choosing Filter > Surface Blur.

You can either use a black background for a portrait or use Photoshop to make a black background for a portrait. (See the following sidebar.)

Figure 21.2 This photograph shows an example of how some of the backgrounds of Mapplethorpe's images looked.

MAKING A GRADIENT BACKGROUND

To make a gradient background:

1. Navigate to New > Background from Layer.
2. Click on the Magnetic Selection tool in the Tools palette.
3. Enter 2 px for your Feather value in the top of the window.
4. Select the flower by clicking and dragging around it with the Magnetic Selection tool.
5. Navigate to Layer > New Layer.
6. Select Inverse.
7. Click on the Gradient tool. (If the Paint Bucket tool is showing in the Tools palette, hold the click until you see the Gradient tool show up in a small drop-down menu bar and then click on it.)
8. Select black as the foreground color and navy blue as the background color.
9. Click and drag from the top to the bottom of the image.
10. Choose Select > Deselect.

In *Anemone, 1989*, Mapplethorpe created a gradient background for a purple flower, which extends from a stem placed in a vase. The gradient background goes from black at the top of the frame to medium gray at the bottom. The vase matches the background with gray tones and white tones. You can make this kind of background in Photoshop. (See the preceding sidebar for directions on how to do this.) In another image of an orchid that is the same color (but not the same shape) as what you see in Figure 21.3, Mapplethorpe created a gradient navy blue background. In Figure 21.3, I've re-created this using Photoshop.

Frame a Subject Covering Her Face with Her Hands

In Mapplethorpe's image of Kathy Acker (a feminist novelist and poet), he has her modeling topless with her eyes covered. You have to study the photo to notice she's topless, as she has a shirt on, but it's cut so low that her breasts are exposed yet covered up by her arms. The image puts the focus on the hands and body of the subject. It's quite an unusual effect.

You don't need expensive studio equipment to shoot this and other similar portraits. All you need is a camera where you can adjust the ISO speed, some light coming though windows, and a bare wall facing the windows. Don't worry about shadows on the wall; those can be taken out later in Photoshop.

Figure 21.3 Orchid with a gradient background.

To take the image, set your ISO speed to 800. Position your subject as shown in Figure 21.4. Make sure the subject's hands are relaxed. If the subject's hands are tense or squeezed, that will show up in the photo. If you have a telephoto lens, step back and shoot at about 150mm, framing all of the body above the knees.

GETTING RID OF SHADOWS IN PHOTOSHOP

To create an image like Mapplethorpe's, you first have to convert your photo to black and white (see Chapter 1) and then get rid of any shadow around the subject. After you've converted the image to black-and-white:

1. Choose the Magnetic Selection tool.
2. Click and drag around the subject where the shadow begins. Then click and drag around the shadow on the wall until you've got it all contained within the selection you've made. Click on the Clone Stamp tool and set your source point in an area of the wall that's at the same height as the selected area. Click and drag until the selected area is filled in. Note that you might have to choose new source points as you go.

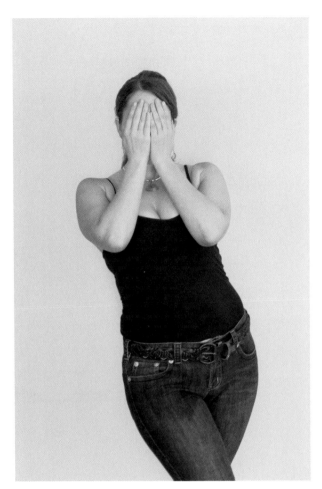

In Figure 21.4, a model assumes the same pose as Kathy Acker (www.psmuseum.org/ content_files/ exhibitions/robert_mapplethorpe/ kathy_acker.jpg) did in Mapplethorpe's photo. This was a handheld shot. It came out sharp because I used a wide aperture (f/2.8) and I placed the subject where she got light from windows that were both in front and on the side of her.

Figure 21.4 Framing a subject with her hands covering her face can make a quite provocative image.

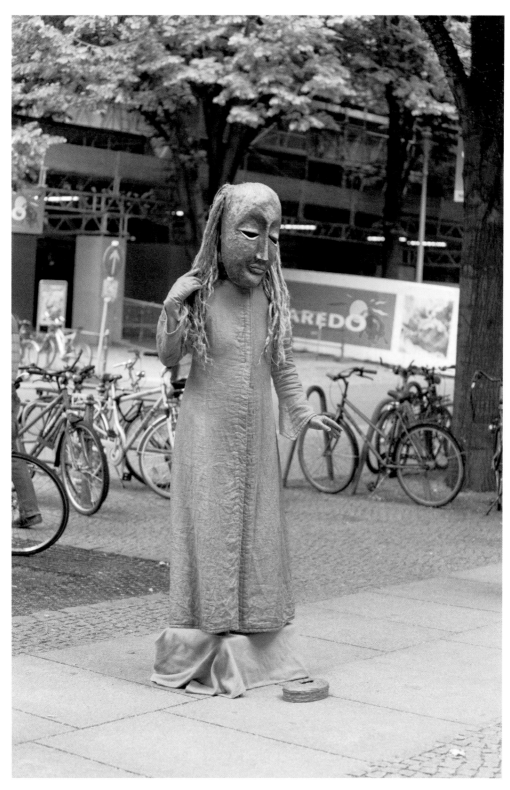

Masks add a touch of surrealism to an image.

Ralph Eugene Meatyard (1925–1972)

R alph Eugene Meatyard was a devoted family man whose artistic creations represent an odd portrayal of family connections. As an optician, he worked for an optical company that also sold photography equipment, which he eventually used for his own photography. After he opened his own practice, Meatyard displayed his photographs in the waiting room of his office. He photographed family members in his neighborhood, often in abandoned buildings and much of the time wearing masks. His mask photographs are among his best known. He died at age 46.

Photograph Subjects Wearing Masks

One might wonder why a devoted family man would photograph people wearing masks. As the *New York Times* put it in a 2004 article, Meatyard wanted to "capture the mysterious, inexpressible ties among people." Meatyard got the idea to use masks in his work from the Belgian painter, James Ensor.

Meatyard photographed people wearing masks in different Kentucky settings, such as in front of the back of a pickup truck, in front of the side of a house, at the entrance to a stairwell inside, in a garden, and in front of two windows. In one better-known photograph, *Romance of Ambrose Bierce #3* (www.mocp.org/collections/permanent/meatyard_ralph_eugene.php), four boys sit randomly on steps. Under each step are the repeating numbers 1, 2, 3, 4, and 5. All the boys are wearing masks similar to those seen in Figure 22.1. In another noteworthy photo, Meatyard and his wife switched clothes. Most of Meatyard's subjects are shown standing or sitting. He never photographed the masks up close.

Figure 22.1 Cruise ship passengers wearing masks.

Figure 22.1 shows two passengers on a cruise ship who donned masks for a Halloween party. While the photograph isn't a full-body portrait where you can see the environment around the subjects, like in Meatyard's photos, it does have similar masks to what Meatyard had his subjects wear. Most important, the masks show a connection between the man and woman behind them. (They are a married couple.)

Make a Silhouette in Front of a Window

In the 1991 book *Ralph Eugene Meatyard: An American Visionary*, there's an image, *Madonna, 1964*, of a woman and child who face each other in front of blinds (www.geh.org/ne/str085/htmlsrc8; scroll down to the Madonna image). The blinds are closed except in the area near the women's head, where they have been pushed open so that a blast of light comes in through lines that are curved downward. The child's chin is set just below the woman's waist.

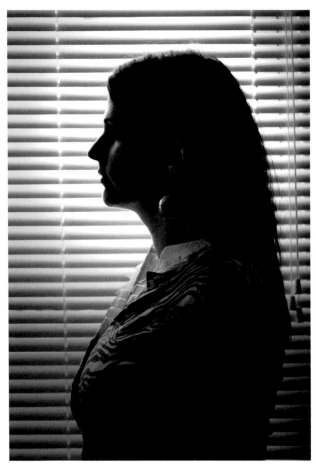

Creating a silhouette in front of a window is easy; you just have your subject stand in front of a window and shoot into the light coming from it. With one subject the effect works quite nicely. In Figure 22.2, I placed my subject in front of a window with light coming through so I could produce a silhouette, which I eventually put into Photoshop to tweak the lighting to make it similar to Meatyard's lighting in the woman and child portrait.

Figure 22.2 Photographing subjects inside in front of windows creates silhouettes.

Although the light isn't the result of the blinds being pushed open, it does resemble an effect that could be caused by the sun shining on the window. To create the effect, see the following "Manipulating Lighting Effects" sidebar.

MANIPULATING LIGHTING EFFECTS

To create a blast of light, make sure that Photoshop is set to RGB color and 8 Bits/Channel. You can do this by navigating to Image > Mode > RGB Color and Image > Mode > 8 Bits/Channel. Now, choose Filter > Render > Lighting Effects. Although in Meatyard's photo the blast of light is centered behind the woman in the photo, I centered the light in my photo so that it was behind the taller window, so the light was increased around the subject. To do this, in the Lighting Effects dialog box, I chose Omni from the drop-down menu and adjusted the Properties sliders to my liking (as you can do to your liking). At that point, I wanted to light up the entire frame a bit. I did this by adjusting the Levels (Image > Adjustments > Levels) sliders.

Lisette Model
(1901–1983)

Model came from wealth, and like many photographers of her era, she studied painting before becoming interested in photography. Her subjects often knew she was taking their picture and didn't necessarily want to have her do so, making them appear resistant in the image. Model once said, "We photograph not only what we know, but also what we don't know." She also said, "Never take a picture you are not passionately interested in."

Model began photographing after she met her painter husband, Evsa Model. Model's first published work was a set of storefront windows with reflections on them. Her first photography experience was shooting on the street at Promenade des Anglais in Nice. There she caught all types of interesting subjects in full-body portraits, often sitting down and often amusing. Model was fond of shooting late in the day, a time when the light is just right to get good portraits without flash. Finally, many of Model's subjects were obese. In America today, subjects like these are not difficult to find.

Model knew many well-known artists and performers, and her photographs appeared in many magazines. Her images appeared in the *Saturday Evening Post, Vogue,* and *Popular Photography* magazine. During World War II, her images of a New York rally were published in *Look* with writer Carl Sandburg writing the text for them.

She also photographed celebrities such as Louis Armstrong, Dizzy Gillespie, and Ella Fitzgerald.

Photograph a Pair of Elderly Women

Model would photograph very different types of people, mostly elderly from contrasting backgrounds. On the wealthy end of one of Model's photographs are two women decked out in nearly identical light-colored overcoats and similar teased hairstyles on a park bench—just one of her many visions of the rich. Each woman wears big glasses and gloves on hands while clutching their bags close to their body. In contrast is an emaciated, elderly man who lays half on the top of a wall and half on the grass that extends from it. His hat is tilted off his head, and his hand rests on his face, creating a down-on-my-luck kind of feeling. Both images were shot in San Francisco's Union Square in the 1970s.

You can spot an elderly pair of women almost anywhere. It's best to have your camera with you at all times and be on the lookout for well-dressed elderly women. On a recent trip to LA, I ran into a group of Japanese people in a lobby, which was very crowded at the time. In the crowd I spotted two elegantly dressed women that I immediately knew would be perfect subjects. I had two cameras with me, but no flash unit. I wanted to get a sharp shot, and I knew it would be dicey in that lobby even at a high ISO speed, so I opted for my Canon Digital Rebel, which has an in-camera flash. I asked the women whether I could take their picture and pointed to a nearby couch where they could sit. The women obliged cordially. Everyone else in the crowd politely moved out of the way so I was able to frame the women and the couch using the Rule of Thirds. (Note that in Figure 23.1, the women are placed one-third from the left edge of the frame.) The contrast between their outfits is interesting in that each reflects the light from the flash differently. The outfit on the woman on the left appears to be almost glowing in the frame.

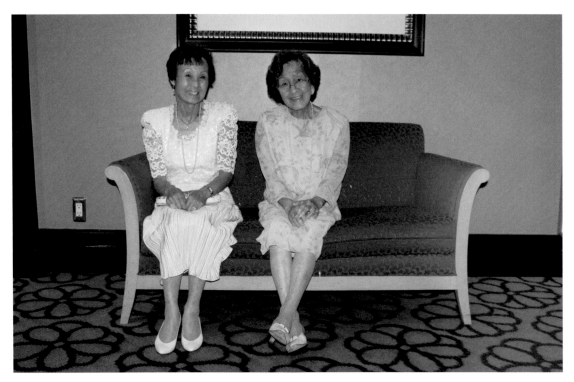

Figure 23.1 Model photographed both wealthy and poor elderly subjects.

Frame Only the Bottom of People's Legs

One photographic technique Model used was to set the camera on the curb and photograph people's legs walking by. In *Legs Walking, 42nd Street, New York, 1940/41*, Model created a scene of just legs walking. The blurred legs of a woman appear in the foreground, with the crowd's legs sharp in the background. In another image of the *Running Legs* series, one woman's leg shows up in the frame with a 1930s-style black car in the background. At the very top of the frame is part of an American flag.

To get a similar shot to Model's, you have to set your camera on the curb next to the street and aim it at the people walking by on the sidewalk or set your camera on the sidewalk close to a storefront and aim it toward the sidewalk. When people walk by, you keep snapping your camera to get a series of fascinating shots.

After I followed the steps just described, I came up with the image of one leg in Figure 23.2. It's kind of a modern version of Model's image—a man instead of a woman and a modern black car. When I saw that black car (in the background), I immediately set my camera near a storefront so that the foot traffic was in front of the car.

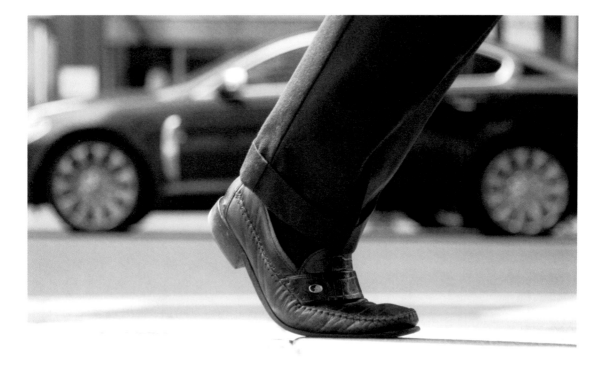

Figure 23.2 Setting your camera on a curb facing the sidewalk on a busy street yields compelling results.

Note that because there's a lot of movement here, you need to use a wide aperture for the shot. (I used f/4.) Since I set my camera to Aperture Priority mode, the wide aperture was accompanied by a fast shutter speed...faster than at other apertures, allowing a sharp focus on the foot. Finally, you have to consider focal length. I shot this with a 24-105mm L series Canon lens at 75mm.

CHAPTER 24
Tina Modotti (1896–1942)

Born in Italy, Tina Modotti moved to the United States when she was 16. She moved to San Francisco, where she became a seamstress for a department store. She then moved to LA, becoming a model and actress. After living in LA, she moved to Mexico during a significant time in the country's history. It was a time of revolution and change. Tina Modotti was at the forefront of the change, creating a set of photojournalistic images that are some of the most memorable photographs of Mexico taken in the twentieth century. Modotti was friends with Frida Kahlo, another revolutionary artist. When in Mexico, she became a communist, fighting for worker's rights. She also became Edward Weston's model and then partner. He took a number of erotic photographs of her. Modotti documented the works of master muralists José Orozco and Diego Rivera and some of the events associated with Mexican political movements.

Photograph a Large Group Wearing Hats

In the 1920s, Modotti had become deeply involved in the worker movement in Mexico, a large group that consisted of mostly men who fought for worker's rights. Although she did photograph women, many of her best-known works are photographs of men, from the close-up of a workman's hands on a shovel (1928) to images of the peasants of rural Mexico.

Modotti's photographs of the poor in Mexico are among her best works. A sea of hats occupies the frame in *Workers Parade, 1926* (www.lensculture.com/webloglc/images/folgarait_3.jpg), a photograph that shows the tops of hundreds of wide-brimmed sombreros that many of the workers wore at the time. In the frame of that photo, the hats contain circular shapes so it looks as if the frame is covered in circles. Modotti had an eye for shapes, from circles outlining the shapes of the hats as seen from above, to curves, shadows, and lines when you look at other photos of the workers from different perspectives. In one photo of a few of the workers, Modotti concentrates on the curves the hats make by photographing them up close, leaving no one hat showing up entirely in the frame.

In Figure 24.1, a group of men—many of them wearing hats—gathers to listen to a speaker in Bolivia. What makes this photo compelling is that the hats present an array of shapes throughout the frame. From the circles and curves of sharp-brimmed hats and baseball hats in the foreground to the softened shapes in the background, the hats stand out as the primary focus in the frame.

Photograph Multiple Telephone Wires

Utility wires are the main subject in Modotti's 1925 photograph, *Telephone Wires* (www.masters-of-photography.com/M/modotti/modotti_wires_full.html). More than 100 thin wires move from the top of the frame downward to a telephone pole at the bottom of the frame. The phone pole contains eight dark vertical lines that show up in the frame, tilted counterclockwise. Soft clouds make a compelling background.

The most important aspect of photographing phone wires in the way Modotti did is to exclude any other objects from the frame. Keep trees, land, and buildings out of the frame as much as possible. Figure 24.2 shows power lines with little of anything else in the frame. (There is some vegetation at the very bottom of the frame, but it's negligible compared to the space the power lines take up in the frame.)

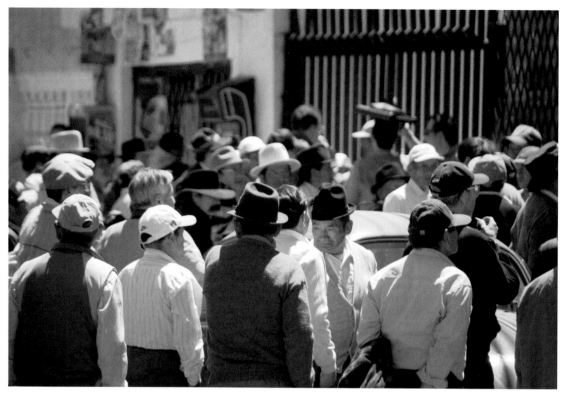

Figure 24.1 Group of workers in Bolivia.

If you photograph telephone wires or power lines so that the sun is behind them, they'll be silhouetted against the sky. At sunset, phone wires can be a real landscape treat with the various shades of orange (or grays, if the photo is in black and white) you get with the sunset.

Power lines and poles provide photographers with the opportunity to sketch with lines that have been engineered solely for the purpose of getting power from one place to another. When you photograph the poles and lines, you get a chance to show perspective in your frame.

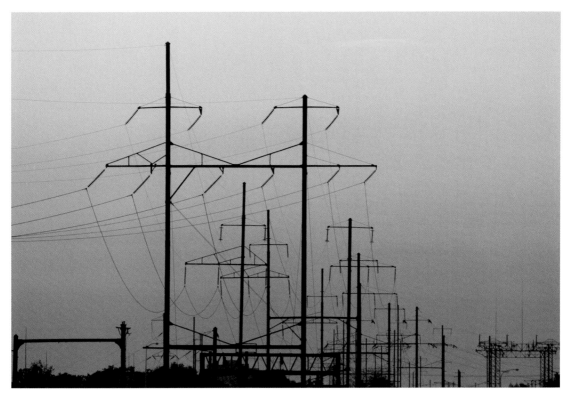

Figure 24.2 Fitting only power lines into the frame can create interesting designs.

Arnold Newman
(1918–2006)

Considering the surroundings of your subject can help make or break a photo. You have options to stage photos with surroundings that seem natural for your subject, or you can choose to place your subject in his immediate surroundings. For many shots, Arnold Newman chose one or the other, depending on who the subject was. If it was a president (he photographed many), he'd make sure to include things in the frame that would make you know that (such as photographing in the Oval Office with presidential artifacts in the frame). If it was an ordinary person, that person would be included in the frame along with his immediate surroundings, objects and subject carefully placed in the frame. For example, he photographed Ronald Reagan in the Oval Office and Martha Graham in her ballet studio.

Newman spent part of his youth in Florida. At first he wanted to become a painter, studying and engaging in the subject at the University of Miami. Not having enough money to finish school, Newman went to Philadelphia, where he worked as a portrait photographer. His interest in photography took off as he learned the ropes of the profession. Newman went on to photograph for *Harper's Bazaar*, *Newsweek*, and *Life*, photographing many celebrities, such as Andy Warhol, Lyndon Johnson, Henry Miller, Ronald Reagan, Moshe Dayan, Ansel Adams, Zero Mostel, Truman Capote, Rupert Murdoch, Gordon Parks, John F. Kennedy, Marilyn Monroe, Brassaï, Georgia O'Keeffe, Andrew Wyeth, Marcel Duchamp, Bill Clinton, Martin Scorsese, Lillian Hellman, Walter Cronkite, Dr. Jonas Salk, Gerald Ford, and Yasser Arafat.

Frame Porches with People

Although Arnold Newman was known for his still lifes and portraits of famous artists and presidents, he also photographed people and street scenes around him. He wanted to capture people in their surroundings, places where they spent a lot of their time. He owned a portrait studio in West Palm Beach, and he photographed around that community.

In *Two Men and a Dog, West Palm Beach, 1941* (www.arnoldnewmanarchive.com/Portfolio_ EarlyWork.swf; click on the third thumbnail), Newman framed two African-American men sitting on the porch of a frame house. They sit on chairs on either side of a doorway, and the door is open so viewers can get a peek inside the house. A dog looks on, ears perked, at the man sitting in the left side of the frame, who's apparently eating something on a plate. The other man sits with his legs spread apart, extending beyond either side of the chair. His hands are folded in front of his groin area. It's a scene that might have surprised many at the time, because the Palm Beach area was known as a resort for the rich.

The same general attitude exists today about the Caribbean. When one thinks about the area, there's a general feeling that it's paradise—glittering city streets by the seaside. Many people are shocked that once they get there (most of the time by cruise ship), it's not the paradise they thought it would be. The islands are mostly Third World places where the majority of the population is very poor.

In Figure 25.1, two Afro-Caribbean men are seen on a porch in front of a frame shop/home on the island of Antigua. The man on the left sits as he fools around with a transistor radio, and the man on the right leans against the rail as he interacts with the photographer. (He's joking around that he wants money for the photo.) The man runs a watch repair shop, hence the clocks that can be seen inside the shop (and the sign). The photo's purpose is to show the men where they live—a study of their surroundings, a part of Caribbean island life that is often not shown in the cruise travel brochures.

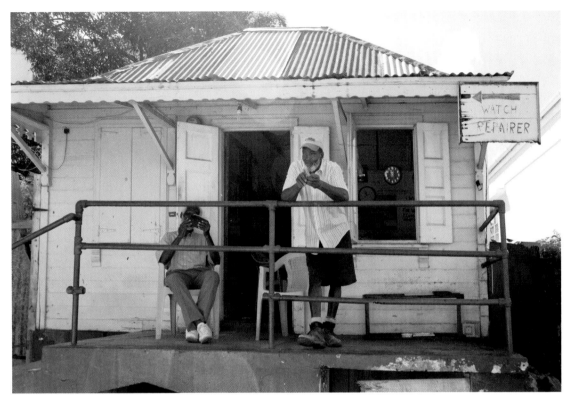

Figure 25.1 Newman photographed porches in the South similar to this one.

Include an Arrow in the Frame

You might think that arrows serve the purpose of indicating direction, which is certainly true, but arrows have also been symbols for various concepts since humans first walked the earth. Arrows symbolize everything from war and power to Greek mythological gods. If used strategically, they also can control how people look at art.

When Newman included an arrow in one of his photographs, he did so to provide balance in the frame. In doing so, he also asserts control over where and how viewers look at his photograph.

In *One Way*, there are three elements on a white wall. One of the elements is a leftward-pointing arrow with the words "ONE WAY" under it. The long arrow and accompanying text are placed on the top-right side of the frame. Since there is an object (which looks like a ramp) below and next to it, the arrow sets up the viewer to look at the photo in a counterclockwise orientation.

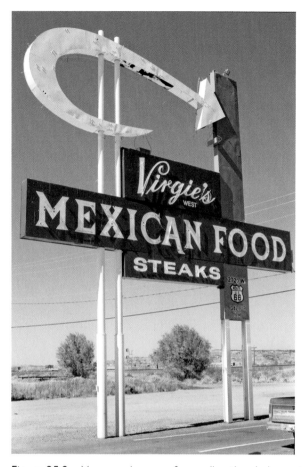

In Figure 25.2, the road and truck show the viewer the way people get to that restaurant. In the 1950s, when the sign was built, it and other signs like it were meant to get people off the road and into the place of business. Viewers can link the road and truck with the sign to figure out what is happening.

In Newman's photo, there is no road or sidewalk, so you don't know who or what the one-way sign is for. You can only guess.

Figure 25.2 You can give your frame directional elements using arrows.

Emphasize Shapes in the Frame

Arnold Newman began his exploration of man and his environment in the late 1930s, taking photographs of poor neighborhoods. It is within these images that you find some of the secrets of his craft. One secret is his placement of shapes in the frame.

To emphasize shapes in the frame, you have to photograph architectural elements straight on. There should be no sky and no ground in the frame. Elements can be anything from façades of buildings to parts of painted walls. They should contain a variety of shapes and can contain text. They can consist of a number of vertical planes, such as a shot of a balcony with the façade of the house behind. In the frame, there can be such things as stairs, beams, posts, chairs, and siding. There also can be shadows of these elements. The shapes are also made of different materials—concrete, glass, and wood, just to name a few.

In *Baltimore Houses, 1939* (www.arnoldnewmanarchive.com/Portfolio_EarlyWork.swf; click on the fourth thumbnail), there are lines, rectangles, squares, a triangle, and an awning cover cloth that's torn and tattered. The image is a façade of a frame building. On either side of the building's façade are neighboring façades, each forming a border on the left and right side of the image. On the left side is a continuation of the frame building, and on the right side is a brick building. In front of the building is a double-sided stand-up sign, positioned so that all you see are the borders of each side forming a triangle in the frame. The window frame is made up of a 5×4 matrix of squares. There are two rectangular doors; one has swung open all the way so that it sits to the left of the other door, which is closed. Both doors have different contrasting rectangular patterns.

Figure 25.3 shows the remains of a house in St. Thomas, Virgin Islands. The wood that holds it together is made up of rectangles of different sizes and shapes. Both windows are open, making the opening in the windows themselves symmetrical. Like in Newman's image, there is torn cloth, which is part of what's left of a curtain. The image most certainly documents the economic woes that islands in the Caribbean face.

Figure 25.3 Frame shapes evident in different surfaces.

Evident in Newman's early images are hints of poverty. What kind of neighborhood would host such buildings? Like many other photographers of his era, he documented the conditions in poor neighborhoods in the United States.

Frame Clothes Hanging to Dry

Newman photographed the urban areas of West Palm Beach, Florida. As part of that photography, he shot objects such as clothes hanging on a clothesline. In *West Palm Beach (Laundry), 1941* (www.arnoldnewmanarchive.com/Portfolio_EarlyWork.swf; click on the eighth thumbnail), six trousers hang on a clothesline in front of a frame house. There are also two cats on the bottom edge of the frame, apart from each other and centered under the line of hanging clothes. Newman showed not only a scene from an anonymous person's house; he also showed what the people wore. All of the clothes are the same, indicating that the person who wore them had to wear the same type of clothing every day.

Depicting drying clothes the old-fashioned way draws in a viewer. Newman not only gives the viewer a feel for the environment of that part of Southern Florida, he documents that the area was not just for the rich. Just to the east is Palm Beach, Florida, an area for the very wealthy. By showing this house with the laundry in front, he made people aware that the Palm Beach area was not only home to the rich. It was also home to many poor people, which the public didn't want to think about at the time. It's a fact of life that shielding people from seeing the poor in that area is still a common practice today.

To find clothes hung outside to dry, you usually have to travel to poor neighborhoods in the United States or to Third World countries. In the United States, almost everyone else has a clothes dryer. Figure 25.4 shows a clothesline in Myanmar (Burma). It, too, features several articles of clothing that are the same and that offer repetition in the frame. As in the Newman photo, there is also a home in the background. In the Newman photo, the house was made of wood; in this photo, it's made of mud with a thatched roof made from palm fronds. It's evident from both shots that when there are clothes hanging out to dry, the setting in which that scene takes place is almost always compelling because it's so different from what many people are used to.

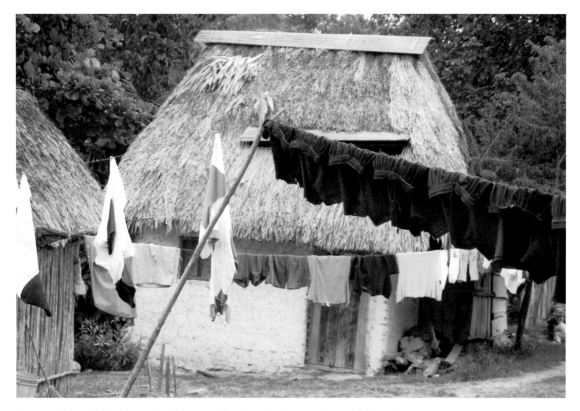

Figure 25.4 Clotheslines like this are difficult to find today in the United States.

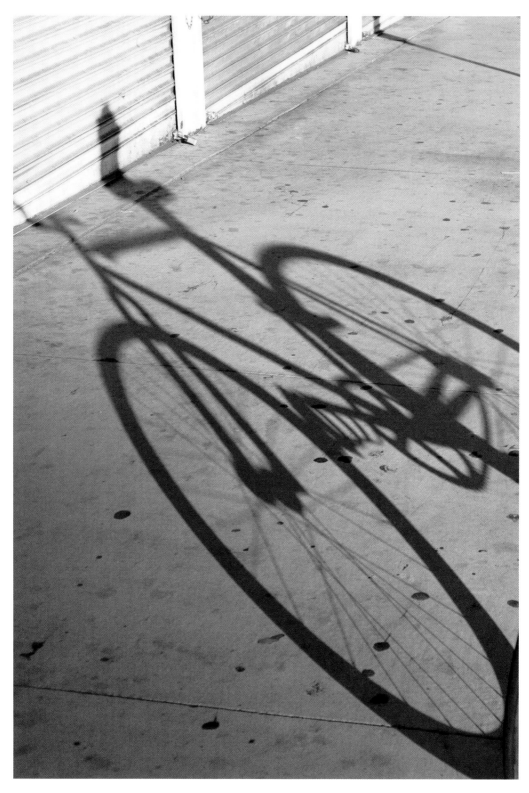

Find a compelling shadow and then frame it.

Marvin Newman
(1927–)

Marvin Newman spent his childhood in New York City. During those years, he shared a darkroom with members of the Photo League, the organization started by Berenice Abbott and Paul Strand and whose membership included many of the twentieth-century photography greats. Newman was one of the first photographers to receive a master's degree in the subject. He first went to school to study sculpture and photography at Brooklyn College. Later, he attended the Institute of Design, where he worked with Harry Callahan and Aaron Siskin. After World War II, Newman photographed the streets of Chicago with Yasuhiro Ishimoto. As a sports photographer, Newman photographed many New York Yankees games, taking images that have become well known today with the recent publication of the book *Yankee Colors: The Glory Years of the Mantle Era*. His photos have appeared in *Sports Illustrated*, *Life*, *Look*, *Newsweek*, and the *Smithsonian*. He was president of the American Society of Media Photographers.

Take a Portrait of a Performer in Costume

The subjects of many of the well-known twentieth-century photographers were often performers or people dressed up or wearing masks (in Meatyard's case). Finding people like this can be a matter of chance. You have a better chance of getting a shot like this in downtown areas of cities, big or small. I've found people dressed up in places as small as Ventura, California. One thing is always certain: You have a wide choice of figures in costume on Halloween almost anywhere, making it a "must" time of year for photography.

In a 1955 shot of a female circus performer, (www.stephendaitergallery.com/dynamic/artwork_display.asp?ArtworkID=2780), Newman placed her from the waist up in the middle of the frame. He photographed her from the side, with her head turned to face the camera. Her hand is on her hip. Her blouse is black, and her skirt drapes outward with a series of repeating pleats.

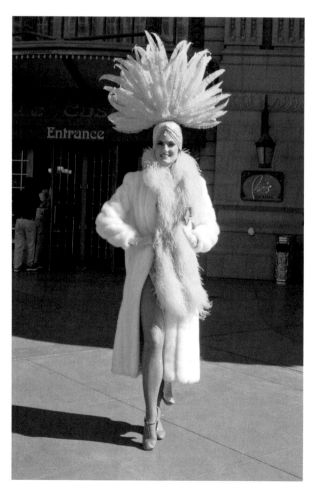

She wears a feathered hat. Her eyes gaze off to her side in the corners of their sockets. His photo captures the moment in the most compelling way.

In a similar photo taken in Las Vegas (see Figure 26.1), a showgirl posed quickly for the camera. When I asked the woman if I could take her picture, she was more than willing to let me. She knows what she's doing—her leg is cast out from under her coat in a pose she's probably assumed many times. She wears a boa around her neck and feathers on top of her head. It's always a treat when someone poses so nicely for a photo. It makes a photographer's job easier.

Figure 26.1 Never be too shy to ask a performer if you can take her picture.

Catch a Passenger through a Bus or Train Window

Newman had an eye for finding artistic objects on the streets of Chicago. In each photograph of a manhole cover series of photos, he included only a manhole cover in the frame. Each one has a different design, and each one is made of worn metal that makes it akin to an old coin. In another untitled image taken in 1955, Newman photographed a young woman as seen through the window of a bus. She's just sitting there. The square window is open, and her arm is set on the sill, with her elbow sticking out. What's significant about this photo is the rectangular shadow cast over the woman's face. It stretches from the right side of her forehead, crossing her right eye and going into her nose. Also interesting is the word EXIT, which is spelled from top to bottom, making a border on the left side of the frame.

Timing is essential in getting an image of someone sitting in a bus from a street perspective. You must have the right angle and the right kind of light, and the bus has to be stopped for long enough for you to get a picture of the passenger.

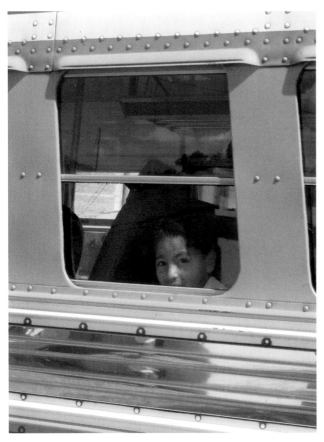

In Figure 26.2, a boy looks out the closed window of a bus. This picture was taken quickly as the bus briefly stopped at a red light. The boy was looking at me, his eyes filled with wonder. Through the window in front of the boy, you can see through the other window on the opposite side of the bus a brick wall, from which there is subtle light. This adds a lot of depth to the photo.

Figure 26.2 Boy looks out the window of a bus.

Photograph a Shadow Upside Down
(or Rotate an Image with a Shadow in Photoshop)

Marvin Newman studied the human form on the streets of Chicago. His master's thesis, "A Creative Analysis of the Series Form in Still Photography," delved into different ways to frame the human form. He considered the shadow an important element in his images, often representing the human form.

Newman brought shadows to life by photographing them on light surfaces. He brought them to life by photographing them as they were cast from people on either side of the noon hour (or at noon in the winter). He then presented the image upside down so that the shadow(s) became the main subject of the photograph. In one such image, *Shadow, Chicago, 1951* (www.stephendaitergallery.com/dynamic/artwork_detail.asp?ArtworkID=2083), he photographed a woman and a man, each standing apart on both a horizontal and a vertical plane so that the shadows cast could be distinguished from one another and so that the shadow cast by the woman appeared short and the shadow of the man appeared tall when the image was turned upside down. Newman also has his subjects turned away from each other so that the man looks to the right edge of the frame and the woman looks to the left.

To emulate a shot like this, you need to place your subjects apart from each other so that the shadows of the individual bodies can be distinguished. You can also place them so that they are apart from each other in a vertical orientation, so that one subject's shadow seems taller than the other even if the actual people are not. After you shoot, turn the print upside down or use Photoshop to rotate it 180 degrees, and you'll have clearly distinguished shadow portraits as the main subjects in the frame. See Figure 26.3.

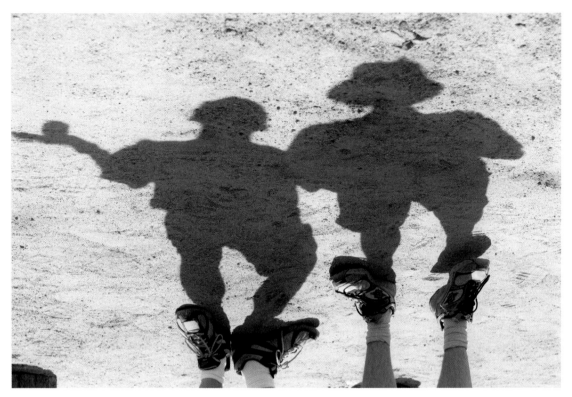

Figure 26.3 Photographing shadows upside down leads to their being seen as main subjects in the image.

Still life with ladder.

Paul Outerbridge
(1896–1958)

Paul Outerbridge took his first photograph when he was in the service. In 1922, Outerbridge had his first photograph published in *Vogue*. After that, he moved to Paris, where he befriended Man Ray and Pablo Picasso.

Outerbridge started out as an illustrator and set designer. He was one of the first to move from black and white to color photography. He staged surreal still lifes and then photographed them, paying meticulous attention to lighting and composition. Outerbridge also photographed nudes. In one such photo—*Phoenix Rising*—Outerbridge framed a woman lying down with her neck at the bottom of the frame to her breasts one-third of the way up. In between her breasts and occupying the rest of the frame is the sculpture of Phoenix. Her arms are on either side of the sculpture with her hands hidden behind it, holding it up. In Outerbridge's era, this photograph would have been considered obscene, so it didn't get much attention. The same was true of his still lifes, which just seemed too surreal. A book of his photographs—*Photography in Color*—was published in 1940.

Photograph a Gas Station

Outerbridge was known for his color photography. He mixed colors of his subjects with colors of their surroundings and placed his subjects with the utmost of care. He also carefully placed subjects and shadows in the settings he chose to photograph.

One of a series of newly found color photographs is of a gas station in Mexico. The gas station's architecture is significant in that it features a large overhang that extends from a building over the pumps. Many gas stations built in the 1940s and 1950s have vast overhangs. These types of gas stations make interesting architectural subjects. Add a person or two and some shadows, and you'll end up with a compelling photograph.

In *Gas Station, Mexico, 1950* (artblart.wordpress.com/2009/04/18; scroll down), a woman wearing a green dress with a white sweater walks at the bottom of the frame, her legs cut out of the image, with a shadow of her full body extending to the gas pumps. The Pemex gas station's flat overhang is significant and extends outward through the entire frame. It's bordered in red, as is the color of the two curbs upon which the gas pumps sit. The lime-green dress and bright red trim of the gas station are quite a match of contrasting color. In the photo, there is also a stray rectangular shadow near the bottom-left corner of the frame.

For my emulation of this photo, I knew of a gas station that has color and a large, flat overhang. On the day I shot, I didn't have a subject, so I decided that it would be me in the frame. Fortunately, I was wearing a blue pair of gym shorts, which provided rich contrast with the yellow of the gas station. I walked around across the street from the station to see what my best vantage point would be. I found a great shadow of a palm tree that I wanted to be in the frame. In order to fill the empty space to the right of the shadow, I decided I would step into the frame while my camera was set on a timer. I got it right on the second try, after nearly getting run over. I also was fortunate to get another man in the frame near the pumps. Figure 27.1 shows the image.

Stage a Still Life

Staging a still life can be a complex project. Outerbridge had a knack for it, creating settings of abstract design, a system of shapes and color—often matching—to fill his frame. He used reflections and shadow to complement his objects, creations that were almost surreal. The prints of his work are astonishing, created using the complex tri-color carbro process that involves a chemical reaction.

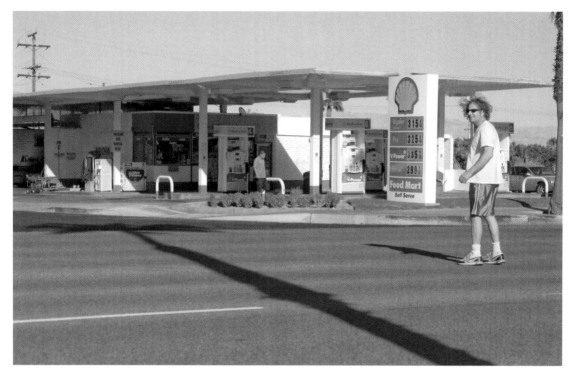

Figure 27.1 Subjects and shadows were strategically placed in this gas station shot.

In *Images de Deauville, 1936* (www.masters-of-photography.com/O/outerbridge/outerbridge_deauville_full.html), Outerbridge photographed a still life from about a 45-degree angle above the objects. There is a die that looks magnified because the objects around it are smaller by comparison. Along with the die is a tall yellow pyramid, a chrome ball, and a seashell, with part of a framed image in the background, in which a small sailboat is placed in the top-left corner of the frame. Each object is meticulously placed so that balance is achieved in the frame. The white space (negative space) is partially filled with shadows. All objects are sharp in the frame, which indicates that he used a narrow aperture. These shadows and the bevels in the frame give the composition depth. Finally, the die is reflected on the chrome ball.

The color in Outerbridge's shot is muted, yet it's important in manipulating the dimension in the frame. Everything in the frame is nearly void of color, with the exception of the yellow pyramid and the blue sea on top of which the sailboat sits. This blue is interwoven with white and has a texture from the Impressionistic style of the picture.

In other still lifes, Outerbridge used assorted objects to create formal vignettes. In Figure 27.2, I staged a still life with some similarities to Outerbridge's. Instead of a die, which was exaggerated in size, I used a model car, which is also exaggerated in size (albeit much smaller than a real car).

I also have chrome in the frame, which reflects the green ball and which also shows (if you look carefully) me photographing the vignette.

The setup shown in Figure 27.2 involved using a tripod. I placed the camera high above a table (at an angle of about 45 degrees from the objects). I shot with an aperture of f/10 so that all of the objects in the frame would remain sharp. In an effort to emulate Outerbridge's shot, I picked objects with colors that are neutral and that have different shades of green and brown, including the surface upon which the objects sit (the table).

Figure 27.2 You can use objects around your house to stage a still life.

Gordon Parks
(1912–2006)

Gordon Parks was not only an adept photographer; he was also a musician and a film director. Parks grew up in a poor, religious, African-American family who believed in personal pride and hard work. He wrote three autobiographical novels and was the first African-American to work at *Life* magazine. He also directed many movies, including the 1971 film, *Shaft*.

Parks' first photography job was photographing models at a department store in St. Paul, Minnesota. He went on to work for the Farm Security Administration with a mission to fight poverty with his photographs. His famous photo *American Gothic* (www.masters-of-photography.com/P/parks/parks_gothic_full.html) was part of his work there. It features a black woman in front of an American flag (which is blurred) with a broom on the woman's right side and a mop on her right. What's incredible about that photo is that the broom is sharp in the foreground in front of the woman, and the mop, which is soft, is behind her in the background. It's kind of an optical illusion in that it looks as if both the broom and the mop are in the foreground when you first glance at the image. You have to look at it a few moments to figure out the mop is sitting below the flag in the background.

Parks also photographed many people during his career, including Dwight Eisenhower, Muhammad Ali, Paul Newman, and Louis Armstrong. His other photographs range from those documenting school segregation to the latest in fashion trends.

Frame a Musician Playing for Money

In *Beggar Man, Paris, 1950* (www.masters-of-photography.com/P/parks/parks_beggar_full.html), a white man plays an accordion with a container with the lid open between his knees. The man wears a cap and overcoat and has a cane under his leg. The accordion's keys show up sharp in the foreground of the image, as do the words "FRATELLI CROSIO" written across the instrument. There are people visible in the background on the street, two of them prominently. The one on the left is carrying a checkerboard bag and a long baguette in a bag. The person on the right is walking into the frame.

The most important aspect of getting a shot similar to Parks' is to frame the musician so that the container in which he is collecting the money shows up in the frame. When you do, you then get the narrative of the beggar in the street—even if it is a bit of a stretch to define a person playing a musical instrument on the street as a beggar.

One of the best places in the world to photograph street musicians is at the Powell Street cable car turnaround in San Francisco. That's where the picture in Figure 28.1 was taken. In that shot, I've included the open trumpet case, which is obviously there to collect money. In the background are stairs, on top of which is a group of people drinking coffee.

What's evident in both images—Parks' and the one shown in Figure 28.1—is that there is no one watching the musicians. They appear as lone souls eking out a living.

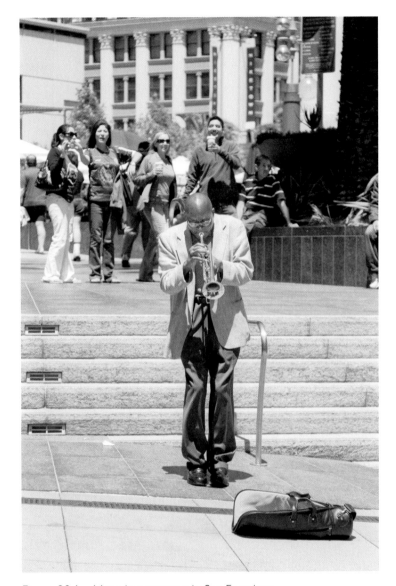

Figure 28.1 Man plays trumpet in San Francisco.

Find Patterns in Religious Dress

Some of the most famous images of the twentieth century are of groups of people wearing the same religious dress. Filling the frame with nuns wearing habits or Muslim women wearing burqas offers a compelling study of religious symbolism.

In Parks' *Ethel Shariff in Chicago, 1963*, an African-American woman (Ethel Shariff) stands in the foreground; her body is visible from the waist up. She wears white, including a white hijab that looks similar to a nun's head covering. She is the first woman in a configuration similar to this:

XXXXXXX

 XXXX

 XX

 X

In Figure 28.2, two nuns are caught walking in lock step up some stairs. The pattern of the bottom of their habits and their feet makes the composition effective. While there is a certain element of luck in this shot, getting other shots of repetition in religious dress is possible in many parts of the world. Think in terms of framing rows of skull caps of a group of Muslim men praying or the orange robes of group of Buddhist monks gathered around a shrine.

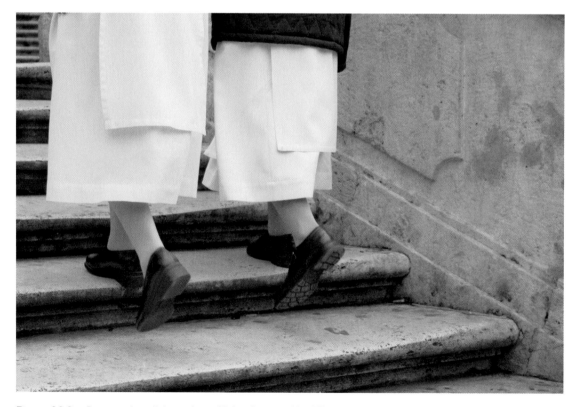

Figure 28.2 Patterns in religious dress fill the frame with different ideas about what people believe.

CHAPTER 29
Alexander Rodchenko (1891–1956)

Inspired by modernists and Art Nouveau, Alexander Rodchenko works show versatility in subject, composition, and form. What you'd usually expect to see in a frame—people and places shot straight on—isn't what you get from Rodchenko. His camera was often at a tilt when shooting, and he looked for artistic shadows into which he'd frame his subjects.

Rodchenko was born in St Petersburg, Russia, and was raised in a family of modest means. His first experience with art was making abstract drawings when he went to art school in Moscow, and his first works were shown at a futurist exhibition in Moscow. He was skilled in many facets of art, from painting to graphic design to sculpture, and he designed the covers for many Russian magazines.

During the early twentieth century, Constructivism became popular. Constructivism was art that consisted of objects that were constructed without any reference to a subject. They were abstract, often technological elements created by man.

It was a glory ride for Rodchenko when the Bolsheviks rose to power in the early 1920s. He was selected to serve as an art commissioner for the new government. He then had to move from painting to photography because the state had strict guidelines for content that the painters were to follow with respect to depicting realism. Rodchenko developed new themes and media that were compatible with the values of the new Soviet Union. He created photo montages with new Stalinist state themes of worker power and the right to leisure.

This didn't last for long, as the revolution went bad, leaving Rodchenko butting heads with the new state. By the 1930s, state law forbade photographers from working in the streets without a permit, limiting Rodchenko's repertoire of subjects for his photographs. Eventually, Rodchenko moved out of Moscow, gave up photography altogether, and painted instead.

Use a Variety of Angles to Photograph Objects and Subjects

Rodchenko believed that you have to shoot your subjects from a variety of different angles above and below your subject, even tilting them in the frame. He was a minimalist in the sense that he usually only included one subject in the frame, albeit with repeating shadows and/or streamlined architectural forms (such as broad stairways).

In *Girl with Leica, 1934*, Rodchenko frames a woman seated on the end of a bench at a 45-degree angle in a space covered with checkerboard shadows. The woman occupies the top half of the frame, from her head at the top-right corner to her crossed legs, which are positioned about a third of the way from the right edge of the frame, almost halfway down into the frame. The bench moves up the frame from the lower-left corner to where the woman is sitting at the top. It appears as if the woman could slide down the bench if she's not careful. The bench has the same checkerboard shadows as the ground, but the wall above the bench has shadows that are diagonal lines. The shadows also cover the woman and become distorted as your eyes move up her dress and onto her face. The strap of the Leica is over her right shoulder, leading to the camera on her left side.

In Figure 29.1, a man is sitting on a bench in a frame that's tilted about 30 degrees from a horizontal axis. When I framed this shot, I tilted my camera because it became apparent after doing so that the man could have slid down the bench to his present position. The bench comes out of the middle of the frame from under the shadow of a tree leading to the man, who's nearly out of that shadow. The shot is effective because the man chose to sit on the bench so his feet came off the side of it. His legs and body are flush with the bench, adding a bit more uniformity to the shot. The shot also follows the Rule of Thirds because the man is both one-third of the way from the right edge of the frame and one-third up from the bottom of the frame.

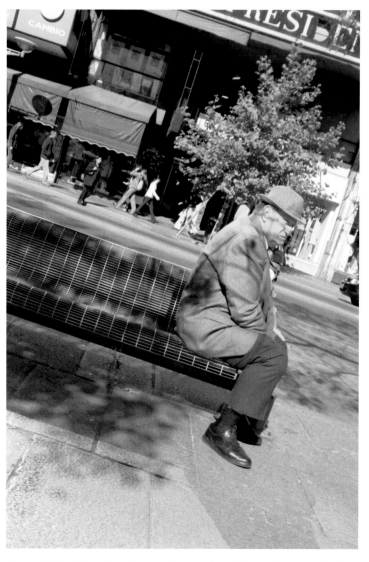

Figure 29.1 Shooting at an angle reveals a distorted sense of balance, which can be interesting.

Photograph Repeating Balconies

Many of Rodchenko's photographs contain balconies. There are two photos of balconies that are noteworthy: *Balconies, 1925* and *Mosselprom Building, 1926*.

In *Balconies, 1925*, Rodchenko shot a building, which occupied the left side of the frame, from the bottom up and at an angle so that the building rises up to intersect the middle of the top edge of the frame. You see the bottoms of the balconies almost in black. You can see the side railings as well as the front ones, which he caught at an angle and which move into the frame. At the top of the frame in the background is the top of a neighboring building. Although the image isn't stellar, it does show how balconies attached to buildings can add depth to a shot while including interesting repeating objects in the frame. (In some photographic circles this is called *echoing*.)

In *Mosselprom Building, 1926*, Rodchenko photographed a building that only had balconies on the three lower floors. The balconies are half hexagons, with two diagonal lines meeting a horizontal line in the middle. Those balconies reach up two-thirds of the way of the frame. Occupying the rest of the frame are the other stories of the building.

In Figure 29.2, the balconies of a modern building in Vancouver are photographed. You see the bottoms of the balconies, which are stacked in such a way that the bottom of each is the ceiling of the one below it. There are all sorts of repeating patterns in the frame, not to mention the curve of the building as you move to the right edge of the frame.

Figure 29.2 Architecture is a good place to find repeating objects.

Photograph Buildings from the Bottom Up

Rodchenko liked to photograph from above and from below. "The most interesting angles of our times are from upwards below and from downwards up," he once said. During the 1920s, the Russian avant-garde, of which Rodchenko was a part, insisted that photography should express new ways of looking at things, which was achieved by photographing at different angles and from above and below. While Rodchenko's assessment of photographing architecture sounds easy, that's not all he considered when framing a building. He used photography's most important rule—the Rule of Thirds.

In the image *Mosselprom Building, 1926*, discussed in the previous photo idea, Rodchenko framed the building so it was set off from the center of the frame. The center of the building falls one-third from the right side of the frame. This makes for a very compelling shot. Also of note is that he didn't include the building's ground levels in the frame.

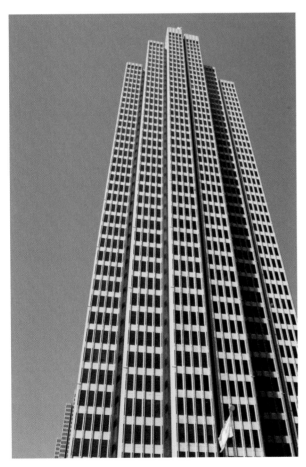

In Figure 29.3, I've shot one of the buildings in San Francisco's Embarcadero Center by pointing my camera up from the street directly in front of it. Instead of placing that building in the center of the frame, I've framed it so that the center of the building sits one-third of the way from the right edge of the frame, so that it emulates Rodchenko's *Mosselprom*. Also, I've omitted the ground floor from the frame, just as Rodchenko did in his image.

Figure 29.3 Frame your buildings from the bottom up the way Rodchenko did and then offset them from the center of the frame.

Make a Photo Montage

When Rodchenko made photo montages, they weren't supposed to look like an assembled photograph. They weren't even supposed to make much sense. They did, however, communicate concepts that were relevant to the time they were constructed. Rodchenko created photo montages for book covers (many for a detective book series), propaganda posters for the Soviet regime, and ads for a professional union. All were a combination of red and black text combined with sepia-toned photographs.

Rodchenko made several photo montages for the poem "About It" by Vladimir Mayakovsky in 1923. In those works he used his own photos and photos cut out from magazines. In *She Is in Bed, She Is Lying There...*, Rodchenko assembled a stunning photo montage of elements.

PHOTOSHOPPING A PHOTO MONTAGE

If you use Photoshop or Elements, you can make almost any photo montage you want. I went for a matrix of windows because I have a collection of window images. Rodchenko did one of animals where he has one animal piled on top of another diagonally across the page.

To do the window montage, I first opened each image window and used the Distort (Edit > Transform > Distort) option to make the converging lines vertical. Next, I created a new document (6×9 at 300 dpi) and made it grayscale (Image > Mode > Grayscale). Because I selected that option, each window image I drag into the new document will automatically turn to black and white.

I opened each image window and pasted it from the open document to the new one. I then selected each image and scaled it down (chose Edit > Transform > Scale and then clicked and dragged the image inward) to approximately where I wanted it.

After I was finished with all of the images, I opened the Layers palette. From there I tweaked each window so it fit together with the one below and beside it, so that there was no white-space in between. Finally, I inserted the woman in the same way: opened her image, selected her with the Polygonal Lasso tool, and then copied and pasted from the document I was working in to the new document.

One more thing—I converted the woman to sepia tone. I made sure she was selected in the Layers palette, converted the image back to RGB color (Image > Mode > RGB Color), and then slid the red Color Balance slider (Image > Adjustments > Color Balance) to the right until I got the amount of red I wanted.

That's it—just don't forget to flatten your image (Layer > Flatten Image) when you're finished.

When observed at first glance, they look disorganized and unrelated. But here you have to stop and study exactly what the artist has done. There are about a dozen cutouts that make up the montage. Basically, it consists of two people lying on a couch. A portable mirror stands out of the image. On top of that is woman in a pantsuit standing on a bed. Behind her and in the background is a large portrait of a woman. Next to her are some chairs, and on top of that, spread across the top of the page, is an old-fashioned phone receiver with a much smaller phone placed near the mouthpiece. This montage looks as if it has something to do with a woman who's talking on a telephone, with the rest of the cutouts referring to what she is talking about. There's all sorts of symbolism that can be written about in the image, but since this isn't that kind of book, I won't go into it here. The assemblage is balanced and, in a way, quite beautiful.

In Figure 29.4, a series of windows are set in a matrix to make up a faux building. Inside one of the windows is a sepia-toned woman. In this piece, I've emulated Rodchenko in that I've created two types of images: sepia toned (albeit only one) and black and white. To create an image like this, see the "Photoshopping a Photo Montage" sidebar on the previous page.

Figure 29.4 You can make a photo montage using layers in Photoshop.

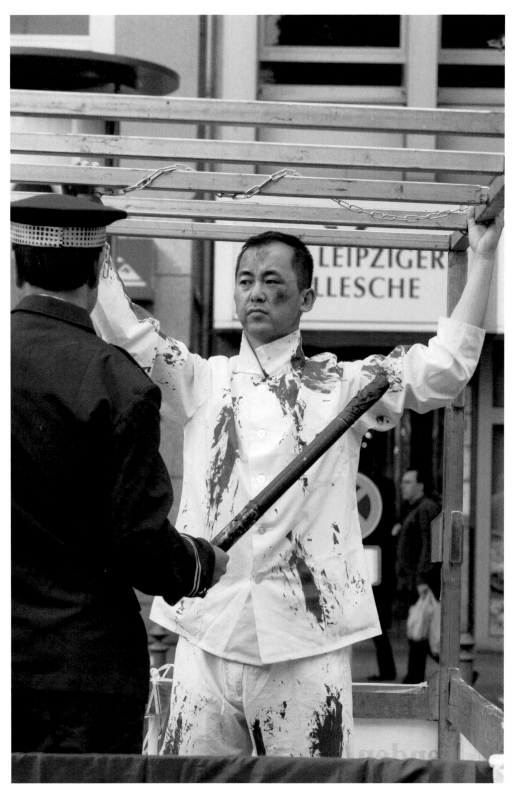

Simulated war image.

W. Eugene Smith (1918–1978)

W. Eugene Smith was an avid aficionado of planes and airports, which he photographed while he was a teen. In high school, he was a photographer for the school paper. He later threw out all the images he had accumulated because he thought that the technique he used to take them was bad. Smith worked for *Newsweek* and freelanced for *Life* and the *New York Times*. He used multiple cameras, mostly 35mm, when shooting.

He covered World War II by traveling the Pacific. He sought to show the victims of the war as real people. Of his war photography, Smith said, "I wanted my pictures to carry some message against the greed, the stupidity, and the intolerances that cause these wars." During World War II, Smith got hit with a missile while photographing the front lines in Okinawa. After a hard recovery, he went on to write photo essays for *Life*. By that time, he felt that he didn't want to be nailed down by the constraints of photojournalism. He left his work at the magazines and went to Pittsburgh to photograph life, not so much in a documentary way, but in a more artistic way.

Smith continued photographing for the rest of his life. In his later years, he moved to New York City and photographed what went on outside the window of his loft.

Photograph Trails from a Moving Vehicle

In *Train Station, Japan, 1961* (www.perspectivefineart.com/content/PopUpWindow.aspx?fwid=8), Smith photographed a train passing by so quickly you only see its trails—streaks of light that appear in the foreground from a moving vehicle with its lights on. Behind the trails are people waiting on the other side of the track who appear flawlessly sharp in the frame. As a matter of fact, Smith's timing was so good that the trails appear to frame the people—they clear up in the space where the people appear. There are two men toward the right side of the image. The one on the left is stooped over, held up by a cane. He has a large makeshift backpack. The man on the right wears a suit and is seen in a full-body profile. There is also one other man toward the left edge of the frame. You can see only his shoulders and head. The rest of his body is covered up by the trails.

In Figure 30.1, a similar scene taken in Paris shows two people framed by the trails of a passing subway car. The shot was taken without a tripod (it's not a good idea to set up a tripod in a subway station), hence the softness of the people. (You'll notice the focus on the image was just to the right of the people, where you see the station name, which is sharp.)

To get a shot like this, you have to position yourself at the end of a subway station stop so you can catch the train still moving as it arrives at the station. To get a sharp shot without a tripod, lean your back against a wall to steady yourself and keep your elbows close to your sides to take the picture.

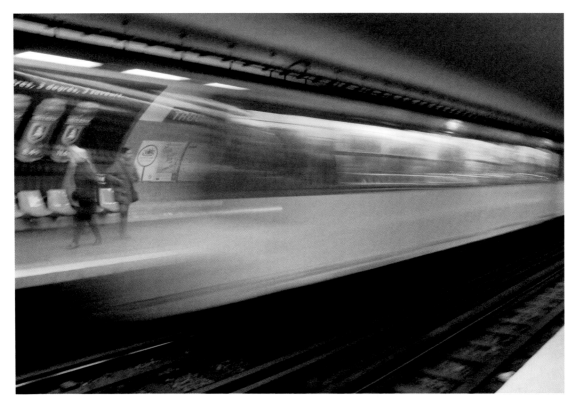

Figure 30.1 You can make trails without a tripod indoors if what you're photographing is moving very fast.

HOW TO CREATE TRAILS IN THE FRAME

Creating trails from moving vehicles can be difficult. The first trick is that you don't need much light. This type of shot is best done indoors (such as in a subway station) or at night. Most of the time you'll need a tripod, but if you've got a steady hand, you can get a fairly decent shot indoors. At night, using a tripod is an absolute must.

Figure 30.2 is a shot of a passing bus, which passed the camera not in front, like in Smith's photograph, but off to the side. I set my camera's shutter for 4 seconds (at f/22, a narrow aperture to get a large depth of field, or to have everything in the frame sharp except the trails of the moving vehicle) to get this shot. I was at a bus stop, but not the stop for the passing bus.

To get these and other shots, I set up my camera on a bus stop island on Market Street in San Francisco about 15 minutes before sunset. I started taking pictures using my camera's timer (set to shoot at 10 seconds after I press the shutter release button) in Shutter Priority mode, with different fractions of a second exposures. As the light dimmed, I upped my exposure time. By the time the sky had turned from navy blue to black, I had shot with 30-second exposures.

There's a balance you have to achieve between the length of time used to get the trails you want (trails through which you can see the background) and just the blur of the bus passing. In Figure 30.2, you see what happens when a bus passes by at a one-second exposure. You can't see the background through the bus passing on the right side of the frame, making the shot less compelling. Finally, if the exposure is too long, the bus won't show up at all.

Figure 30.2 A bus passing a stop in San Francisco.

Aaron Siskind
(1903–1991)

In a 1982 interview, Siskind commented about his relationship with his parents. "I never had any real emotional attachment and certainly no intellectual relationship with them—right from the start I was a street child." Perhaps that explains his fondness for art found on the streets of New York City, where he was born and raised—anything from close-ups of graffiti to ragged posters peeling off of a wall.

As a child Siskind became interested first in poetry. He came to find poetry "painful" because he had trouble creating the right words. It wasn't until he got married that he showed an interest in photography, which he called a medium of immediacy—you get to see the picture right away.

Before Siskind became a professional photographer, he taught elementary school for more than 20 years. (I can relate; before I became a photographer, I taught school for 14 years.) He began his photography career by joining the New York Photo League while he was still teaching. In the '40s, Siskind moved from documentary to abstract photography after he became friends with abstract expressionist painters Mark Rothko and Adolph Gottlieb. His interest in having primary subjects in his photographs waned. "For the first time in my life, subject matter, as such, had ceased to be of primary importance," Siskind explained. "Instead, I found myself involved in the relationship of these objects, so much so that the pictures turned out to be deeply moving and personal experiences."

In 1951, Siskind taught with Harry Callahan at Black Mountain College, an art college that closed in 1957. Siskind was a photography professor at Institute of Design, Illinois Institute of Technology in Chicago for nearly 20 years. There, he photographed Chicago architecture with his students in a study of architects Adler and Sullivan and interior designer Mies van der Rohe.

Place People in Motion on a White Background

In one of the photographs from the *Pleasures and Terrors of Levitation* series taken in 1956 of divers in midair, only a diver is seen. There is a light-gray background throughout the frame. His right arm touches his bicep; his left is extended from his body and bent down at the elbow. He wears rolled-up jeans. His left leg is fully extended; his right is bent at the knee to extend outward toward the right edge of the frame. There are dark shadows throughout the subject, which is embedded in a solid light-colored background. Siskind took these photographs with a handheld twin-lens reflex camera at the Lake Michigan shoreline. The title of the series suggests that the divers experience both pleasure and terror while they are suspended in midair.

In Figure 31.1, a man is in the air as part of his performance art near the Brandenburg Gate in Berlin. He was cut out from the scene and placed on a nearly solid background. (To learn how to make this background, see the upcoming "Making a Cutout Person in Photoshop" sidebar.) It's questionable if Siskind's title can apply to this image, as a jump is not nearly as scary as, say, diving off of a cliff, but both Siskind's work and this photo isolate all that's possible with the human body in solo human endeavors.

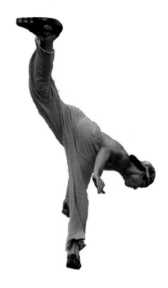

Figure 31.1 What used to take a lot of work processing in film days is easy with Photoshop today.

MAKING A CUTOUT PERSON IN PHOTOSHOP

Siskind's photographs of divers have been an inspiration for many photographers. I can recall an artist who, in emulating Siskind, created cutouts of people on a light background. The people weren't divers; they were just people jumping in different ways. Creating this piece of art is easy in an image processing program, such as Photoshop or Elements. Here's how:

1. First, you select the figure you want. Choose an image with someone jumping or doing gymnastics (or diving, as Siskind did).
2. Open your image and save it with a new name.
3. In the Layers palette (Window > Layers), double-click the padlock to unlock the Background layer.
4. Select the Polygonal Lasso tool and type 2 px in the Feather field (in the Options bar).
5. Click the Polygonal Lasso tool around the part of the image you want to cut out (see Figure 31.2).

6. Choose Select > Inverse.

7. Click Delete on your keyboard. Everything that you've cut out will now have squares, which means that area of the image is transparent (see Figure 31.3). Click on the image once to release the selection.

Figure 31.2 Figure selected before selecting the inverse, which makes the background selected.

Figure 31.3 The checkerboards mean that the background is transparent.

8. At this point, you may need to scale the figure down. To do this, just select with the Rectangular Marquee tool, choose Edit > Transform > Scale, and then click and drag the figure to the size you want. Next, you'll make the clouds for a textured background.

9. Choose Layer > New Layer. Name the layer Clouds.

10. Make your foreground white and your background light gray.

11. Choose Filter > Render > Clouds. Your image will turn solid light gray, but don't worry...the figure will come back! See Figure 31.4.

12. Choose Filter > Blur > Surface Blur with a low threshold and a Radius setting of nearly 100.
13. Repeat as necessary for uniformity by choosing Filter > Surface Blur.
14. In the Layers palette, click and drag the Clouds layer below the Background layer. At this point, the figure will come back with the clouds in the background
15. Choose Layer > Flatten Image. See Figure 31.5.

Figure 31.4 The image turns to clouds after you render them.

Figure 31.5 Completed image.

Find Abstract Art on Walls

One of the newer elements of art today is called *found art*. In essence, found art is art that can be anything you've found in your environment, from a collection of small bits of trash you'd find on the street to part of a wall whose peeling paint reveals something older underneath. Much of the found art that Siskind worked with is related to the concept of *pentimento* in the art world. Centuries ago, artists often painted something on a canvas, decided they didn't like it, and then painted a new painting over it. Sometimes over a long period of time, a painting gets worn, eventually showing the work underneath. When this happens, it's called *pentimento*.

Siskind often framed chipped paint or torn playbills that revealed something different underneath. He shot the walls with this found art when he saw patterns he liked—patterns that looked like abstract paintings. To Siskind, photography had no requirement to represent persons, places, or things.

In the graffiti work *Chicago, 1960* (www.metmuseum.org/toah/hd/pmet/ho_1991.1212.htm), he framed an image of a black wall where paint had peeled to reveal a picture of a box of cigarettes and thick, block text underneath it. The work appears like a puzzle in the game of Concentration. The paint is also peeling on the cigarette box, which has been scrawled upon by removing the paint from it with a sharp instrument. One of the words scrawled is "Grease."

In Figure 31.6, remnants of the Berlin Wall have been photographed up close so they look like an abstract work. In the shot there is peeling paint showing the exposed wall, text from a marker, and thick black lines, one of which cuts through one-third of the way from the right edge of the frame, following the Rule of Thirds.

Figure 31.6 You can find abstract art in places where there is *pentimento*.

Find Abstract Art in Architecture

Siskind made abstract works from architecture by framing parts of a building so that its shape and form are almost unrecognizable. In one such photo (www.darjanpanic.com/content/mop/aaron-siskind/images/aaron-siskind_004.jpg), he framed a frame building whose vertical planks of wood stand tall. Embedded in the wood is a door, which has three horizontal splices of wood intersecting the vertical planks. A third horizontal splice sits in the lower-right corner of the frame. The door has been framed with the building so it plays by the Rule of Thirds. It extends, embedded into the building of vertical planks, two-thirds of the way up the frame and is one-third from the left edge of the frame.

In a similar photo (Figure 31.7) shot in the South of France is a door with horizontal planks of wood. The door is worn but has been refreshed with a coat of glossy paint. There are two diamonds at the top of the frame that almost look like eyes. One column of planks ends in sharp arrows, which are locked into the larger planks next to them.

Figure 31.7 Abstract art can be found in different building parts.

WHAT IS ABSTRACT EXPRESSIONISM?

Did Siskind learn abstract expressionism from painters or was it the other way around? Siskind and other photographers and the abstract expressionists belonged to the New York School, a group of artists who put their soul into their art, creating patterns, shapes, and objects along with amorphous forms juxtaposed according to the artists' feelings. They included such artists as Jackson Pollock, Willem de Kooning, Mark Rothko, and Adolph Gottlieb.

Many artists, including Siskind, moved away from social realism—the recording of social turmoil associated with the Great Depression—to abstract art, which some say offered an escape from social realities. Probably the biggest influence on these American artists is what they saw in European art, which made its way to New York in the early '30s, shortly after the Museum of Modern Art opened in 1929.

The art form began as the artists replicated primitive forms and ended with their works becoming art events in which every inch of the canvas was covered with something, seemingly meaningless to some and quasi-religious to others. Other photographers whose work lent a hand to the abstract art movement were Frederick Sommer (discussed in Chapter 32) and Ralph Eugene Meatyard. Today this concept can be seen in the Los Angeles subway (see Figure 31.8) if you frame a design in one of the stations so that it looks as if disparate elements fit together in an abstract way. With a photo the object switches to two-dimensional, and it can take a long time to figure out what it really is.

Figure 31.8 You can create an abstract shot by framing architecture carefully.

Frederick Sommer (1905–1999)

Sommer was not only a photographer. He dabbled in many art forms, from painting to drawing. He also made collages.

Sommer was born in Italy and grew up in Brazil. He became a United States citizen in 1940. Sommer's works can be divided into two categories: landscapes of Arizona and surrealist images of found subjects/objects.

Many of Sommer's repertoire of surrealist images were created through working with dead, found objects/subjects. There's no doubt about it; some of these images are gruesome. He'd go to the butcher's trash to get chicken heads and innards, which he'd attach together for his photographs. In one such photo, *Chicken, 1939* (www.masters-of-photography.com/S/sommer/ sommer_chicken2_full.html), a grotesque chicken head and lumpy innards covered with a liquid film look as if they were slapped into the frame. Watery blood drips in space above and to the right of the chicken's head. He also photographed an amputated foot of a man whose leg got run over by a train.

Remains of Animals

One of the more stunning of Sommer's images was *Coyotes, 1945*, which shows an arrangement of several coyotes' decomposing carcasses. The arrangement is rather artful, with the tops of the heads of two meeting near the middle of the frame

The coyotes are very light (almost white with light-gray streaks from the decaying fur), and their teeth are protruding from their mouths.

Sommers also photographed a dead jackrabbit he came across in the desert near his home in Prescott, Arizona. There is little contrast between the dead animal and the surrounding ground. In fact, you have to look hard to find the borders between the rabbit's body and the surrounding ground.

In Figure 32.1, the carcass of a marine iguana on the Galapagos Islands is tightly framed. It's started to disintegrate into the sand. The texture of the dead animal looks very dry and tough, as do the coyotes in Sommer's image. According to the Getty Museum in LA, Sommer once stated, "Climatic conditions in the West give things time to decay and come apart slowly. They beautifully exchange characteristics from one to another." The same truth holds true for decaying animals in any desert. When things decay on the Galapagos, they really dry out because there is very little precipitation there. The islands are in essence a desert landscape.

Frame a Landscape without a Horizon

To Sommer, some landscapes were better off without a horizon. As a matter of fact, for Sommer, some landscapes didn't need much of anything except barren land. In *Arizona Landscape, 1943* (www.vam.ac.uk/images/image/11183-popup.html), Sommer framed the Arizona landscape without a sky. In framing his landscapes without the sky, mountains and hills are flattened considerably. In this and other landscapes, Sommer reveals the texture of the land.

Figure 32.1 Decaying body of a Galapagos marine iguana.

These black-and-white photographs were meant to soothe—a frame filled with desert vegetation that covers the land in different forms and shades of gray.

Figure 32.2 shows a similar scene to Sommer's, except in California's desert, not Arizona's. In framing this image without the horizon, I, too, have created a flattened look to the landscape. The image makes the land look vast and peaceful. The texture is important, too. It varies from one end of the frame to the other. Since the landscape is in black and white, color doesn't play a role in viewing the landform. The changes in landform are marked by the texture of the desert shrubs versus the different-sized rocks that cover the landscape.

Figure 32.2 Landscapes appear flattened when framed without the sky.

CHAPTER 33
Stephen Shore (1947–)

Along with photographers Robert Adams and William Eggleston, Stephen Shore photographed the everyday, mundane scenes that represented the inner core of America. Shore's most successful work is considered by many to be his series *Uncommon Places*. It was published as a book in 1982, and it shows America's inland nooks and crannies. It's filled with scenes that show what makes the country tick, from the food in a diner to a billboard along a pristine highway.

Shore became a photographer at an early age. At age nine in the late 1950s, he was shooting color photographs. By the age of 25, Shore had an extensive body of work. He had photographed since he was a child and had traveled around the country, shooting the landscape with a large-format camera. As a friend of Andy Warhol, Shore also shot at his studio, The Factory, where a collection of colorful characters worked and played.

Shore's photographs have been exhibited all over the world, and he has received a number of awards for his work. Today, he is a director of the photography program at Bard College in New York.

Photograph an Old Car in an Old Neighborhood

A black or white car won't work here. It's best for the car to have color—blue, green, red, yellow, or any shades in between.

In *Natural Bridge, New York, 1974*, Shore framed a dark-green Plymouth parked in a scruffy residential neighborhood. The photograph got its name because of the dark-green grass next to the car in the lower-left corner of the frame. It forms kind of a bridge to the car because it is the same color. None of this is all that obvious, and you have to look at the image for a long time to get the picture. Once you recognize what he's doing, you can see it in others of his images (the green grass bridge in the foreground that leads you to the vehicles in the middle or background). The colors in the shot are beautiful. Green is a hard color to capture on film, and Shore does it well.

I've framed two colorful vehicles in Figure 33.1. The picture was taken in Uruguay, just outside Buenos Aires. Just as the dark-green grass in the image matched the vehicle in Shore's photo, the red spokes and hubcap on the vehicle on the right match the red garage on the building. Also important is the omission of most of the sky to keep the focus on the vehicle(s), which happens in both photos. Upon first observing this photo, I noticed that the car was glowing. It looked unnatural, especially compared to the tone in Shore's image. Clearly, the car's blue and cyan tones were oversaturated, which often happens with digital cameras. It's an easy fix, though, and I'll show you how to tweak it in Photoshop in the upcoming "Toning Down Color in Photoshop" sidebar.

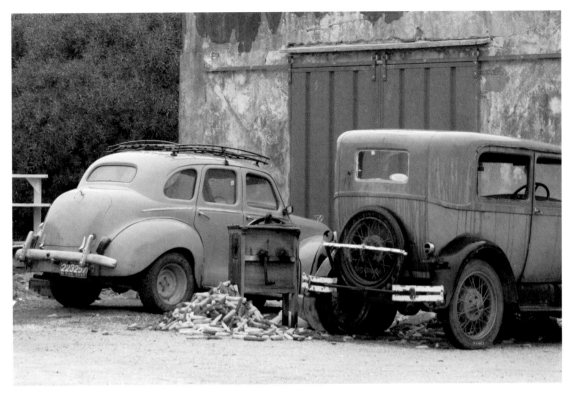

Figure 33.1 Color becomes a primary focal point when photographing an old car.

TONING DOWN COLOR IN PHOTOSHOP

Often you'll get a JPEG digital image, in which the colors look unnatural, and you'll find you have a tough time pinpointing the problem. Most likely what's off in the image is the saturation—it's simply oversaturated. Photoshop (the main program) fixes this quite nicely with no loss of image quality and no pixilation. (You can also do it in Camera Raw if you choose the Saturation tab in the HSL/Grayscale panel.) To do this, navigate to Image > Adjustments > Hue/Saturation. In the dialog box that comes up, open the Edit drop-down menu by clicking where it says Master at the top of the dialog box. If your blues and cyans are oversaturated (if they appear glowing), navigate first to Blues and lower the Saturation slider. It will also help to make the blues darker (if they appear to glow) by clicking and dragging the Lightness slider to the left. Repeat with the Cyans. (Navigate there by clicking on the Edit drop-down menu.)

Take a Picture of a Parking Lot from Above

Any random parking lot is likely to have some interesting elements—at least in the eyes Stephen Shore and some of the other twentieth-century master photographers. Considering the wide range of vehicles you might find there among other elements—parking attendants, fences, lampposts, lights and so on—Shore was on to something.

Shore featured a parking lot on the cover of his book, *Uncommon Places*. It's filled with details that keep your eyes on it. First, there's the Sambo's restaurant sign. If you were alive when the controversy about the name of that restaurant filled the airwaves because of its connection to the book *The Story of Little Black Sambo*, the image probably will have more meaning—a narrative, if you will. Although the content of the book was not especially controversial, the name of it was because of its connection to racial stereotypes. Also interesting in the lot on Shore's book cover is the color of the cars, which, with their greens and tan bodies, were the dominant colors associated with the 1970s.

In an updated version of a parking lot (see Figure 33.2), I frame one with all of its details. There are a lot of elements to look at in the shot. On the right there's a truck with an ad for "Aid and Abet Bail Bonds." Running parallel to the lampposts are the shadows cast by the cars parked in a vertical line on the right. In the center of the frame are three red lampposts that are connected with overhead wires. In the middle ground are a parking attendant booth and a purple umbrella. Finally, if you notice in the background, there is a car inside a trailer. To be sure, it's a busy image. Some people like this type of thing. One thing is for sure: All the elements in the photo keep the viewer looking at it for more than a short time.

Shoot a Landscape of a Road with Two-Thirds of the Frame Filled with Sky

If you were a fine art photographer in the 1970s, you just didn't shoot in color. Color photography was for the masses and for glossy magazines. Art photographers used mostly black and white. Not Stephen Shore. He took pictures using a large-format color film (8×10). His subject matter was the diners, motel rooms, lonely roads, and offbeat people he encountered on the way. He used 35mm film on the first trip he took, and then he moved on to 4×5, then 8×10 film, capturing every mundane detail he could. In Shore's words, he photographed "every person I met, the beds I slept in, the toilets I used, art on walls, every meal I ate, store windows, residential buildings, commercial buildings, main streets, and then anything else…." Somehow, the photos were a hit. Shore had captured and made as art all those things he found on his trip.

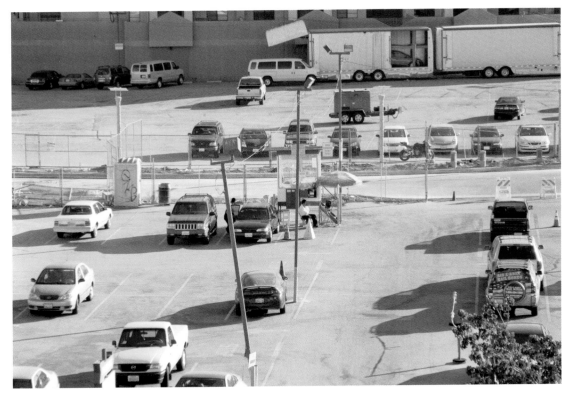

Figure 33.2 Outdoor parking lots always have something going on.

In Shore's *I-8 Yuma* (www.bbc.co.uk/photography/genius/gallery/shore.shtml) photograph of a lonely road and sky, he captured puffs of small clouds that are so detailed and sharp that they look as if you can grab them. The sun reflects off of the road, making it glow. The wide shoulder of the road begins at the middle of the bottom of the frame and leads down a path along the road right into the middle of the horizon, one-third of the way up the frame. Around the road is the desert, brown and smudged with scrub.

In shots where the sky is a dominant focus in the photograph, clouds help to make it more interesting. Just as the clouds in Shore's photograph are a focus point, the layer of clouds is the focus in Figure 33.4, a lonely road in the West. Clouds have always measured the pulse of humanity. They've appeared in artwork since man first scoured the planet. Catch them in the right light, and they are master subjects, illuminating the heavens with hope and serenity.

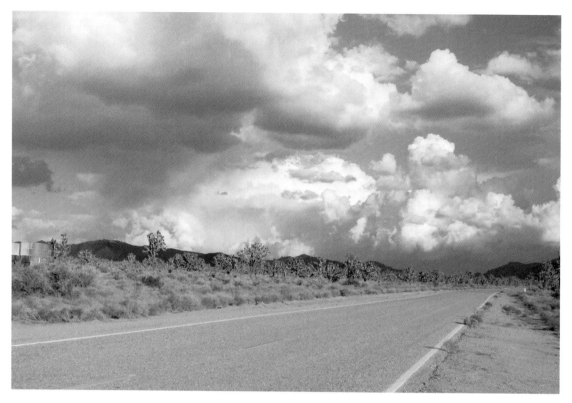

Figure 33.3 Beautiful cloud formations can make a shot of a lonely road worthwhile.

CONCEPTUAL PHOTOGRAPHY

Do you have certain things that you know you'll photograph—perhaps to create a collection of photographs of certain things? If you do, and if the images convey an idea that you've planned beforehand, then you're making conceptual photographs. Stephen Shore made conceptual photographs in the '70s, as did many other photographers. Andy Warhol created conceptual art as a rebellion to the status quo. His images of Brillo pad boxes and Campbell's soup cans made history. They made everyday life bigger than life. Before Warhol, Campbell's soup cans would never have been considered art. In the 1960s and 1970s, photographers such as Shore and Ed Ruscha (who brought gas stations into the realm of art) brought a whole new everyday world to photography.

In Figure 33.4, I've brought the idea of conceptual art—or art with a concept—to life. The concept of the demise of the phone booth is clearly stated in the photograph. The phone booth is empty. It once was an active place where people made phone calls. As soon as I saw the phone booth, I knew I'd photograph it because whenever I go out shooting, I'm always on the lookout for phone booths. I have a series of images of phone booths from around the world, so when they are no longer around, I'll have something to show that they were here.

Figure 33.4 Years ago, before conceptual art, people wouldn't have considered an image of a phone booth art.

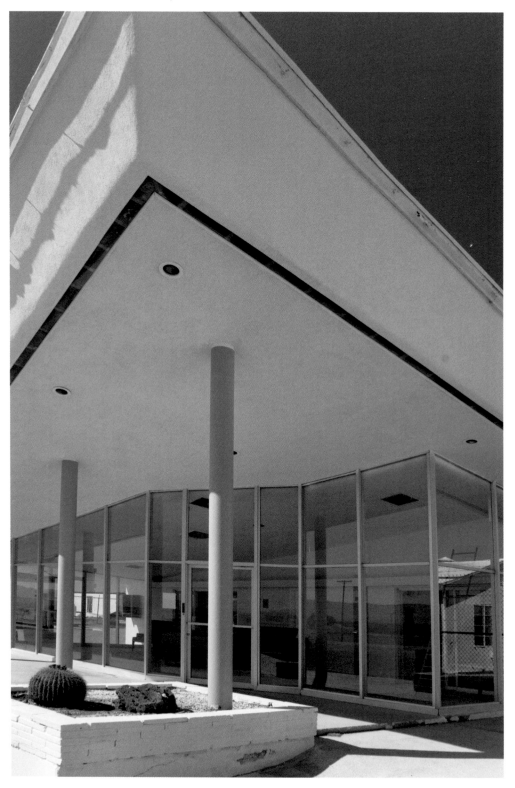

Modern architecture in Amboy, California.

Julius Shulman
(1910–2009)

Julius Shulman spent the early part of his life in New York and Connecticut. He moved with his family to California when he was 10 years old. In high school he took a photography class, which started him out in the field. That was to be the only formal training he received in the craft. Shulman's photography career took off when he met architect Richard Neutra in 1936. When Shulman took some snapshots of a house Neutra was working on, Neutra liked them and purchased them from Shulman.

Shulman photographed mid-century modern houses by some of the world's best architects, such as Frank Lloyd Wright, John Lautner, Charles Eames, and, of course, Richard Neutra.

His best known series of photographs are his images of case study houses. In the Experimental Case Study House program, an architecture magazine sponsored architects to design modern homes in Southern California. Julius Shulman photographed many of them.

Shulman liked to use props in his photos. When he didn't have any, he'd make do with what was laying around. On one occasion he went so far as to stack several gas burners on a table to make an ornamental object.

Like most architectural photographers, Shulman shot with narrow apertures and a tripod to keep the entire frame sharp. He'd often place subjects, perfectly coiffed and immaculately dressed, in his architectural shots, creating what many have thought to be the perfect shot.

Avoid Converging Lines in the Frame

There's one thing Julius Shulman didn't do in his photos—create distortion by using converging lines. In a 1990 interview, Shulman said he wanted the architecture to scale: "My pictures always were indicative of the design and the scale, the proper lenses, the proper wide angle, the medium-angle lenses we used to convey without over-exaggerating the perspectives." One result of distortion is having converging lines in a photo. This is something that skilled architectural photographers avoid.

In *Alexander Twin Palms House 2, 1957*, Shulman framed a house angled at less than 10 degrees from a horizontal axis with a butterfly roof. Part of the house is cut out of the frame so that only about three-quarters of it shows up. In the front yard are big, round concrete slabs of different sizes embedded into the grass. In the photo is one of Shulman's staged effects—a woman posing in the left side of the frame in front of the house.

The house in Shulman's photo was designed by the father/son team of George and Robert Alexander. Such houses came to be known as Alexanders. These tract homes (2,500 of them) were built for middle-class families moving to the desert. Figure 34.1 shows almost the exact orientation, framing, and style of the Alexander photographed by Shulman. All lines in the photograph are straight up and down so the house is shown to scale.

To avoid converging lines, which happens quite easily when you are using a wide angle lens, you need to step back from the architecture you are photographing until the vertical lines of the building are vertically oriented. There are two ways to avoid converging lines if you are close to a building. The first is to use a tilt/shift lens, which is prohibitive for many because of its high cost. The second is to use Photoshop. It's very easy to make converging lines straight up and down using Photoshop. First, you select the entire frame with the Rectangular Marquee tool. Then you navigate to Edit > Transform > Distort. Finally, you click and drag the top-left corner outward until the lines are straight up and down, and then you repeat this for the top-right corner.

Figure 34.1 House with butterfly roof...one kind of house Shulman often photographed.

THE RED FILTER

Shulman often used a variety of filters when shooting landscapes. He used a red filter most often. If you want a subtle change in tonal variations in your image, you can add a bit of red to them. Just choose Layer > New Adjustment Layer > Photo Filter and then in the New Layer dialog box that comes up, click OK. Another dialog box will come up. In that one, choose red from the Filter drop-down menu. You then can control the amount of red in the photo using the Density slider.

There's another way you can do this, too, with a little bit of a different effect. First, you create a Fill layer. After you've created it by navigating to Layer > New Fill Layer > Solid Color, choose red from the drop-down menu. After you click OK, a color picker will come up. Choose bright red on the palette. You'll now see your picture replaced with solid bright red in the frame. Then go to the Layers palette and bring the Opacity slider in the new layer down to 5–10 percent. That's it! Flatten your image, and you're finished. You'll get a black-and-white image like you see in Figure 34.1.

Choose Indoor/Outdoor Settings

One of the most important features of modern design is providing access to the outdoors. Modern architects provided that access by using floor-to-ceiling glass for windows so you can see outside. One of Julius Shulman's most remarkable photos is *Case Study House #22, 1960* (www.wirtzgallery.com/exhibitions/2003/2003_06/shulman/js13.html). The image shows the side of a house whose walls are made entirely of floor-to-ceiling glass, so that you can see through to a view of Los Angeles. The house is shot at an angle. You can see the inside of the house through the windows in the left half of the frame. On the right side of the frame is a stunning view of Los Angeles. In the foreground is part of a chaise lounge and a potted plant on top of concrete. Occupying the entire top of the frame are the eaves of the flat roof, which are made of planks of board that cross horizontally into the frame. Two women in dresses are sitting inside the house.

In Shulman's image of the Palm Springs Tram Mountain Station, he shot so that the inside of the station was on the right side of the frame and the outside was seen through the window on the left. The dividing point between inside and outside is the left edge of the frame, where the floor-to-ceiling glass walls begin and extend inward toward the center of the frame.

Another noticeable technique Shulman used in these shots is having a major line formed by the architecture come out from the edge of the frame. In *Case Study House #22*, the line is the bottom of the foundation coming out of the bottom-left corner of the frame and moving into just off center from the middle of the frame. Another thick line formed by the top frame of the house (where the tops of the windows end) moves from the top-left edge of the frame inward, parallel to the foundation line.

The line that leads from the edge of the frame into it isn't always formed by part of the architecture. In one image of the inside of a house, the top of a couch forms a thick line that moves from the bottom center of the frame inward to near the middle.

In Figure 34.2, an image of the inside of a museum in Tokyo, a curve moves from the right edge of the frame inward, to just off center of the middle of the frame. The curve is made by the division panel that separates the hallway from the seating area. Like in Shulman's tram station image, you can see through a floor-to-ceiling glass window outside. There was enough light in this shot to get a sharp image with a handheld camera. Shot with a wide angle lens at f/10, ISO 400, at a focal length of 10mm, the image looks vast because of the wide angle used to photograph it.

Figure 34.2 Including a part of the outside in an inside shot can add natural light to the frame.

Sky photographs can be compelling.

Alfred Stieglitz (1864–1946)

A lfred Stieglitz was born in Hoboken, New Jersey. His parents took him to Berlin when he was a teenager. There he studied photochemistry and began taking pictures of the European countryside. After 10 years in Europe, he returned to the United States, where he advocated for photography to become associated with the arts through his work as editor of *Amateur Photographer* magazine and later through the Camera Club of New York.

Not enamored with the conservative views of the Camera Club of New York, Stieglitz started his own club, the Photo Secession. Stieglitz raised the profile of photography so that it could be considered art through his writings in the magazine *Camera Club*.

Stieglitz opened a gallery in New York City in 1905. He mingled with other artist greats who often showed their works at his gallery. Stieglitz met Georgia O'Keeffe when she found out he had shown one of her drawings at his gallery without her permission. She forgave him, and they went on to fall in love. She was a talented painter whose paintings of flowers became valuable art pieces. Stieglitz was still married at the time he met her. O'Keeffe was 23 years his junior, and he ended up divorcing his first wife and marrying O'Keeffe. They became one of the best known couples in the art world.

Find Dead or Dormant Branches in Front of a Cloud

Stieglitz's father owned property in St. George, an area north of New York City. He photographed everything around there—barns, sheds, trees, and even people who visited.

He thought of these everyday subjects and objects as worthy of a photograph because he saw them as art forms, especially when they were framed in a compelling way. Stieglitz once said, "Simplicity is the key to all art—a conviction that anybody who has studied the masters must arrive at."

Stieglitz often photographed dead or dormant trees and/or tree branches. In *Chestnut Trees, Lake George, 1927* (http://sfmoma.museum/artwork/13798), he framed the top of a dead tree whose branches extended out from the bottom-left edge of the frame and another solo branch that rose one-third of the way up on the right side of the frame and extended inward to cover a good part of the top of the frame.

In one other dead tree photograph (*Life and Death, Dead Tree, Lake George*) Stieglitz framed a tree that divided into two major branches—one with smaller branches that extended upward into the frame and another whose thick branch rose as a stump that stopped a third of the way up the frame. In the background is a very faint mass of light clouds, which break up into a clear spot in the sky in the middle of the frame.

In a similar photo (Figure 35.1), a leafless tree branch extends outward in two places from the right edge of the frame. The picture, taken in the Amazon, also has a small bird in it. The cloud behind the branch makes the photo compelling because of its softness and color. (I kept this image in color to do it justice.)

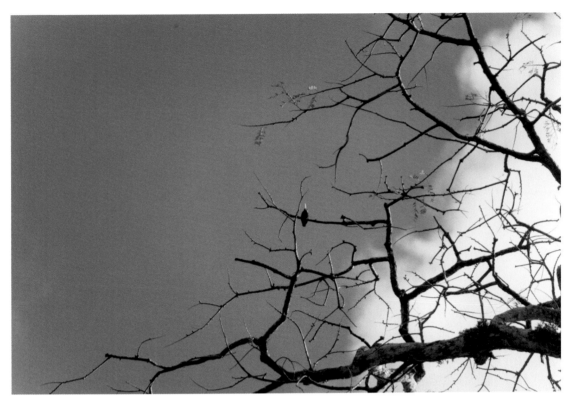

Figure 35.1 Intertwined tree branches.

Rotate Cloud Photographs

One way to give your cloud photographs a new look is to rotate them either in Photoshop or after they're printed. Stieglitz used this technique for his series of photographs of clouds.

Stieglitz's photographs of clouds became part of his *Equivalent* series, which were taken late in the 1920s. Stieglitz had used a tripod to photograph landscapes, but then he switched to a handheld 4×5-inch Graflex camera so he could aim the camera in any direction he wanted. In showing the images, he'd often change them from portrait orientation to landscape. Stieglitz's cloud photos were dark and contrasty, with shades that ran from black to light gray. He made an analogy of his photos to music, saying that "their keynote is simplicity in arrangement and the true rendering of tonal values."

If you spot a beautiful cloud scene, you have to work quickly, as Stieglitz did. Clouds can change rapidly, and missed opportunities will never be seen again. Figure 35.2 shows a cloud formation I shot from a hotel room in Bangkok. When I walked in the room, I had to grab my camera and shoot the formation because it practically sang to me. The colors were incredible.

Figure 35.2 An image of a cloud formation taken in Bangkok.

To emulate Stieglitz, I converted the photo to black and white and rotated it 90 degrees, in the same way Stieglitz might have. The result is shown in Figure 35.3.

Figure 35.3 Rotating a photograph of clouds and converting it to black and white can give it a whole new look.

Zoom in Close When Photographing a Celebrity

Alfred Stieglitz's main subject was his wife, painter Georgia O'Keeffe. He certainly wasn't shy about zooming in with the camera to get close-ups of her, nor was he shy about zooming out to photograph her nude.

Stieglitz photographed O'Keeffe in every way, including:

❋ In a bathrobe with her hands, one on top of the other, just below her chest.

❋ In a doorway wearing a hooded jacket and standing next to thick wood trim. She appears dwarfed because the top of her head only reaches two-thirds of the way up the frame.

❋ Framed from forehead to shoulders, with the neck and lower part of the face covered by a turtleneck sweater, which her hands are delicately wrapped around.

❋ A nearly full-body shot in an overcoat and a hat, her body turned to the side, placed in the middle of the frame, with her head facing forward.

❋ A straight-on portrait in a white, baggy, button-down shirt and dark coat, with the collar up and lying flat from the back of the neck to the chest.

❋ A straight-on portrait, holding an ear of Indian corn near her face.

❋ A close-up head shot, smiling, with her head turned partway to the side.

❋ A shot from the waist up, in a dark, short-sleeve open sweater with a white shirt underneath, her hair tied tightly back.

> **N O T E**
> You can find various portraits of Georgia O'Keeffe by Stieglitz at www.artbeat123.com/ marymac/ganda.html.

In one photograph he framed just her face. She was wearing a hat that cast a light shadow over her forehead. I happened to catch a film star framing her face almost exactly the same way Stieglitz framed Georgia O'Keeffe in a close-up shot of her from 1922.

In the Stieglitz shot, a sepia haze appears over O'Keeffe. This can be easily replicated in any portrait in Photoshop, after a photo is converted to black and white. (See the following "Photographing and Photoshopping a Star" sidebar.)

Figure 35.4 shows an image of a movie star that was taken at a film festival. (See the "Photographing and Photoshopping a Star" sidebar below.) I remembered to zoom in so I could get just her face. Close-ups are some of the best photos you'll get of the stars.

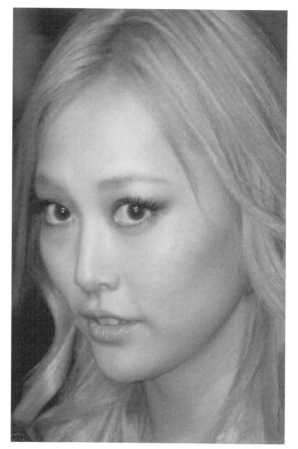

Figure 35.4 Stieglitz used a sepia haze like the one shown in this photo.

Photograph a Reflection of Subjects/Objects in a Body of Water

During his travels in Europe, Stieglitz visited Venice in 1894. He photographed the canals reflecting the buildings and sky above them (en.wikipedia.org/wiki/File:Stieglitz-Venetian_Canal.jpg).

Stieglitz cropped the image so you can't see the tops of the buildings and the sky above them. However, he made sure you could see the tops of the buildings and the sky in the reflection. He caught a number of variations in light, each distinct and compelling. There are buildings on both sides of the canal. The light on each side of the canal varies from darker shades in the foreground to lighter shades at a bridge where the canal ends. The change in light is due to the fact that the buildings are made of darker brick in the foreground and are whitewashed in the middle and background.

PHOTOGRAPHING AND PHOTOSHOPPING A STAR

In 2006, I photographed the red carpet of the Palm Springs International Film Festival. My mission: to get close-ups of the stars. That year *Babel* received many Academy Award nominations. The actors of the movie were acknowledged at the festival. As they were coming through, I photographed all the stars by tucking myself at the end of a tunnel of other photographers. I stood behind the open door so I was able to stick my lens out and get close-ups of all the stars (Brad Pitt and Cate Blanchett among them). The most interesting shot was of the relatively new star who was nominated for best supporting actress, Rinko Kikuchi.

In an effort to get my photo looking like it was taken in the 1920s, I wanted a sepia color cast over it. After turning the photo into black and white (see the "Black and White Conversion in Photoshop" sidebar in Chapter 1), I wanted to work in color to add a color cast to the photo, so I switched the mode from Black and White to RGB Color (Image > Mode > RGB Color). I then adjusted the Color Balance (Image > Adjustments > Color Balance) by moving the slider until the color cast was the same as the Stieglitz photo. At that point the photo had way too much contrast. To soften it, I used a Fill layer (Layer > New Fill Layer > Solid Color, then pick a color close to white using the Color Picker). At that point my image turned a solid color. I then adjusted the Opacity slider in the Layers palette until I got the softening I wanted (about 20 percent). Voilà, I got the same color tone and contrast as the Stieglitz photo.

Just as the buildings change shades from foreground to background, so do the reflections they cast on the water. The reflection of the sky is almost semicircular in the bottom third of the frame. While the buildings leave dark shadows as you move away from them to the left and right, the light changes quickly, becoming very bright. Its effect, when combined with the rest of the image, is that you feel as if you're looking into an abyss—a white hole, if you will. In the center of the frame, there are three gondolas—two on the right and one on the left. The ones closest to the foreground cast dark reflections, which looks like hearts.

In Figure 35.5, the city of Strasbourg is pictured with a bridge reflected on the water. In order to get sharp reflections, the water has to be fairly calm. In this image there are some slight ripples, which make the reflection soft. Most notable about the reflection of the bridge in this image are the two ellipses that are formed by the bridge meeting its reflection.

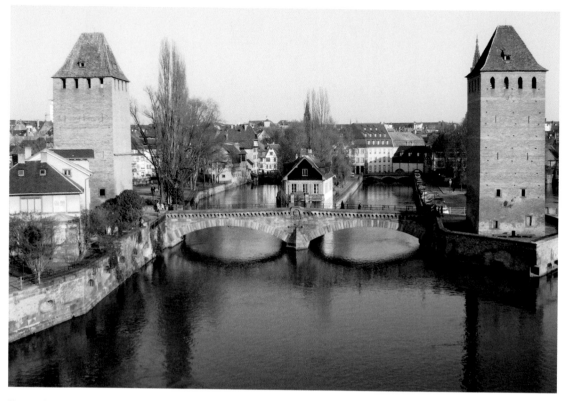

Figure 35.5 Reflections of landscape onto bodies of water vary according to the weather and sea conditions.

CHAPTER 36
Paul Strand
(1890–1976)

As a teenager, Paul Strand worked with Lewis Hine. And in the first decade of the 1900s, Alfred Stieglitz introduced Paul Strand to artist greats such as Picasso and Cezanne.

Strand started out as a pictorialist, making his photographs look like paintings. To shoot this type of photo, Strand used a soft focus lens. He switched to making his images sharp when he was in close communication with Stieglitz, and he ended up creating a new type of photography that was more abstract than anyone had seen before.

In the 1920s, Strand moved to filming motion pictures when he learned the craft after serving in World War I.

Isolate Buildings from Exterior Elements

Strand and other photographers looked for small frame buildings with gabled roofs that had few exterior elements around them—no trees, phone wires, mailboxes, planters, and so on. They had a minimalist approach to framing their shots. Back in Strand's day, they didn't have Photoshop. They had to do the best they could without it, which means they had to look harder to find structures without exterior elements around them.

In *Church, 1944*, Strand framed a church where the only exterior elements were a few trees in the top right of the frame. The church has a gabled roof, two small, rectangular windows, and double doors below. The gabled roof is outlined with trim so that it makes a triangle at the top of the frame. It's topped off with the square part of the steeple that sits behind the top part of the triangular-shaped gable. A small portion of the church is cut off on the right side of the frame.

In Figure 36.1, I've tweaked an image of a Wisconsin church to look similar to that of Strand's. I removed a thick telephone wire and some trees to the left of the church. To do this, I first enlarged my image to 300 percent on the screen. Then I used the Clone Stamp tool in Photoshop, setting my source point on an appropriate area to replace the tree or wire.

You can see that without any external elements, the lines that create different shapes in the photograph are emphasized. There is a triangle that is formed by the roof's gable, just as there is in Strand's church photo. Also similar are the horizontal lines made up from the building's siding and the rectangles, large and small, that make up the windows and windowpanes.

Photograph a Toadstool

Toadstools or mushrooms often make good photo ops. Strand's *Toadstool and Grasses* (www.masters-of-fine-art-photography.com/02/artphotogallery/photographers/paul_strand _04.html), *1928* shows a toadstool as viewed from about a 30-degree angle from a vertical axis. You can't see the stem because tall, thin grass enveloped in dark shadow surrounds it, occupying the bottom half of the frame. You get a good view of the vanilla top through a few strands of grass. The edge of the mushroom begins about two-thirds of the way from the bottom of the frame. The entire top of the mushroom occupies a good part of the top third of the frame. At the top of the frame, a triad of leaves sits on the toadstool's edge.

Figure 36.2 shows a mushroom that grows on dead tree bark. This type of growth is known as a *shelf fungus*. It feeds off decaying bark. It's dark with a white edge that makes a semicircle off center from the middle of the frame. To give the shot the same overall color tones as Strand's shot, I first changed the photo to black and white (see the "Black and White Conversion in Photoshop" sidebar in Chapter 1), then changed the mode back to RGB (Image > Mode > RGB Color), and finally tweaked the midtone Color Balance sliders (Image > Adjustments > Color Balance).

Figure 36.1 Eliminating external elements from the frame brings out the shapes evident in the building.

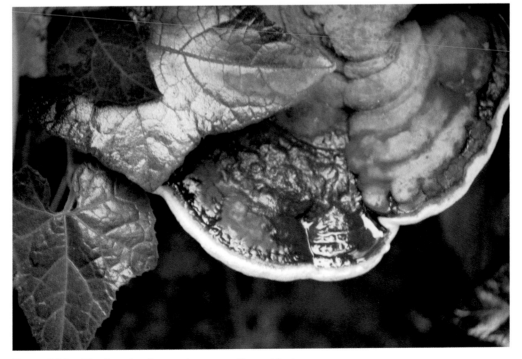

Figure 36.2 Toadstools often make compelling subjects.

Find Architectural Shadows That Border on the Abstract

The "Find Abstract Art in Architecture" idea (in Chapter 31) presented the merits of making architectural elements look abstract. However, that idea didn't include the use of shadows to help create abstract art. You'll find that creating an abstract work with shadows is a bit trickier than it is with just an architectural element. The shadows have to create some sort of pattern on the surface upon which they are cast.

Strand was published in Alfred Stieglitz's *Camera Work* magazine (refer to Chapter 35) and was a member of the Photo Secession group that Stieglitz started. The group's principal goal was to create works that emulated paintings. Strand became so good at taking abstract photos that Stieglitz commented that his photos came close to emulating Picasso's work.

Strand began to take semi-abstract photos in which you could recognize the objects, and then he moved on to creating totally abstract works in which the objects became unrecognizable. It was part of a movement from pictorialism to modernism.

In *New York, 1917*, which was published in *Camera Work*, Strand framed a street scene from above so the frame was occupied by a huge shadow of a tower. The only identifiable objects in the photo are two people walking on the sidewalk next to the shadow. The shadow is quite remarkable, with one giant curve below which a set of V's are lined up that go along it. The rest of the frame is filled with intersecting lines, large and small. The entire shadow of the structure is placed so that it lies diagonally in the frame.

Figure 36.3 shows a semi-abstract image with shadows cast on an inside wall of an abandoned house. In the middle is a window open to a view of the desert. The shadows make horizontal, vertical, and diagonal lines in the frame. The abstractness of the image really stands out when you view the sunlit areas—the areas not covered by shadow. They form different polygons—triangles, quadrilaterals, pentagons, and hexagons—on either side of the large rectangular window.

Make a Fence Your Primary Subject

In *White Fence, Port Kent, 1916*, Strand did the unthinkable: He made a fence the primary subject of a photograph. For the first time, a photographer used an image to focus on geometrical elements. It was the onset of the modernist movement. In this case, it was the lines that made up the fence that were being emphasized. The image is high contrast with a sharp focus, which is what back then was referred to as *straight photography*.

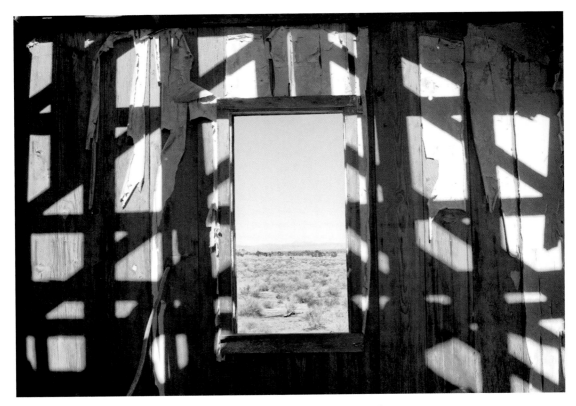

Figure 36.3 Shadows can often create an abstract feel to a photograph.

In the image, a fence extends from the right edge of the frame to the left. The fence reaches through the bottom half of the frame more than halfway to the top. Behind the fence, in the background, are two buildings, one behind the other. Prominent on the building closest to the fence is a door with four X's, two on top and two on the bottom. "Why did I photograph that white fence up in Port Kent, New York, in 1916?" Strand said of the image, "Because the fence itself was fascinating to me. It was very much alive, very American, very much a part of the country."

In a similar image (Figure 36.4), a light-colored fence is shown as the primary object in the frame. It's longer than the strand fence and doesn't stretch horizontally through the frame. Instead, it rises at an angle through the frame, becoming horizontal near the right edge of the frame. The vertical lines in the image are just as prominent as those in Strand's fence.

Also notable in Figure 36.4 is the image's sepia tone. I used the same sepia tone as that in Strand's photo.

Figure 36.4 A fence as the main subject in the frame.

Edward Weston
(1886–1958)

Edward Weston took his first pictures at age 16, when he received a camera as a gift. He began in the photography business as a portrait photographer in California. In his early days as a photographer, he was a pictorialist. (He made his photographs resemble paintings.) Later, he abandoned that type of photography for one that was more in tune with the medium of photography. His images went from soft to sharp and filled with details. No matter the method, Weston stuck with large-format cameras and usually shot with a tripod. Weston befriended Imogen Cunningham. During the 1920s, the two pursued the same type of photography—pictorialist portraits and still lifes. He photographed a profile of Cunningham in that soft style.

In the early 1920s, Weston moved around a lot. First, he went to New York, where he met Alfred Stieglitz and Paul Strand. The following year, he left his family in Los Angeles to travel to Mexico with his companion, Tina Modotti, who also became an accomplished photographer (see Chapter 24). There, he met muralists José Orozco and Diego Rivera. In Mexico, he photographed landscapes, female nudes, and portraits.

By the 1930s, Weston came back to the United States, moving to Carmel, California. As cofounder of Group f/64 (Ansel Adams was a member), he advocated straight photography—photography that was sharp and pure, showing things exactly as they are.

By then he was concentrating on all types of shapes and forms, from parts of the human body to the surfaces of vegetables and rocks. His most famous images show the ripples of a sand dune and a close-up of a nautilus seashell. He received the first Guggenheim grant for photography in 1937. He focused on the landscapes of the West.

By the 1940s, Weston met a new young lover whom he photographed nude in a variety of ways. One such photo is a close-up of an arm, a leg, another arm, and another leg squeezed tightly together.

Photograph a Lake Scene from the Top of a Hill

Weston and Tina Modotti moved to Mexico in 1923. During this time Weston moved from pictorialist photographs to straight photography, such as that seen in the work *Janitzio, Mexico, 1926* (www.edward-weston.com/edward_weston_architecture_4.htm). In this image the landscape is sharp throughout the frame, indicating that Weston used a narrow aperture to capture the scene. To take the image, Weston stood above a hamlet on a lake in Mexico. The lower third of the frame is filled with the tile roofs and walls of four one-story buildings, each on a different level. The middle of the frame has the lake water almost uniformly white. Across the lake in the far background is a mountain range with a bit of sky. Weston also used a similar vantage point in his work *San Carlos Lake, Arizona, 1938*.

In Figure 37.1, I've framed the lodge at the Napo Wildlife Center from a lookout tower in back of the lodge. I, too, used a narrow aperture to take the shot (f/16). At the time I shot the pictures, ripples had been made in the water, which makes the image compelling, as does the color of the trees in the background. I left the image in color because of the autumn-like feeling brought on by the orange, yellow, and green trees, colors which catch many people by surprise when they visit there.

Figure 37.1 A lake scene from above.

Frame Vegetation against the Sea

In *Grass Against the Sea, 1937*, Weston used the sea as a backdrop for simple vegetation. Although Weston had been involved with Group f/64 as early as 1932, he didn't always stick to using narrow apertures. It's evident that he used a wide aperture and focused on the grass in the image because the grass in the foreground is sharp, and the ocean in the background is soft. Having the sea soft puts more focus on the grass, making it stand out in the frame.

In Figure 37.2, I've framed an oleander plant in front of the sand of the beach, the ocean, and the sky, which are soft in the frame. Having those three elements in the background gives the shot multiple textures. Because they are soft, they don't take the focus away from the oleander plant and flowers. The picture was taken in Turkey with a film camera and then scanned.

Figure 37.2 Oleander plant with beach and sea soft in background.

Find Programmatic Architecture

Programmatic architecture is a building that was constructed in the shape of a familiar character or object. This architecture was popular in the middle of the century. Weston photographed *Mammy, 1941*, of a structure in Natchez, Mississippi, that was a Shell station when Weston shot it. The main building is a half-sphere that resembles a dress, on top of which there is a sculpture of a woman with a bandanna over her head. Weston included other elements—a truck and gas pumps in the foreground—so as not to cramp the main figure in the frame. Although Weston doesn't use the Rule of Thirds in the image, he does place the figure just left of center in the frame so that there is more space to the right of the figure than there is to the left.

IS FILM BETTER THAN DIGITAL?

Now that I'm nearing the end of this book, I've gotten to thinking about film—all kinds of film, from 35mm to 4×5 to 8×10. One thing is for sure, no digital camera is comparable to 8×10 film. A 16-MP full-frame camera is the equivalent of 35mm film.

If you compare 35mm film to a full-frame sensor on comparable camera models and blow up both images, the digital camera is going to be better both in the detail and the color (according to a test of both mediums by The Gadget Show). I don't think that's the whole story. It only considered an image blown up to wall size. At a smaller size, I find film much more compelling because it makes objects and subjects less sharp at the edges. With digital, the images are so sharp that sometimes everything in the image looks as if it has been cut and pasted together. Check out the edges in Figure 37.3. They are smooth and refined.

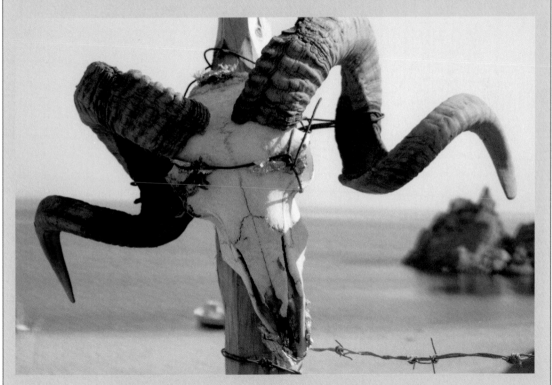

Figure 37.3 An image scanned from 35mm film.

After viewing hundreds of images of both on the Internet (many of them high resolution), I'd give the award to film, especially if it's done in large format. It's the large-format film that helped to make the master photographers of the twentieth century great.

Weston had an advantage in getting a better photograph of this iconic piece of architecture because he shot it when it was new, only a year after it was built. Also, the trees around it weren't nearly as high as they are today. In images of the place today, a forest of vegetation surrounds it, which takes the focus away from the structure. This vegetation was almost nonexistent when Weston took his picture.

In Figure 37.4, I've photographed a California desert restaurant that is in the shape of a barrel. Coincidentally enough, the name of the restaurant is Barrel. Because much of this type of architecture is more than 50 years old, you get a different feeling than if it were brand new, like when Weston was photographing. When architecture is worn by time and the elements, it brings out a lost, end-of-the-world feeling.

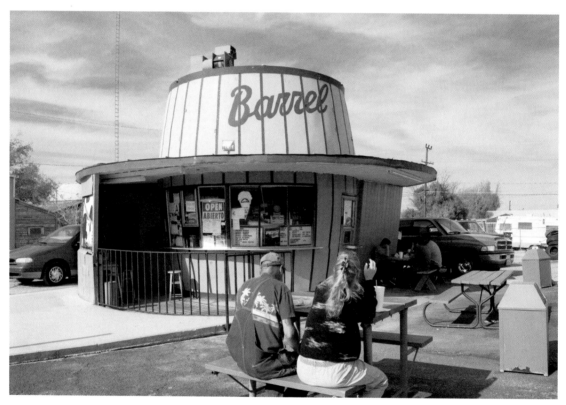

Figure 37.4 Programmatic architecture is a building that was built to look like a shape or object in real life.

Index